D0565378

50 PHOTO PROJECTS

50 PHOTO PROJECTS

IDEAS TO KICK-START YOUR PHOTOGRAPHY

LEE FROST

David and Charles

FOR NOAH AND KITTY

A DAVID & CHARLES BOOK
© F&W Media International LTD 2009, 2011

David & Charles is an imprint of F&W Media International, LTD
Brunel House, Forde Close, Newton Abbot, TQ12 4PU, UK

F&W Media International, LTD is a subsidiary of F+W Media, Inc.,
4700 East Galbraith Road
Cincinnati OH45236, USA

First published in the UK and US in 2009
This UK paperback first published in 2011

Text and illustrations copyright © Lee Frost 2009, 2011

Lee Frost has asserted his right to be identified as author of this work in accordance
with the Copyright, Designs and Patents Act, 1988.

All rights reserved. No part of this publication may be reproduced, stored in a retrieval
system, or transmitted, in any form or by any means, electronic or mechanical, by
photocopying, recording or otherwise, without prior permission in writing
from the publisher.

Names of manufacturers, art ranges and other products are provided for the
information of readers, with no intention to infringe copyright or trademarks.

A catalogue record for this book is available from
the British Library.

ISBN-13: 978-0-7153-2977-1 hardback
ISBN-13: 0-7153-2977-4 hardback

ISBN-13: 978-0-7153-2976-4 paperback
ISBN-10: 0-7153-2973-3 paperback

Printed in China by R R Donnelley
for David & Charles
Brunel House, Newton Abbot, Devon

Commissioning Editor: Neil Baber
Editorial Manager: Emily Pitcher
Editor: Verity Muir
Senior Designer: Jodie Lystor
Production Controller: Beverley Richardson

F+W Media publishes high quality books on a wide range of subjects
For more great book ideas visit: www.rubooks.co.uk

CONTENTS

INTRODUCTION

How often do you break out of your creative comfort zone and try something new? When was the last time you threw caution to the wind and took a photographic risk?

The reality is that few of us do. It's easier to stick to the same old routine and play it safe, especially in this digital age when modern cameras produce perfect pictures with minimal input from the user.

Unfortunately, predictability doesn't necessarily encourage creativity and originality. Quite the opposite in fact – usually it breeds boredom and complacency. If you take the same journey to work each morning, eventually it becomes so familiar that you no longer see anything along the way. If you eat the same meals day-in, day-out, eventually you stop tasting the food.

It's the same in photography. Shoot the same subjects using the same techniques and equipment for too long and if you're not careful you will find yourself in a creative rut, devoid of ideas and inspiration. Photographers who specialize in one subject area are especially at risk and must evaluate what they're doing every now and then in order to avoid going stale.

I found myself in this position a few years ago. Having started out in photography as an all-rounder keen to try anything, my range gradually began to narrow as I channelled my energy towards one main area – landscape photography.

The benefit of specializing was that my photography improved. I was more focused, and though I produced fewer images they were of a higher quality. However, eventually I began to feel that I was missing out. I would see the diverse work of other photographers in books and magazines and envy them. I wanted to break out and experiment with new ideas, techniques and subjects. I yearned to push the boundaries of my creativity and see just how far I could go. My photographs were good, but they were becoming predictable, and I knew that unless I took radical action my long-term success as a photographer would be in jeopardy.

Digital technology acted as a catalyst in this process. I could see my contemporaries making the switch to digital capture, but I wasn't ready; partly because there was still a lot I wished to achieve with film and partly because I feared that if I did take the digital route it would add to my problems rather than solve them. Consequently, I made the decision to give new technology a wide berth and concentrate instead on alternative approaches to image-making.

In the spring of 2006 I discovered 'toy' cameras, which made me realize that you really don't need expensive, high-end equipment to create wonderful images and that technology can often stifle creativity. I then started to experiment with vintage Polaroid cameras, producing images that are almost as instant as those from a digital camera but worlds apart in terms of expression

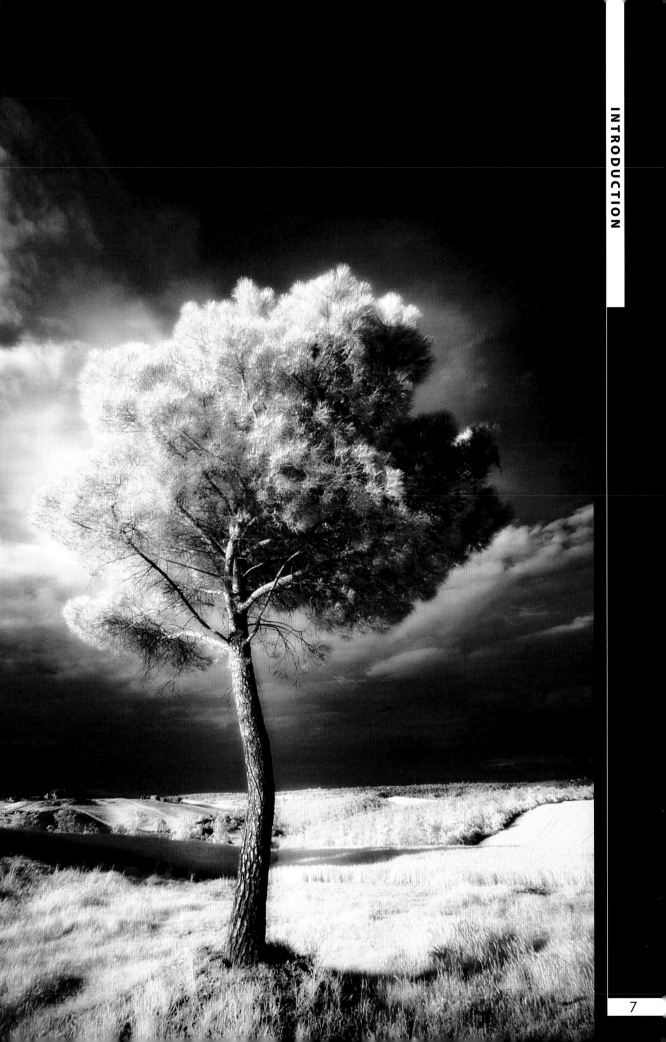

and individuality. Pinhole cameras were my next port of call and I revelled in the art of making photographs with a camera that not only lacks a lens but a viewfinder as well, giving a whole new meaning to the phrase 'point and shoot'.

I've never been much of an equipment fan and for many years I produced the bulk of my work with just a couple of cameras and a limited range of lenses. But suddenly I had a bizarre collection of cameras in various sizes, shapes and forms, from ancient Kodak Box Brownies and crude Russian rangefinders to modified Polaroid models and vintage bellows cameras – all purchased with the purpose of putting them to good use and making unique images.

I also began to take tentative steps towards digital capture. I started carrying a digital compact with me and using it like a visual sketchbook to grab pictures as and when they caught my eye. My flatbed scanner was pressed into service as a large-format digital camera with surprising results. I even purchased a second-hand digital SLR and had it modified to record infrared light – an area

of photography I used to explore with infrared film.

These creative meanderings were just what my photography needed. They introduced unpredictability, because I was continually trying things for the first time and never quite knowing what the outcome would be, and they allowed me to create images that were totally different to anything I'd achieved before.

I found myself once more excited about picking up a camera and making images and the more I experimented, the more motivated I became. Creatively I felt totally revitalized and reborn. My passion for photography had been reignited and I can honestly say that I am more inspired now than at any other point in my life as a photographer.

This book has been written to help you avoid that creative black hole by providing a range of inspirational ideas that will keep your own passion for photography alive. As well as equipment-based assignments that involve working with alternative and unusual cameras like those mentioned above, there are subject-based techniques that will encourage you to broaden your creative horizons and visual exercises designed to help you develop a keener eye for a picture.

I have tried them all many times over and have the pictures to prove it, so I feel confident in saying that this book will seriously improve your photography! It will also open your mind to the amazing potential that photography offers for artistic and self-expression and set you on a path of discovery that will continue for a lifetime.

During the writing of this book my own photography took yet another significant turn in that I finally embraced the idea of digital capture and am now the proud owner of a Canon EOS-1Ds MKIII. Two years ago it was something I couldn't contemplate, which is why this creative journey began. Having completed it, and re-established

my aims and ambitions, I now have the confidence to embrace digital technology and use it to take my photography to the next level.

I still shoot film, and can't ever imagine a time when I won't, but my eyes have been opened to the many benefits of digital capture. In order to look forwards I first had to travel backwards. I still shoot landscapes too. You won't see many of them here, because that's not what this book is about, but I can let you into a little secret – they're better than ever!

Lee Frost
Northumberland

ARCHITECTURE WITH ATTITUDE

The last decade has seen a rapid increase in the construction of amazing buildings throughout the world. Despite doom-and-gloom forecasts for the global economy, adventurous architects have been let loose on our towns and cities with a free rein to make their wildest ideas a reality – regardless of the cost – and in many cases the results are nothing short of spectacular.

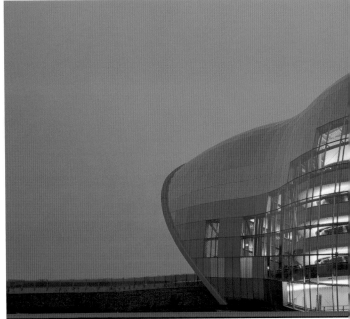

You only have to look at Dubai for evidence of this. As recently as 1990 it was a dusty desert city in the middle of nowhere, but today it's a showcase for some of the world's most lavish constructions. The Burj Al Arab, the world's tallest hotel at 321m (1,053ft) high, resembles a giant sail and stands on an artificial island in the sea. Yet already it is overshadowed by the Burj Dubai, which will be the world's tallest building at possibly 818m (2,684ft) when it is finished – though the final height is still under wraps at the time of writing.

Such is the scale of work in Dubai, it's said that up to one-fifth of all the world's cranes are currently there, and there are more construction workers than citizens.

But Dubai isn't the only place to find exciting and extravagant architecture. Valencia, on the east coast of Spain, is home to the City of Arts and Science, a stunning development of buildings, bridges and monuments that has to be seen to be believed. Head north to Bilbao and you will find Frank Gehry's Guggenheim Museum, a radically sculpted building covered in titanium panels, while the new Madrid Barajas Airport created by London-based architect Sir Richard Rogers continues the space-age trend.

And let's not forget London itself, where more of the wondrous work of Richard Rogers can be seen in the form of the Lloyds Building, still amazing two decades after it was completed. There is also the ill-fated Millennium Dome and the Leadenhall Building. Number 30 St Mary Axe, fondly referred to as the Gherkin, is another must-see, along with City Hall and the London Eye on the south bank of the Thames.

I would never describe myself as an architectural photographer, but when I am faced with subject matter such as this I find it difficult to resist. Modern architecture is a form of art, and the best architects create buildings that are not only functional but visually stunning, unique works of art built for all to admire.

▲▼ THE SAGE, GATESHEAD, TYNE AND WEAR, ENGLAND
Set on the banks of the River Tyne at the heart of Newcastle and Gateshead Quayside, the Sage was designed by Sir Norman Foster and completed in 2004. Day or night it makes a spectacular sight and offers enormous photographic potential. The main panoramic image was taken at dusk and shows the building in profile. What appears to be an image projected on the curvaceous shell of the building is actually the illuminated interior visible through glazed panels. The smaller black and white shot was taken from a similar angle using an infrared-modified digital SLR.
CAMERA: FUJI GX617 AND CANON EOS 20D INFRARED/LENS: 180MM ON FUJI, 16-35MM ON CANON/FILM: FUJICHROME VELVIA 50 IN FUJI

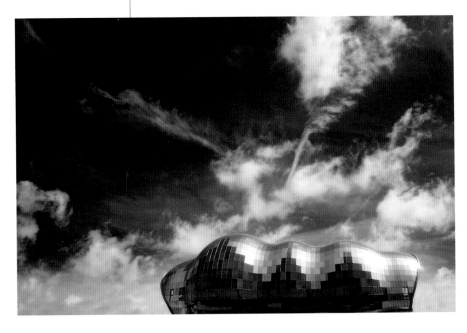

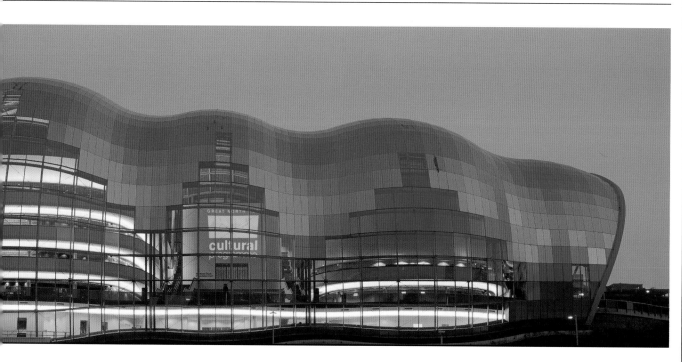

Location, location, location

Getting the best photographs from modern architecture is dependent on a number of factors.

At the top of the list is its location. Some buildings are so hemmed in by others that your only option is to shoot from close range. The Selfridges Building in Birmingham is a typical example. Set in the busy heart of Birmingham's retail sector, it's surrounded by other buildings on all sides and there is no angle available where you can get a clear view of the whole structure – at least not one that really shows off its amazing shape. The solution? Get in close with a wide-angle lens to exaggerate the building's fluid curves and keep other buildings out of the frame. Or home in on details, of which there are many.

Tall buildings are easier in this respect because they stand head and shoulders above their neighbours. The downside is that if you shoot from close range you inevitably have to look up to include the top of the building and this leads to converging verticals.

One way to avoid them is by backing off and finding a more distant, high viewpoint so you're looking across rather than up. In crowded cities this is often the best option, and if you shoot from a distance with a telephoto lens you can also compress perspective so the surrounding buildings appear much closer together. Alternatively, use your telephoto lens from close range and again concentrate on details.

ⓘ PHOTO ADVENTURES

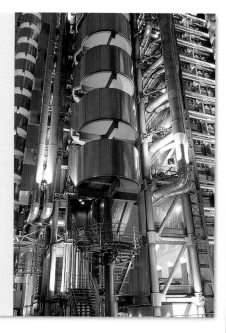

For me, the most exciting thing about shooting modern architecture is that the buildings themselves encourage a more imaginative and adventurous photographic approach. When an architect has created such a spectacular structure, how can you treat it like any old subject? Consequently, I find myself experimenting with unusual techniques, shooting from alternative angles, using different cameras and generally trying to push the boundaries of creativity in an attempt to do the building justice.

Cross-processing film, digital infrared, ultra wide-angle lenses, black and white, panoramic cameras – I've tried them all and more, though technique is merely a means to an end. The most important consideration has to be that the final image does the building justice.

▶ LLOYDS BUILDING, LONDON, ENGLAND
This towering tubular structure was one of the first futuristic buildings to appear in London and despite being over 20 years old still appears ahead of its time. Twilight is the prime time to shoot, when artificial illumination brings it to life.
CAMERA: NIKON F5/LENS: 80-200MM/FILM: FUJICHROME VELVIA 50

▲ THE DEEP, HULL, ENGLAND

Housing a state-of-the-art aquarium, this fantastic building has been described as 'a geological metaphor, rising out of the ground like a crystalline rock formation'. Designed by architect Terry Farrell, it offers many different faces – a leaping robotic fish from one side, a futuristic installation from another. I decided to play on its space-age characteristics when I took this shot, using the sweeping metallic rails and concrete walkways to lead the eye into the scene. Careful dodging and burning of the image during printing completed the look and created an image that did the building justice.

CAMERA: HASSELBLAD XPAN/LENS: 30MM/FILTERS: 0.45 CENTRE ND AND RED/FILM: ILFORD FP4+

▲ CHARLES DE GAULLE AIRPORT, PARIS, FRANCE

Modern airports are at the cutting edge of architectural design, and Charles de Gaulle – especially Terminal 2E with its daring design and wide-open spaces – is no exception. I had several hours to kill in the terminal while waiting for a connection back to Edinburgh after a trip to Cuba, so I used the time to wander around the terminal and take snapshots with a Holga toy camera. The symmetry in this scene caught my eye, and I love the soft blur across most of the image, which gives it an abstract feel. The strong green colour cast is a side-effect of cross-processing outdated colour slide film in C41 chemistry.

CAMERA: HOLGA 120GN/LENS: FIXED 60MM/FILM: FUJI PROVIA 400F

Light fantastic

The quality of light is another major factor because it defines how a building appears. It would have been given serious consideration by the architect when the building was being designed.

More often than not, extravagant modern architecture looks its best once the sun has gone down. After sunset, there is no direct light striking the building. Instead, the sky acts like a huge diffuse light source and, because the majority of modern buildings are covered in acres of glass and steel, the colours and clouds in the sky are reflected. Whatever colour the sky is – red, orange, blue, purple – the building also takes on that colour. As a result, it changes day to day depending on the weather.

As natural light levels begin to fade during twilight, man-made illumination takes over. The appearance of modern architecture changes yet again with colourful spotlighting and illuminated

panels. The Lloyds Building in London is a classic example. By day it looks rather drab, despite its stunning design, but by night, glowing green and blue, it comes to life.

The best time to take night shots of buildings is during the crossover period between day and night when the effects of artificial illumination are clearly seen but there's still colour in the sky (usually a deep blue). Once the sky appears black to the naked eye it's time to call it a day because contrast will be too high and black sky has no visual appeal.

If you can manage an early start after your late finish, dawn is worth trying too. Before dawn the effect is similar to dusk. With the sky providing all the light rather than the sun, reflective exteriors are enveloped in colour. Whichever angle you shoot the building from the effect is the same.

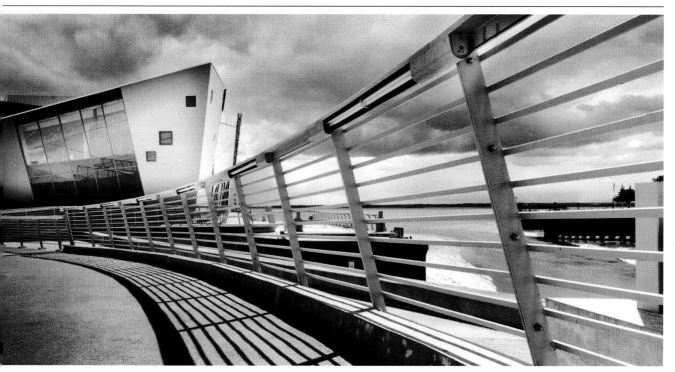

During the daytime the light isn't as effective. When the sun is low in the sky and the light has a golden touch you can take great detail shots. However, the shadows of adjacent buildings are often a problem because they throw large areas of the subject building into shadow. Contrast becomes too exaggerrated and wide shots are out of the question.

If you're forced to take daytime shots, the middle of the day is often the best time. With the sun overhead, shadows are short and dense so they don't pose a problem. Also, the intensity of the light in clear, sunny weather suits the boldness of modern architecture and will help you produce strong, graphic images.

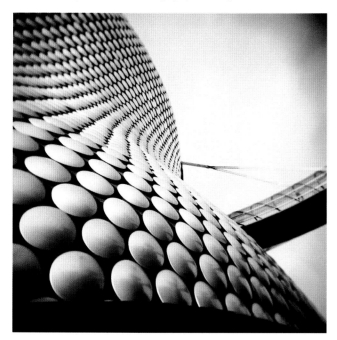

ℹ ON THE ROAD

Though London is the heart of architectural excellence in the UK, there are many marvellous modern buildings in other towns and cities. Here are ten that are worth investigating:

- **Selfridges Building, Birmingham**
- **The Deep, Hull**
- **The Scottish Parliament Building, Edinburgh**
- **Millennium Library, Norwich**
- **The Sage, Newcastle Quayside**
- **The Clyde Auditorium, Glasgow**
- **Salford Quays, Manchester**
- **The Planetarium, Bristol**
- **Millennium Stadium, Cardiff**
- **Princes Dock, Liverpool**
- **Sheffield Winter Garden**

◀ SELFRIDGES BUILDING, BIRMINGHAM
The three-dimensional curvaceous form of this magnificent building is covered in a skin of some 15,000 aluminium discs. Surrounded by other more period properties, including an old church, it looks like something that has dropped from space and landed in the middle of a traditional English city. After exploring it from all angles I deduced that photographically this one was the most effective, showing off the curves of the building and those amazing metallic discs. I also chose to shoot in black and white to make the image simple and graphic.
CAMERA: HOLGA 120GN/LENS: FIXED 60MM/FILM: ILFORD XP2 SUPER

BLUR, BLUR, BLUR

Question: Do photographs always have to be sharply focused and sharply rendered, or is this whole sharpness thing vastly overrated?

For a long time I worked to the belief that sharpness was the ultimate objective, so I used slow, fine-grained film and the best lenses I could possibly afford to achieve optimum image quality, a tripod to keep the camera steady and small apertures to maximize depth-of-field.

Then one day I had one of those happy accidents that changed everything. I grabbed a shot – assuming my lens was set to autofocus – but it wasn't and the image that resulted was completely out of focus. But the strange thing was that I liked it. It stopped me in my tracks and made me take a second look to work out what was going on. From that point on, blur has played an active role in my photography and I've since experimented with various ways of creating and recording it.

Focus pocus

Intentional defocusing works best with SLR cameras that offer through-the-lens viewing because, despite it looking accidental, you really need to be able to see what you're doing so that you can control the effect. Then it's a case of adjusting the focus so that your subject is increasingly out of focus. When the effect looks right, take the picture. Stick to simple, bold subjects that will still be identifiable even though they're blurred, such as flowers, people or monuments, for example. Shots taken against a bright background work well because the main subject will stand out strongly.

Slow it down

Another way to create blur is to keep the camera steady while shooting a moving subject using a slow shutter speed. This way, only subject movement registers and the background stays sharp. This works on any moving subject, from commuters rushing off a train to a flag fluttering in the breeze.

The shutter speed you use will depend on how quickly your subject is moving and how much blur you want. A speeding car will blur at 1/30sec and barely register at all on 1/2sec, whereas a person walking would appear sharp at 1/30sec and only just begin to blur obviously at 1/2sec. The key is to experiment. If you're shooting digitally you can check a shot, and then adjust your technique if it's too sharp or too blurred. However, gauging that will be down to personal preference.

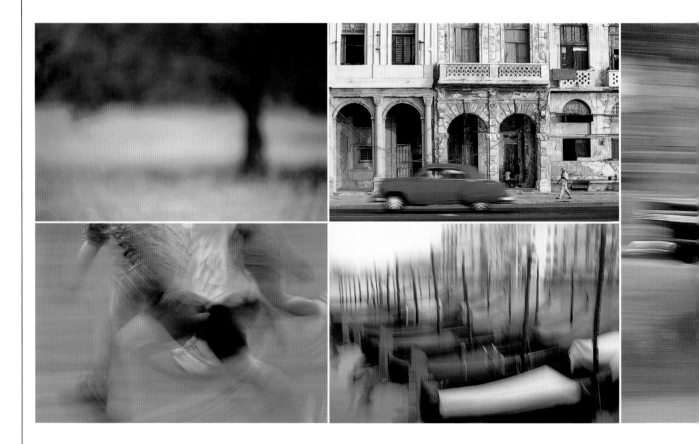

Shake it all about

A third option is to move the camera while taking a photograph so that everything in the scene blurs whether it's moving or not. This is a fun technique to try because it's totally unpredictable. Just set your camera to auto exposure (I use aperture priority). Stop the aperture right down to f/16 or f/22 so the camera sets a slow shutter speed, and then get shaking.

If you're indoors and light levels are low, the exposure will last several seconds. You'll get lots of blur and any bright points of light will record as colourful streaks. Outdoors, exposure times will be briefer, but even 1/15 or 1/8sec will allow you to record blur if you move the camera quickly while tripping the shutter.

The effect you get will depend on how the camera is moved. If you shake it around in a random fashion then the blur will be random. If you move it in one direction – up, down, left, right – the blurring will also register in one direction. Experiment and see what happens. If nothing else you'll enjoy yourself.

Pan the camera

Tracking a moving subject with the camera and tripping the shutter at the same time is a great technique to use when you want to inject a sense of motion into a picture. It's widely used by sports photographers and when done properly, the main subject will remain pin sharp while the background records as blurred streaks.

It's actually a difficult technique to master, and whenever I try it, not only does the background blur but the subject as well. Far from being frustrated by this, however, I embrace it. I intentionally over-pan using shutter speeds that are far too slow (anything from 1/15sec to one second or more depending on the subject) to introduce lots of blur and create graceful, impressionistic images.

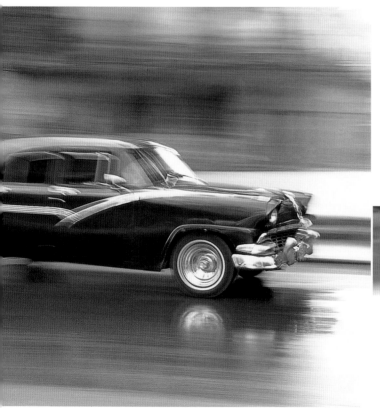

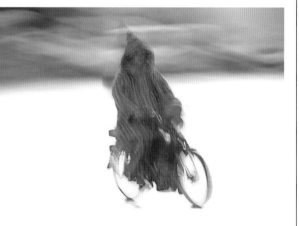

◀ ▼ This set of pictures demonstrates all of the techniques discussed, from defocusing and using slow shutter speeds to moving the camera during exposure and panning. Hopefully they will convince you that blur can be a creative tool and that sharpness is overrated.
CAMERA: NIKON F5 AND NIKON F90X/LENS: 28MM, 50MM AND 80-200MM/FILM: FUJICHROME VELVIA 50

COAT YOUR OWN

Coating paper, fabric and other materials with light-sensitive liquid emulsion has been a popular darkroom technique for decades. It allows photographers to create unique pieces of work with a wonderful hand-made feel. Serious practitioners even go as far as making their own emulsions, using recipes that date back to Victorian times.

But what if you use a computer and inkjet printer to make prints, instead of a traditional darkroom? Luckily, there is an inkjet equivalent to liquid emulsion, known as InkAID, and in creative hands it is capable of stunning results.

▼ PEBBLES, TARANSAY, OUTER HEBRIDES, SCOTLAND
Heavyweight watercolour paper and handmade paper are ideal for hand-coating with inkjet precoats. The resulting prints have a high-quality, fine-art feel about them. Despite the natural texture of the paper, they are capable of great resolving power. I prefer the Matte White precoat for use on white paper.
CAMERA: HOLGA 120GN/LENS: FIXED 60MM/FILM: ILFORD XP2 SUPER

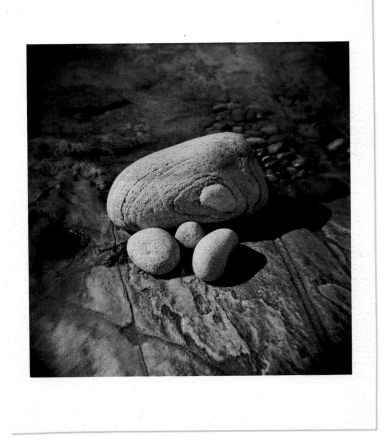

YOU WILL NEED
- **SET OF INKAID PRECOATS**
- **A SELECTION OF DIGITAL IMAGES IN COLOUR OR BLACK AND WHITE**
- **PAPER, FABRIC AND OTHER SUITABLE SUBSTRATES**
- **A BRUSH TO APPLY THE PRECOATS (I USED A JAPANESE JAIBAN BRUSH)**
- **A CLEAR WORK AREA**
- **A COMPUTER AND INKJET PRINTER**

A sample pack which allows you to experiment with a range of different precoats (see panel, page 18), is available. That way, if you prefer certain ones, you can buy them individually in larger quantities.

No instructions are supplied with the sample pack, but they're posted by the maker, Ottowa Speciality Coatings Corporation, at www.inkaid.com. Using them is very straightforward. Unlike liquid photographic emulsion, which is light-sensitive, InkAID products can be handled and applied in daylight. It's simply a case of paint-on, air dry, flatten and print.

Any inkjet printer can be used to print images on materials coated with InkAID precoats. I use an Epson Stylus 4800, which is an A2+ (17in) model. However, smaller-format printers are equally suitable. If your printer has a straight or flat-feed system, you can also print on rigid materials, such as plexiglass or plywood. If not, you will have to stick with paper and flexible materials, such as fabric.

As well as paper in its many shapes and forms, glass, metal, fabric and anything else that can be safely fed through an inkjet printer can be treated with the InkAID precoats, so you can print both colour and black and white images onto them. The materials don't have to be plain or blank, either. Photographs can be printed on paper containing text, such as pages from books or old scripts, or you can create mixed-media artworks by combining photographic images with paintings. The options are almost limitless.

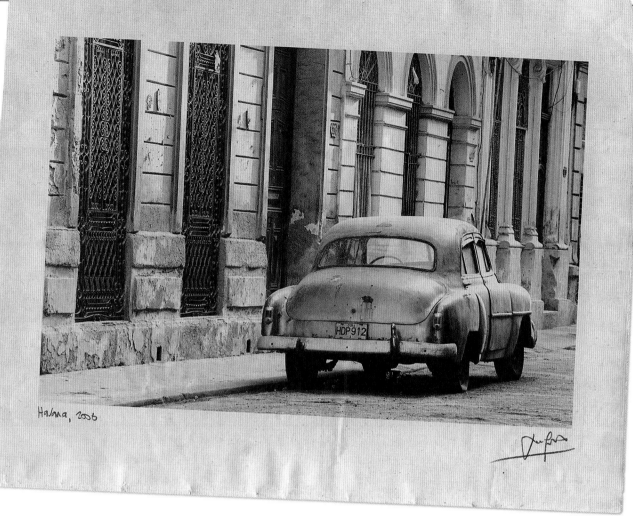

Havana, 2006

Not that paper is limiting in any way because there are so many different types. You can choose from textured art papers, plain paper, colour paper and card, parchment, handmade paper – the list goes on. I also removed the endpapers from some old books that were falling apart. They had developed a wonderful antique look over time, making a perfect background for warm-toned prints.

Applying the precoats

The on-line instructions for InkAID say that the precoats can be applied using a brush. For a smoother finish, though, they recommend sponge brushes over bristles. Glass rods can also be used to spread the liquids, which have a consistency similar to PVA glue, in a thin and even coat. I use a Japanese Jaiban brush that I purchased originally in order to apply liquid photographic emulsion to art paper. Bristle brushes can leave brush strokes in the surface of the applied coat, but I quite like that effect because it gives the prints more of a handmade look.

The precoat you choose depends your material and the type of effect you hope to achieve. For example, Clear Semi-Gloss, Clear Gloss, Matte White and Iridescent Gold are designed for use on such porous surfaces as paper, wood and fabric. For non-porous surfaces, like plexiglass and metal, an adhesive is applied first to create a key for any of the other precoats mentioned above.

▲ **OLD AMERICAN CAR, HAVANA, CUBA**
For this print I applied two coats of Clear Semi-Matte precoat to the old, yellowing endpaper of an antiquated book discovered in my loft. It suited the subject matter well and the natural colour of the paper has given the image an attractive warm tone.
CAMERA: NIKON F5/LENS: 80-200MM/ FILM: ILFORD XP2 SUPER

Matte White precoat dries white so, while it's a good choice for use on white paper or card, it may look a little odd on non-white papers. The Semi-Gloss and Gloss precoats dry clear, so you can use them to coat any colour. The original colour of the material will show through, making Semi-Gloss and Gloss precoats ideal for old paper, parchment and so on.

The Iridescent Gold precoat supplied with the sample kit has a faint gold tint to it and also has a slightly metallic look. It can be used on both white and off-white papers.

One thing to remember when coating colour or tinted materials with the clear precoats is that the highlight value in the printed photograph will be determined by the base colour of the paper. This means the darker it is, the flatter the image will appear, giving rise to a need for some experimentation when it comes to determining correct image density for printing.

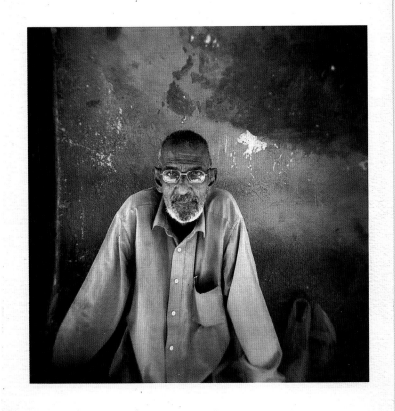

▲ PORTRAIT, STONE TOWN, ZANZIBAR
Even detailed images like this portrait reproduce well on precoated paper and the results are every bit as good as you would expect from off-the-shelf inkjet papers. This portrait was printed on Fabriano 5 paper coated with two applications of Matte White precoat.
CAMERA: HOLGA 120GN/LENS: FIXED 60MM/FILM: ILFORD XP2 SUPER

You will need a wipe-clean work surface and a clean plastic dish, though any spills or splashes are easy to wipe up. Give the bottle of precoat a good shake, then open it and pour a small amount into the dish.

Coating the paper is child's play. All you do is paint it on, but try to avoid getting hairs, dust or other visible debris trapped in the emulsion. Make sure the precoat is applied in an even layer. That said, if you intentionally want to see brush strokes and texture in the precoat you can apply a thicker layer and be more random with your strokes.

Once the precoat has been applied, leave it to one side to dry thoroughly. Then apply a second coat, ideally brushing at 90° to the direction of the first coat to achieve an even finish.

The instructions suggest hanging the sheets of paper on a line while drying to avoid them curling, rather like drying fibre-based photographic paper. However, I just let them dry on a desktop and they show little sign of curling.

Once two coats have been applied and each sheet is fully dry, place them between the pages of a big book. Weigh the book down with anything heavy, and then leave everything overnight. By the next morning the sheets will be flat and ready for you to use.

The printer settings that are required to achieve the best results really depend upon the type of printer you have, the material you are printing on, the precoat you are using and the type of image you want to create, so be prepared to experiment.

Try a media setting such as Archival Matte paper or Watercolour Paper initially and a printer resolution of 720dpi (anything higher is unlikely to make a difference). Any high-speed printer setting can be switched off.

ⓘ INKAID PRECOATS

The InkAID sample pack is all you need to get started. It contains six 118ml (4fl oz) bottles of precoat, including Clear Semi-Gloss, Clear Gloss, White Matte, Iridescent Gold, Clear Gloss Type II (with adhesive) and a separate adhesive precoat for use with the Clear Gloss precoat. Each bottle contains enough precoat to prepare a dozen or more sheets of A4 (letter) paper. Later, you can purchase larger quantities of individual precoats of your choice. For more information go to www.inkaid.com.

▶ Here's the InkAID sample pack with a Japanese Jaiban brush I use to apply the precoats.

I find the Clear Semi-Gloss precoat to be the best choice for old, coloured or off-white paper while the Matte White precoat is the best choice for white textured paper. The images are rendered crisp and sharp, so fine detail can be recorded with great clarity, while the white base of the precoat records a wide tonal range. I've used both Fabriano 5 paper and basic watercolour paper from an artist's pad. However, any heavyweight art paper would be suitable.

If you're going to put the prints into a portfolio, it's a good idea to give them a protective coating using a product such as Lyson Print Guard or Hahnemühle Lumijet Protective Spray. Not only will the delicate surface be protected from dirt, fingerprints and moisture, but also from harmful ultraviolet rays that cause prints to fade over the years.

▼ **NOAH, NORTHUMBERLAND, ENGLAND**
Printing images on hand-coated paper allows you not only to choose a paper that will enhance the image, but also to make the paper itself a crucial part of the finished work, adding depth, texture and mood. Here I used the yellowed page from an old book, which I had coated with Clear Matte precoat.
CAMERA: HOLGA 120GN/LENS: FIXED 60MM/FILM: ILFORD XP2 SUPER

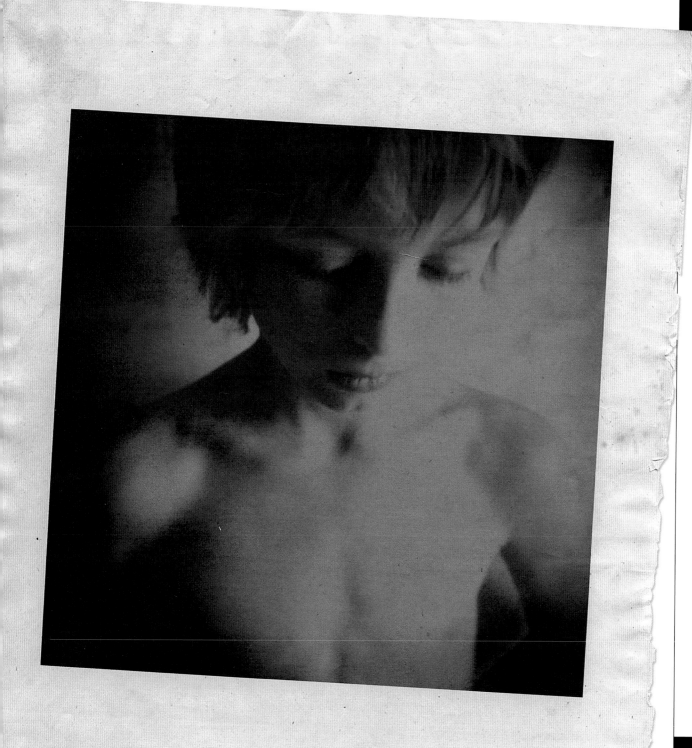

COLOUR CODED

Think back to when you were a child and, armed with some pots of poster paints, you set about creating a masterpiece for your mother to stick on the fridge door. There was no delicate brushwork in pastel hues; no intricate detail. It was all big, brash splodges of primary colour slapped on the back of an old roll of wallpaper. Reds, yellows, blues, greens – the brighter and bolder the better. Houses were drawn as squares with triangles on top. You depicted your parents as lollipops with sticks for arms and legs, an over-sized smile and big, round eyes.

At the time you probably had no idea what you were doing, other than having fun and making a mess. Subconsciously, however, you were paring everything down to the simplest form, rejecting all the details that didn't matter and concentrating instead on just the shapes and colours that formed your subject.

Before long, we lose this innocent view of the world. We become unable to look at things in such simplistic terms, and details become more important than the bigger picture. A toddler is happy with a dozen oversized building blocks to make his space ship, yet within just a few years this will be replaced by a complicated Lego set with hundreds of tiny pieces.

However, there's a lot to be said for photographers taking a step back and trying to see things through a child's eyes. More often than not, the colour and form make a picture work more than the smaller details. By stripping things back to these two elements, powerful pictures are guaranteed.

One at a time

A great way to increase your appreciation of colour and also improve your eye for a picture is by shooting sets of images that make use of a single colour. This could be red, blue, orange or yellow, or any colour that you like.

Make this a project for the day. Head out with your camera and a couple of zoom lenses and go in search of your chosen colour. Ignore everything else and really focus your mind on seeking out a single colour. You may get off to a slow start, but once you've got one or two shots in the bag and your vision begins to sharpen, others will soon follow.

Urban locations are ideal for finding colour because towns and cities are busy, bustling places where traffic, street furniture, roadworks, building sites, shops, offices and even passersby can be the source of endless images. Look out for interesting signs, posters, hoardings and shop window displays.

Markets are another great hunting ground. Or try a harbour, where boats, nets, even lobster pots, all provide opportunities.

The thing about isolating colour is that it can be done on any scale, large or small. One minute you could be photographing the side of building with a wide-angle zoom, the next a box of apples outside a greengrocers with a telephoto. Maybe you could capture a close-up of a vibrant flower using a macro lens. Anything goes, and the more variety you manage to cram into your colour collection, the more interesting it will be.

Coloured light

Light can work in your favour, adding or creating a colour all of its own. Shoot at sunrise or sunset and often your pictures will take on a distinct yellow hue because of the warmth of the light. It's the same when shooting under tungsten lighting.

At the other extreme, shots taken at twilight or in bad weather may come out with a strong blue cast because the colour temperature of the light is high.

The way to compensate for these effects is to add colour using filters. The strongly coloured filters used in black and white

◀▼ CAMERA/NIKON F5 AND F90X/LENS: 20MM, 28MM, 50MM, 105MM MACRO, 80-200MM/
FILM: FUJICHROME VELVIA 50

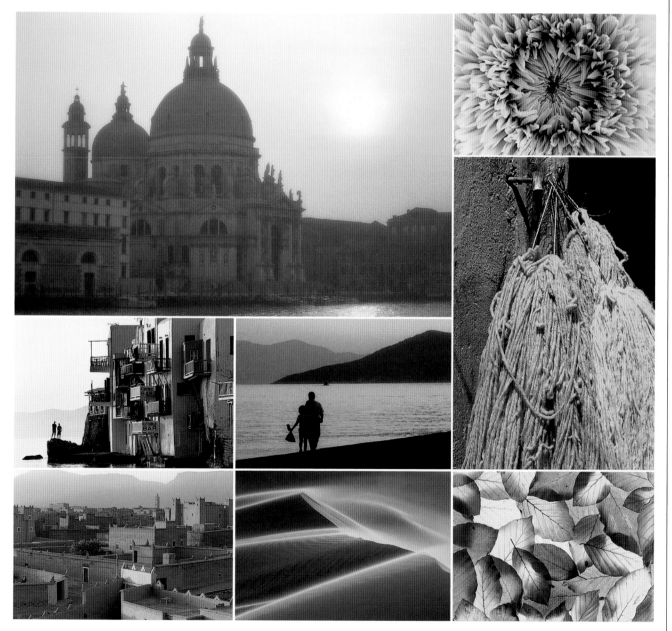

photography will overwhelm any natural colour in a picture, while the orange 85 series filters can be used to create a yellow/orange cast. The blue 80 series filters will cool everything down.

The symbolism of colour

While you're searching for subjects, also consider the symbolic power that colour has. All colours convey particular moods and messages. We use them as visual codes to emphasize our thoughts, just as advertisers use them to influence our emotional response to the products they're promoting.

• *Red* is a very dominant, advancing colour that symbolizes blood, danger, passion and urgency. Think of the phrases 'red with rage', or 'like a red rag to a bull'. Red is the colour used to warn us, so pictures containing lots of red create tension. Red is also the loudest and most obvious colour. Even a tiny amount is powerful enough to stand out, such as a single red poppy in a field of wheat.

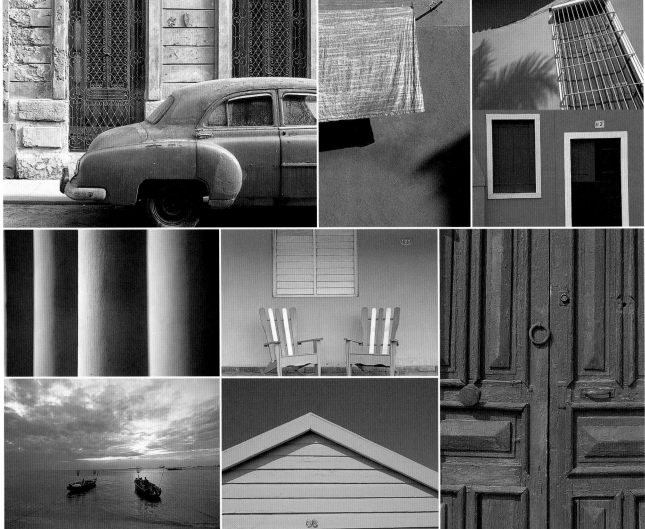

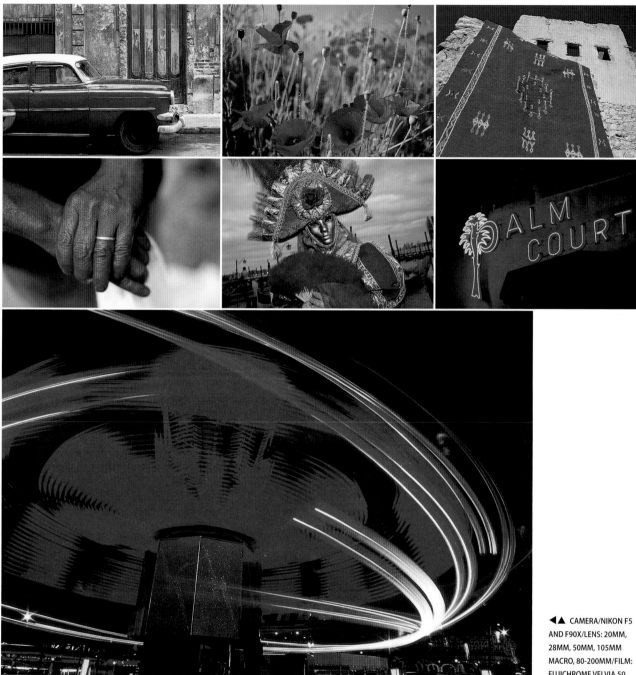

◀▲ CAMERA/NIKON F5 AND F90X/LENS: 20MM, 28MM, 50MM, 105MM MACRO, 80-200MM/FILM: FUJICHROME VELVIA 50

• *Blue* is a tranquil, serene, reassuring colour, symbolizing authority, truth, hope, freshness, the sky, the sea and wide open spaces. It can also represent loneliness, depression, loss and sadness. Think of 'feeling blue'. It is also associated with cold, as in 'blue with cold'.

• *Green* symbolizes life, health, freshness, nature and purity. It reminds us of the landscape (green fields and rolling hills) so it's refreshing to look at. Be warned, though; it can also look rather sickly when used to add a strong colour cast with filters unless the natural colours in the scene are predominantly green anyway.

• *Yellow* is the colour of the sun, gold, corn and lemons. It's a powerful colour, symbolic of joy, happiness and richness and, like red, it advances to produce images that leap from the page. If you fill the frame with yellow subjects, such as a field of rape in flower, a crate of lemons or a detail of a painted door, use a yellow filter for added impact.

DAWN CHORUS

Beep, beep. BEEP BEEP. In the midst of a pleasant dream involving Claudia Schiffer and a fridge full of exotic fruits/Russell Crowe and a bucket of yoghurt (delete as appropriate), you're shocked into dazed reality by the ear-shattering sound of an over-sized alarm clock and fall out of bed into the remains of last night's pizza.

It's 4am, the world is silent and outside streetlights are creating ghostly yellow haloes in the misty gloom before dawn. Fumbling around in the darkness, you pull on a pair of jeans that feel damp they're so cold, and then slowly crawl downstairs to prepare a pot of industrial-strength coffee to jumpstart your body into life.

Is this some nightmare scene from a war zone, or an extract from the diary of an Arctic explorer? Unfortunately, no. This is the tortuous routine of rising with the larks in order to capture the first – and best– light of the day.

Actually, 4am is a lie-in. In June 2008, I spent a week on the Isle of Lewis in Scotland's Outer Hebrides running a photo workshop with fellow photographer Duncan McEwan. There are few places more northerly in the UK than Lewis. Consequently, if you want to shoot a summer sunrise, especially in late June around the summer solstice, you need to set your alarm clock nice and early.

How early? How does 2.50am sound? That's right, 2.50am! To most sane folk, that's still the middle of the night, a time to be tucked up in bed and sound asleep. But when the sun rises at 4.15am, the location you want to shoot is at least 20 minutes' drive away and the predawn glow could start at least an hour before sun-up, there's no time for hanging around. Or sleeping.

As it happened, we only managed three early starts – cloud and rain on the other mornings made it pointless heading out. But we still set our alarm clocks for 2.50am, just to

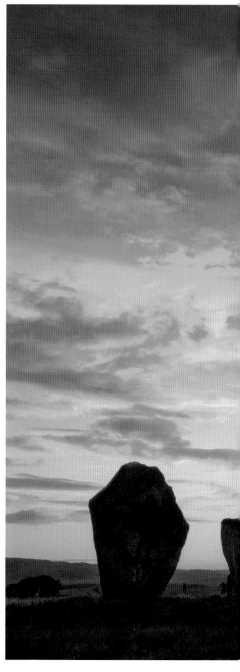

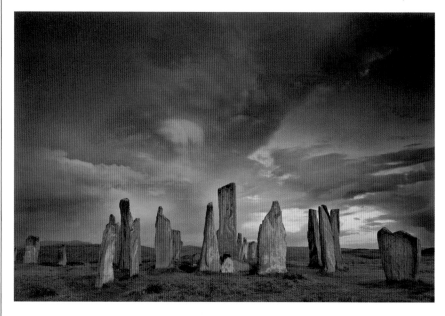

◀▲ CALLANISH, ISLE OF LEWIS, OUTER HEBRIDES, SCOTLAND
These two photographs show how the quality of light can change dramatically in the space of a few minutes at dawn. The smaller image was taken at 4.33am, just as the sun was rising and bathing the stones in soft light. The second image was captured 12 minutes later at 4.45am, looking toward the rising sun.
CAMERA: CANON EOS 1DS MKIII/LENS: 16-35MM/FILTER: 0.6ND HARD GRAD ON FIRST SHOT, NONE ON SECOND

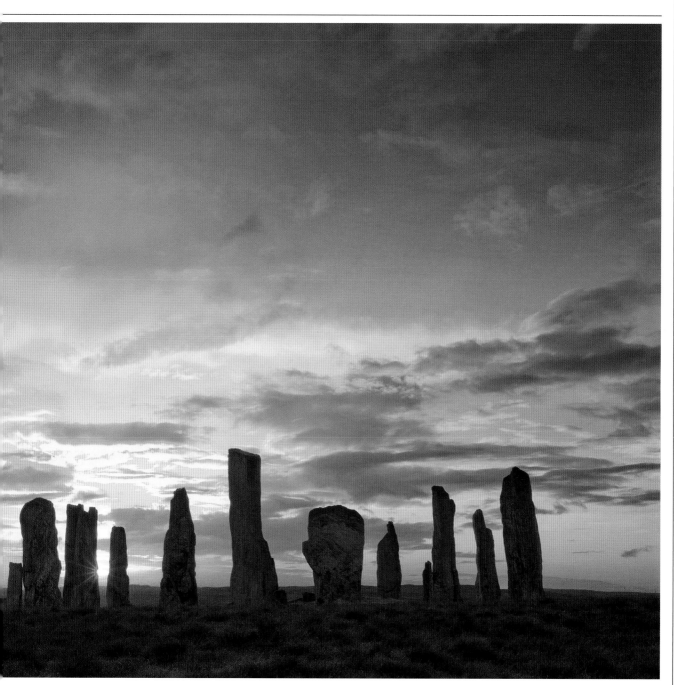

be sure. It's easy to crawl back into bed and doze off again at that time of day if the weather's foul, or catch up on your sleep later if conditions do look promising. But determining if there's going to be a decent dawn is impossible if you never bother to get out of bed in the first place.

All change

What I can tell you is that when the conditions are right, rising for dawn is worth every second of lost sleep. The light can be truly magical, and the experience of witnessing and recording it utterly unforgettable.

In clear, cloudless weather, a deep yellow/orange glow often appears over the eastern horizon as much as an hour before the sun is due to show. This predawn glow can be more beautiful than the sunrise itself, which is why you need to be on location well in advance. In fact, in clear weather, sunrise itself tends to be a non-event because, when the sun does finally peep over the horizon, the light is so intense that you literally have seconds to shoot before flare ruins your images.

The way around this is to hide the sun behind something, such as a tree. Or, you can turn around and photograph the scenery bathed in the first light of day, rather than shooting into the sun.

When I'm planning dawn shoots, I try to give myself a choice of locations, for example, one shooting towards the sunrise, one shooting the first light. Then I wait until I get up the next morning and assess the weather before deciding which one to head for.

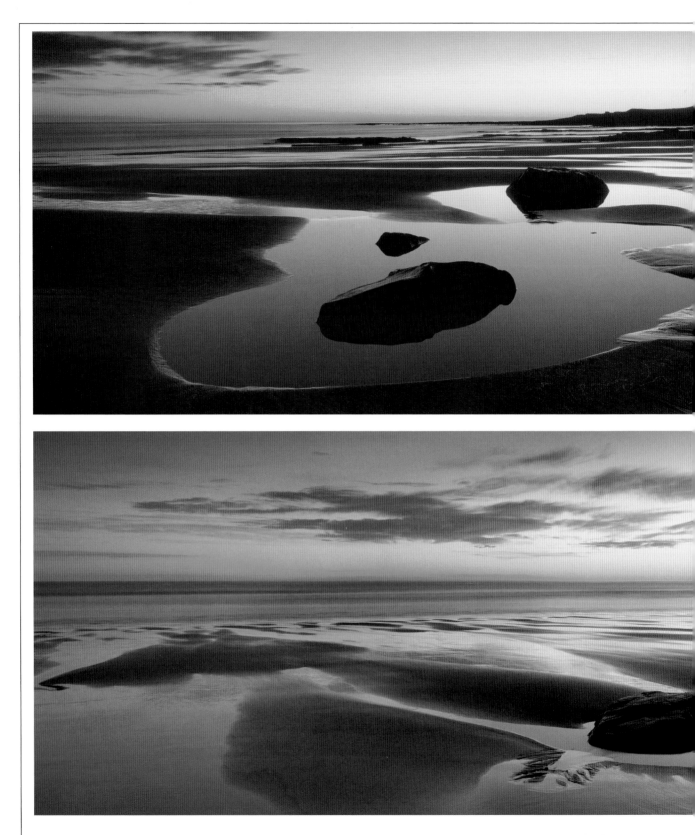

▲ Here's another pair of photographs taken at the same location on the same morning. Conditions couldn't have been better. The tide was receding, leaving virgin wet sand and rock pools to reflect the vivid blue of the overhead sky while the eastern horizon was on fire with yellows and oranges. This intense colour contrast (seen in the top image) lasted perhaps 30 minutes before broken cloud drifted in and picked up a red glow from the sun. This softened the colours and changed the mood of the scene, creating yet more fantastic photo opportunities. I couldn't have predicted such an amazing morning. It was possibly the best dawn I have ever photographed, and I'm just so pleased I managed to drag myself out of bed.
CAMERA: FUJI GX617 PANORAMIC/LENS: 90MM/FILTERS: 0.9ND HARD GRAD AND 0.3 CENTRE ND/FILM: FUJICHROME VELVIA 50

This is where intimate knowledge of an area comes into its own. I live on the coast of north Northumberland, and I know it well enough to decide instantly where to go for sunrise, based on prevailing weather conditions, when I crawl out of bed.

The ideal is a location where you can start shooting towards the eastern sky, then if the sun starts to flare out when it rises, you can swing 90–180° and photograph the light on the scene, or vice versa. Lochs and lakes are ideal in this respect because you can move around the shoreline as the light changes. The same applies with coastal views. In fact, this applies to any location close to water because its reflective qualities help to maximize the colour of the light.

The magical thing about dawn is you really never know what you're going to get until you're there and it's unfolding before you. No two mornings are ever the same, especially in regions where the weather is unpredictable and changeable. I've photographed locations on Britain's north-east coast, such as Bamburgh Castle, dozens of times at dawn. I can honestly say that no two shots have ever been the same.

The light can change minute by minute – literally. All it takes is for a few clouds to drift into the eastern sky and be up-lit by the rising sun, or a dense cloud bank that was snuffing out the sunrise to suddenly start clearing. An unpromising morning suddenly turns into a magical photo opportunity.

I've sat in my car many times watching rain roll down the windscreen, wondering why I ever bothered to get out of bed. Then suddenly a small hole appears in the sky, colour begins to bleed through – and there's a shot. Even drab grey weather can produce successful images at dawn if you're in the right location because the low light necessitates long exposures, which causes reciprocity failure and often results in weird and wonderful colour casts. If you're shooting a coastal view the long exposure will also record motion in the sea, which itself can look amazing (see pages 136–141).

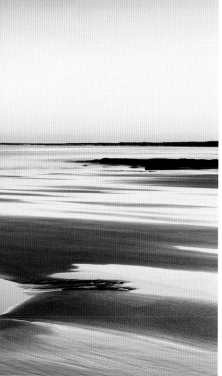

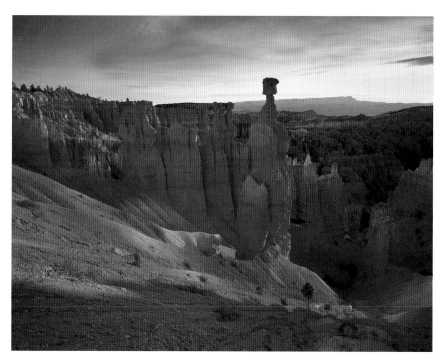

▲ BRYCE CANYON, UTAH, USA
I recced this view of Thor's Hammer in Bryce Canyon on the previous evening and realized that if the morning were clear, the light would be spectacular. The limestone from which the canyon is created has a soft pink/orange hue even on a cloudy day, so when bathed in the first golden light of the day it could be out of this world. By 6am the next day my tripod was set up and ready and, as hoped, the weather stayed clear long enough for the light to perform its magic. This is the result. Minutes later, cloud drifted in, the sun disappeared and I didn't take a single shot all that day, or the next.
CAMERA: MAMIYA 7II/LENS: 43MM/FILTER: 0.6ND HARD GRAD/FILM: FUJICHROME VELVIA 50

Season by season

Of course, it's not only the weather that makes a difference to the nature of the light and the appearance of a scene at dawn, it's also the time of year. During the spring and summer months, the sun rises much further to the north than it does in autumn and winter. This means that a location bathed in glorious side-lighting at sunrise in May will be backlit by the rising sun in November.

This is another factor that must be considered because it changes the whole dynamic of the shot and where you need to take it from. If you're returning to a familiar location, you'll know that, but if it's somewhere new, you could easily make a bad call and be in the wrong place. You'll only do it once, though, so the worst-case scenario is that you have to return the next day.

Dawn photography is for serious photographers. It's hardcore stuff, especially from late spring to late summer when the sun rises at an ungodly hour. Shooting at dusk is a doddle in comparison becuase you're already up and awake. Dawn is different. It takes a concerted effort because you have to fight against your body's natural instinct to sleep.

I hate getting up in the middle of the night. It's an inhuman form of self-torture. But the pain only lasts a matter of minutes, and once you're out there, filling your lungs with sweet fresh air and anticipating things to come, it makes the effort worthwhile. Dawn is a magical time of day – not only to take photographs, but simply to be alive. Even if I return empty-handed because things didn't go quite to plan, I have no regrets. I also know that breakfast is going to taste just that much better.

▶ MARSDEN BAY, TYNE AND WEAR, ENGLAND

This photograph was taken on my very first dawn visit to Marsden Bay. I had visited the location before and could see potential for great sunrise shots, but never expected to witness such an amazing one on the first attempt. The tide was coming in fast so, with my backpack set high on a rock out of harm's way and me balanced precariously to avoid wet feet, I set about recording the scene. Using an ND grad was tricky because the top half of the cliff face and rock arch would have ended up black. I made two exposures, one to record some detail in the limestone and a second to get the sky right. The two transparencies were then scanned to high resolution and merged in Photoshop.

CAMERA: FUJI GX617 PANORAMIC/LENS: 90MM/FILTER: 0.3 CENTRE ND/FILM: FUJICHROME VELVIA 50

ⓘ GRADUAL SUCCESS

Contrast tends to be very high at dawn because the sky is bright but there's no direct light falling on the landscape. This makes ND grad filters essential for holding back the sky if you want to record detail in the shadows without blowing out the highlights.

I find that a 0.9 density hard ND grad is the most effective when shooting towards the eastern sky. Anything weaker and you'll block the shadows or blow the highlights. Shooting digitally, you may even find that you need to use a 0.3 or 0.6 grad with the 0.9 as digital sensors don't seem to handle extreme contrast as well as film.

Contrast is lower when shooting a scene bathed in first light, so you don't need to be so excessive with your use of grads. This means that a 0.6ND hard grad will usually be strong enough to balance sky and foreground.

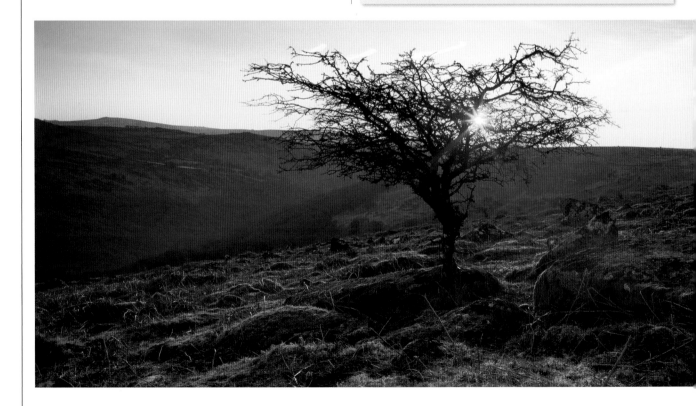

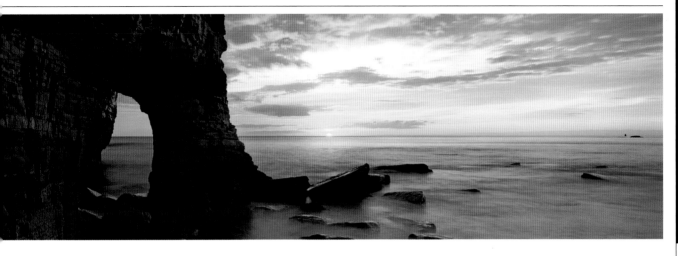

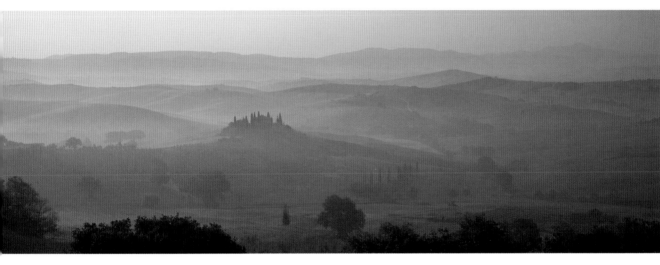

▲ VAL D'ORCIA, TUSCANY, ITALY

Seasonal variations can make a huge difference to the mood of a scene. In Tuscany in May, for example, it's relatively common to find mist filling the valleys at dawn (5am). As the sun rises, the mist slowly burns away, leaving behind a delicate palette of colours that looks absolutely stunning. I've photographed this view many times, but I never cease to be moved by it. You couldn't dream up such a heavenly scene. Best of all, it's a two-minute walk from the hotel. You can almost smell the coffee and freshly baked pastries.

CAMERA: FUJI GX617 PANORAMIC/LENS: 180MM/FILTER: 0.6ND HARD GRAD/FILM: FUJICHROME VELVIA 50

◄ DARTMOOR, DEVON, ENGLAND

The sky was a little clearer than I'd hoped on this particular morning and I knew that by the time the sun appeared over the distant hill, the light would be intense and flare unavoidable. Noticing a small tree nearby, I changed position and hid the sun behind it, hoping that would give me a few minutes. It worked. I was able to capture golden light kissing the moorland in front of me. The sun bursting through the branches actually adds to the final image rather than detracting from it.

CAMERA: FUJI GX617 PANORAMIC/LENS: 90MM/FILTERS: 0.75ND HARD GRAD AND 0.3 CENTRE ND/FILM: FUJICHROME VELVIA 50

DESPERATE MEASURES

If there's one thing that sorts the sheep from the goats in photographic terms it's trying to produce successful images when all the odds are stacked against you, and you are facing bad weather, flat light, maybe rain thrown in for good measure, or an uninspiring location. We've all found ourselves in these situations. The question is, how do you respond? Do you pack your gear away and head for home feeling defeated, or see imperfect conditions as a challenge to be faced head-on?

I like to think that I fall into the latter category. I'm an impatient photographer and like to get things done. But at the same time, I hate returning home empty-handed, and so over the years I've developed a number of coping strategies. Here are five of them.

1. Shoot in black and white

No matter how bad the weather gets, you can always produce a great black and white photograph. Dull, grey, damp days may reduce colours to flat, muddy hues, but if you record them in mono it doesn't matter. Heavy rain makes life difficult because you're forever wiping water droplets off your lens to avoid flare. But steady drizzle needn't stop play. You can always shelter under an umbrella, or use a polythene bag as a rain cover for your camera.

2. Get closer

Part of the problem with flat, dull weather is that the sky's usually washed out and featureless, and is just an endless blanket of grey. But if you exclude the sky from the shot altogether it can't upset you, can it? In fact, while you're at it, instead of just getting rid of the sky, why not ignore wider views altogether and concentrate on details? Look out for lichens on rocks, tree bark, patterns in sand, peeling paint or rusting metal. The

▲ DERWENTWATER, LAKE DISTRICT, ENGLAND
This image started life as a colour transparency which I scanned and converted to black and white in Photoshop. It was taken on one of those wet, windy days photographers dread, but I knew I could get something out of it.
CAMERA: MAMIYA C220/LENS: 80MM/FILM: FUJICHROME VELVIA 50

▲ ISLE OF LEWIS, OUTER HEBRIDES, SCOTLAND
Overcast days are ideal for close-up shots. The soft light reveals fine detail and colours are well saturated.
CAMERA: MAMIYA C220/LENS: 80MM/FILM: KODAK PORTRA 160VC

▼ ISLE OF HARRIS, OUTER HEBRIDES, SCOTLAND
This pair of photographs shows the difference filters can make. I'm not suggesting the final version will win any awards, but it's so much better than the unfiltered one.
CAMERA: CANON EOS 1DS MKIII/LENS: 16-35MM/FILTERS: POLARISER AND 0.75 ND HARD GRADCAMERA: MAMIYA C220/LENS: 80MM/FILM: KODAK PORTRA 160VC

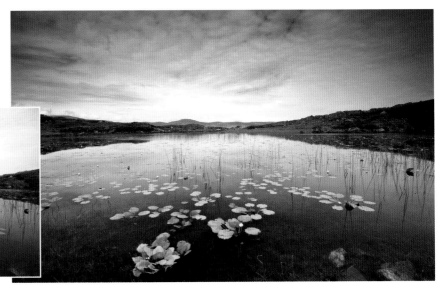

▶ ISLE OF LEWIS, OUTER HEBRIDES, SCOTLAND
I had been on this beach for two hours or more, struggling to find a shot in ever-worsening weather. Then I noticed a rock revealed by the retreating tide and realized I finally had something to work with. A wide lens exaggerated perspective, a strong ND grad added drama to the grey sky and a slow shutter speed blurred the sea. Job done.
CAMERA: CANON EOS 1DS MKIII/LENS: 16-35MM/FILTER: 0.9ND HARD GRAD/EXPOSURE: 2 SECONDS AT F/22

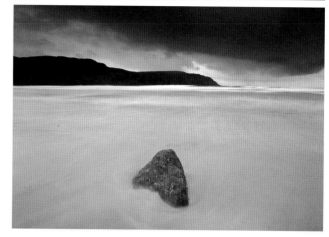

soft light you get on dull days is perfect for shooting details, and once you start looking, you'll find plenty to keep you occupied.

3. Use your filters
I've never been one for advocating the use of wacky filters to try to make a silk purse out of a sow's ear. Purple grads and multi-image filters belong in one place and one place only – the trash. But technical filters such as ND grads, polarizers and warm-ups can offer you a welcome lifeline, so don't ignore them. Soft-focus filters can also be used to add mood to drab scenes, while the 80 series colour conversion filters will turn a boring grey image into an evocative study in blue – ideal for those damp, misty mornings we know and love.

4. Work a location to death
Tell yourself there has to be a great shot somewhere – has to be – and don't give up until you find it. Spend time exploring the location, and you may spot something you'd previously missed. Tap into all those creative techniques you've tried over the years. Take risks, experiment and see what happens. You could be pleasantly surprised, and you'll be better equipped to deal with similar conditions the next time you face them.

5. Head for woodland
This may be a bit of a sissy option compared to the others. However, it is an effective one I'm happy to fall back on when all else fails because it almost guarantees great pictures. Woodland is actually easier to photograph on dull days because the light is soft and revealing. If you use a polarizer to cut through glare the colours will look amazing. Woodland is also a great place to find interesting details, and if it's raining, the leafy canopy overhead will help to keep you dry. A win-win situation, if you ask me.

ⓘ ALSO CONSIDER...

- **Shooting in digital infrared (see page 94)**

- **Trying long-exposure seascapes (see page 136)**

- **Buying a pinhole camera (see page 88)**

- **Going indoors (see page 152)**

- **Shooting rock art (see page 102)**

▼ BORROWDALE, LAKE DISTRICT, ENGLAND
Weather doesn't get much flatter than this, but as you can see, it suits the scene perfectly and an incredible amount of detail has been recorded. The delicate colours look beautiful too. Bright sunlight would simply have destroyed them.
CAMERA: FUJI GX617/LENS: 180MM/FILM: FUJICHROME VELVIA 50

EXTEND YOUR RANGE

If you've ever taken pictures in high-contrast situations you will be aware that both film and digital sensors have a limited capability when it comes to recording a broad brightness range. If you meter for the highlights, the shadows come out inky black and if you meter to record detail in the shadows the highlights blow. Exposing 'to the right' is the best compromise. In other words, expose to record as much shadow detail as possible without blowing the highlights, then pull the exposure back when the RAW file is processed. No matter what you do, however, there is a limit to how much detail you can record on a single frame.

Fortunately, there is a solution for digital photographers, known as HDR imaging. HDR stands for High Dynamic Range, and the idea is that you take several shots of the same scene or subject at different exposures so you have detail in the shadows at one end and detail in the highlights at the other then merge them.

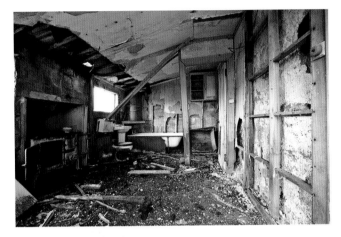

▼ ▶ ABANDONED CROFT, ISLE OF LEWIS, OUTER HEBRIDES, SCOTLAND
This HDR image was created from five original source files, each shot at a different exposure, including -4 stops, -2 stops, Correct, +2 stops, +4 stops. You can see from the original correctly exposed image (right) how much detail is lost in shadow areas, but by merging a series of exposures, a much broader range of detail is recorded. The final tone-mapped image has a surreal look to it.
CAMERA: CANON EOS 1DS MKIII/LENS: 16-35MM

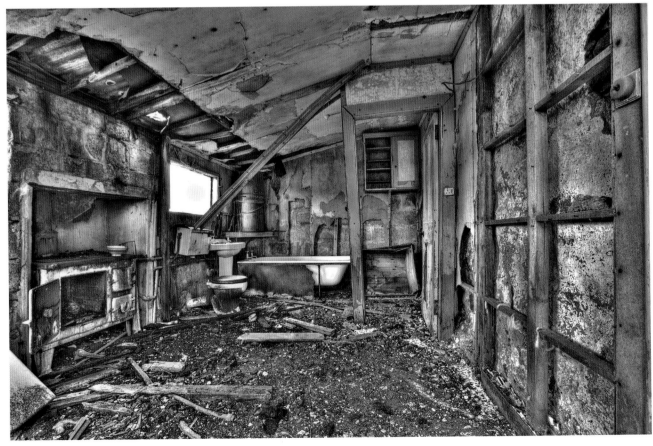

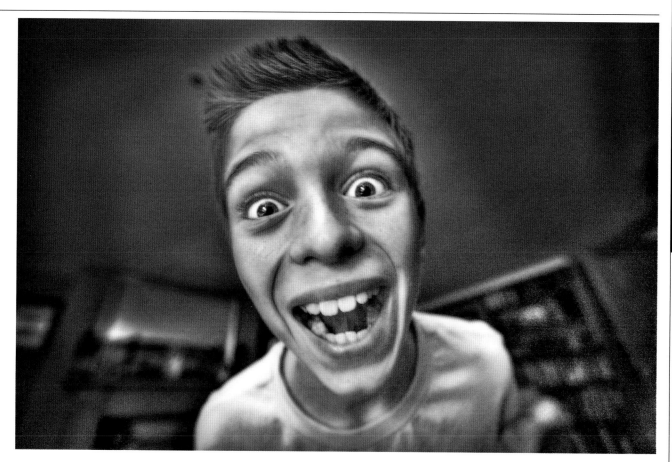

This technique was first employed in the 3D rendering of computer graphics. However, photographers are now beginning to embrace it and to see the immense creative benefits in being able to record a much greater brightness range. The latest version of Adobe Photoshop, CS3, has a Merge to HDR option, though HDR fans prefer to use purpose-made software, such as Photomatix Pro from HDRSoft.

Go forth and multiply

There are two ways to generate the images for an HDR merge. You can either shoot a series of frames at different exposures or take one RAW file and process it several times, adjusting the exposure for each one.

The latter approach is the quickest and easiest and means that you can create HDR images from shots already taken. It's also the best choice if there's any movement in the subject or scene you shoot, as ghosting or repetition will result if you merge separate source images where elements such as people have changed position between frames. The downside of generating source images from a single RAW file is that there will be more noise evident. If you decide to photograph a static scene with the HDR treatment in mind you're better off mounting your camera on a tripod and shooting a sequence of images to be merged later.

The exposure increments you work to are really your choice. As a minimum, shoot three frames at metered, +2 stops and -2 stops (use your camera's Auto Exposure Bracketing (AEB) to save time).

▲ NOAH, NORTHUMBERLAND, ENGLAND
For this fun portrait of my son I made five copies of the original RAW file at -2 stops, -1 stop, Correct, +1 stop and +2 stops. After merging the Tiff files and tone mapping the HDR image, I made a duplicate layer and added a little Diffuse Glow so the final image looked even more unusual.
CAMERA: CANON EOS 1DS MKIII/LENS: 16-35MM

I tend to shoot metered, +2, +4, -2, -4 stops if the subject is very contrasty, such as an interior lit only by light from a window.

Once you're back at your computer it's a case of downloading the source images, placing them in a folder, opening your HDR software and letting it perform its magic (see panel, page 35).

EASY HDR

To show you just how quick and easy it is to create stunning HDR effects, here's a step-by-step guide to transforming a single RAW file using Photomatix Pro 3.0.

Step 1 Open your chosen RAW file. I used Adobe Camera Raw in Photoshop CS3, as well as the camera maker's own RAW converter.

Step 2 Reduce the exposure to -4 stops, then open the file and save it as a 16-bit Tiff to your computer desktop.

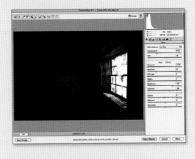

Step 3 Open the RAW file again, adjust the exposure so it reads -2 stops, and then save it as a 16-bit Tiff as above.

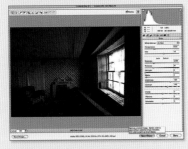

Step 4 Repeat this process twice more, creating Tiff files where the exposure is set to +2 and +4 stops. Then place the four files in a folder along with a fifth copy of the image where no adjustment has been made to the exposure.

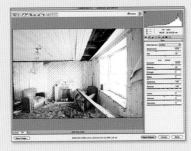

Step 5 Open your HDR software, in this case Photomatix Pro, and click on the Generate HDR Image tab. This opens a window so you can select the source images. Click on Browse.

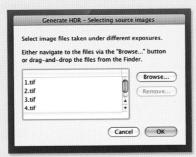

Step 6 Locate the folder containing your Tiff files, then highlight them and click Select. When the file names show in the source window, click OK.

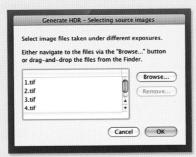

Step 7 In the next window you will be asked to specify the Exposure Value Settings. If the software hasn't set the correct values, select 2EV from the dropdown menu, then click OK.

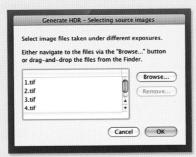

Step 8 A final window (Generate HDR Options) appears. Insert a check beside Align Source Images. Select 'By correcting horizontal and vertical shifts' and 'Take tone curve of color profile' by clicking the circle and then click OK.

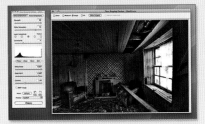

Step 9 The HDR image will now be created from the source files. It can take a while, so be patient. When the image appears, click on Tone Mapping, which will open a window containing various options sliders.

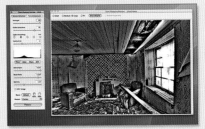

Step 10 Experiment using different sliders to see how the image transforms. There's no right or wrong here, so play around and see what happens.

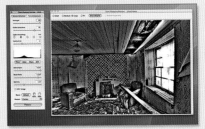

THE FINAL IMAGE

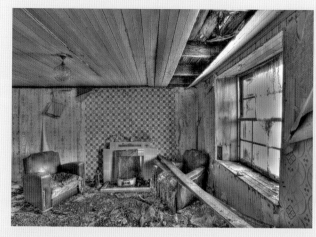

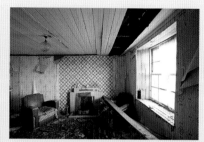

ISLE OF SCALPAY, OUTER HEBRIDES, SCOTLAND
And here's the final tone-mapped HDR image. The amount of colour and detail captured is phenomenal compared to how it looked in the original – down to individual flowers in the fabric of the old curtain draped over the chair and cobwebs among the rotten timbers in the ceiling. There's also a strong 3D feel to the image that makes you feel as though you're actually in the room, rather than looking at a photograph of it.

Endless options

The great thing about HDR imaging is that you can use it for both technical and creative applications. For example, when shooting landscapes, instead of using a strong ND grad filter to balance the sky and foreground, take two shots, the first exposing for the sky and the second exposing for the foreground. Then merge them using HDR software.

Image quality will be higher because you're not putting a filter in front of the lens and the merge will be far more accurate than a grad filter could ever be because the HDR software picks the bits from each image that it wants to merge. This means that if the skyline is detailed or there are important elements breaking into the sky, the software will work around them to give you a perfect blend. A grad filter is more heavy-handed and can't do that.

At the other extreme you can use HDR technology to create images that are truly out of this world by revealing a level of detail way beyond what the human eye can resolve. Our brain is used to looking at a scene and seeing both light and dark areas, in other words, contrast. But HDR images are able to reveal detail in both the lightest and darkest areas at the same time so shadows disappear and our visual senses are bombarded with information. This effect works not only on static subjects such as landscapes, architecture and still-life but can also be used for portraiture, weddings, reportage, figure studies, action, or anything you like.

HDR software can also be used to increase the tonal range of black and white images, so don't feel that you have to stick solely with colour. Try making several copies of the same RAW file but when you convert them to black and white during processing, adjust different colour slides so the tonal balance of each image is altered, then merge them all together using HDR software.

I have myself only recently started experimenting with HDR so I'm still very much a beginner. However, the software is so good now that you can't really fail to create successful images that turn everyday subjects and scenes into spectacular surreal images from another world.

Original colour image

▼ ▶ **ISLE OF LEWIS, OUTER HEBRIDES, SCOTLAND**
HDR imaging works just as well on black and white photographs as colour. You can see from the original image and the greyscale conversion of it that contrast was low and the tones rather flat. However, by creating source images with extreme exposure adjustment and then combining them using Photomatix Pro 3.0 the HDR version looks much more dramatic. Diffuse glow was added to a duplicate layer as a finishing touch.
CAMERA: CANON EOS 1DS MKIII/LENS: 24-70MM

FACE VALUE

When I first started travelling in my late teens, the idea of walking up to a total stranger and asking if I could take their picture filled me with dread. Despite the fact that at every turn I seemed to spot a potential subject, and every day I set out determined to overcome my fear, when it came to the crunch I simply didn't have the confidence to go through with it. What would I say to them? What if they made a scene and embarrassed me in front of everyone? How would I feel if a foreign tourist approached me in the street and wanted to take my portrait? Would I be flattered? Offended?

With so many thoughts racing through my head it was easier just to forget the idea and look for an inanimate object to photograph, because at least it couldn't answer back. Eventually, of course, I did pluck up the courage to ask. I forget when or where, but clearly, the experience wasn't all that bad because whenever I travel now, I always return home with a collection of travel portraits. In fact, photographing local people is often one of the highlights of the trip.

What I quickly discovered is that the vast majority of people are flattered and intrigued when a stranger asks to take their picture. They may expect payment, or something in return for being so obliging, but I never assume this. I never offer payment unless it is specifically asked for because doing so could cause offence. In the case of children, paying for pictures is also tricky because in poorer parts of the world, where tourists are seen as wealthy strangers with money to burn, it can encourage them to beg.

Quick fire

The key is to act quickly. If I encounter a person who I think will make an interesting subject, I approach them and ask if they would mind being photographed. Usually, pointing to my camera then pointing to them gives a clear indication of what I want. If they shake their head or say 'No', I respect that and walk away. If they say 'Yes' or nod approval, which is most often the case, then I get to work straight away.

Different photographers have different ways of working, but over the years I've found that it isn't necessary to spend ages chatting before taking any pictures, or stage-managing a situation.

I rarely ask my subject to change position because using a telezoom set to f/2.8 or f/4 reduces depth-of-field enough to render backgrounds a fuzzy, indistinguishable blur. And because I want to capture natural expressions I avoid asking them to do anything. Usually I just raise the camera, get their attention and start shooting. If they want to smile, I let them smile. If they want to look dignified and serious I let them do that too. Eye contact is the most important factor. If a person is looking at the camera, it means their portrait will engage the viewer. That's why I always, always, always focus on my subject's eyes. As long as they are pin sharp, it doesn't matter about the rest of their face. Out-of-focus eyes, however, are a no-no.

It really is as simple as that, and more often than not it's over in a matter of seconds. If you spend too long shooting, most people feel self-conscious and the spontaneity of the moment is lost. Expressions can quickly go from being natural to forced and it shows. Also, the people I encounter are often busy getting on with their lives rather than waiting for tourists with cameras to come along, so they don't have time to hang around – and neither do I.

ALSO CONSIDER

- A digital SLR is ideal for travel portraiture because you can show your subject the picture you've taken. That said, all the portraits shown here were shot on film.
- A 70-200mm telezoom, or equivalent, is ideal for most portrait situations.
- A 50mm standard lens is ideal for hand-held portraits in low light.
- A wide-angle lens for environmental portraits captures your subject in their natural setting.

▶ **THE FACES OF SOUTHERN MOROCCO**
I've travelled widely in southern Morocco over the last decade and find the people incredibly welcoming, friendly and obliging. Marrakech is becoming trickier due to a huge influx of tourists, and locals in the Medina almost always expect payment for pictures. Once you leave the big city and head south, however, it's a different story. The pace of life is slower, everyone is more relaxed and photographing the local people is an unforgettable experience.
CAMERA: NIKON F5 AND NIKON F90X/LENS: 50MM AND 80-200MM/FILM: FUJICHROME VELVIA 50 and 100F

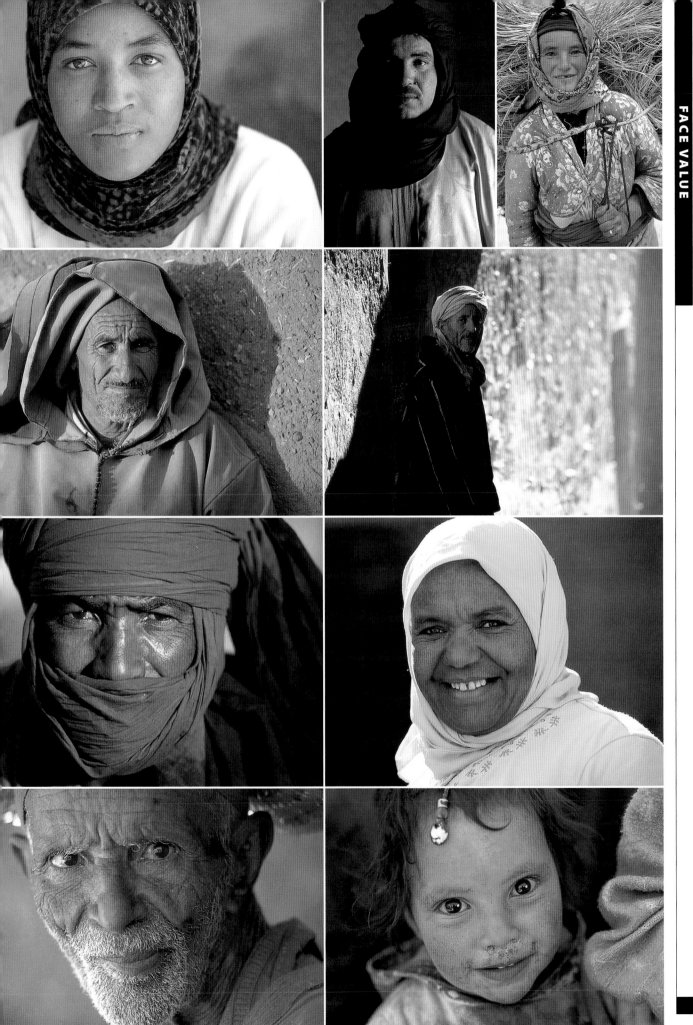

FESTIVAL SPIRIT

It's 7.45 on a bitterly cold February morning, and I'm battling with a dozen other photographers to try to take pictures of a costumed figure posing under the arches of the Doge's Palace in Venice. Stray elbows creep into the frame without warning; out-of-focus heads momentarily block my view; shadows from passersby move across the background as they cross the path of the rising sun.

Glancing over the square, I can see half a dozen similar scrums gathered around masked strangers vain enough to brave the cold. Some stand on the jetties that overlook the lagoon, others hang from ornate lampposts. More still drape themselves on benches bathed in golden sunlight. None of them says a word, movements are slow and graceful, and their masks, devoid of emotion or expression, lend an air of mystery to the whole spectacle.

This is the Venice Carnival, a colourful, crazy celebration that every photographer should attend at least once in their lifetime. There are many other flamboyant festivals around the world, from Rio to London, Trinidad to New Orleans, but the Venice Carnival is different. It's set in one of the world's most beautiful cities, the perfect stage on which to set a masked ball of epic proportions.

Best of all, everyone loves to be photographed. That's why they're there – to pose, pout and be noticed. Costumes range from the sublime to the ridiculous. Ornate medieval gowns compete with futuristic monstrosities while jesters rub shoulders with clowns. But it doesn't matter who's got the biggest and the best costume because they're all there as one happy family, savouring their moment of glory.

ⓘ HOW IT ALL STARTED

The origins of the Venice Carnival can be traced back to 1162, when the inhabitants of Venice marked victory in battle by celebrating in St Mark's Square. However, the wearing of masks in Venetian culture was a separate issue altogether, and seems to have been adopted so the wearer could get up to no good without being identified.

This was first documented in the thirteenth century, when the Venetian Republic seemed to be slipping into moral decline, and a series of laws was gradually passed to halt it; one in 1458 specifically forbade men from entering convents dressed as women. Eventually, masks could only be worn during the annual carnival and the tradition has remained ever since.

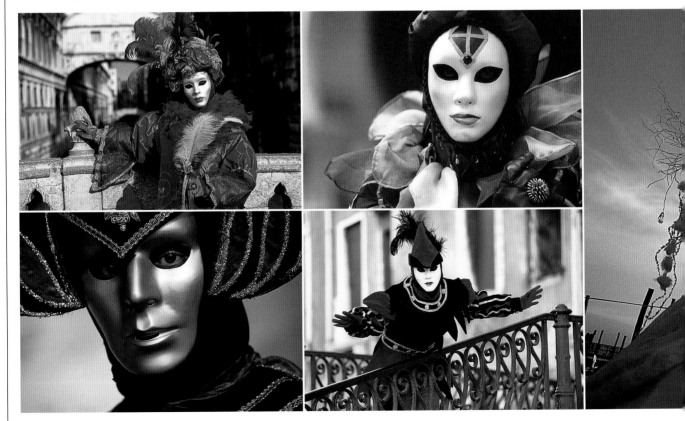

VENICE CARNIVAL TIPS

- The Carnival takes place every winter. Dates vary as the event always ends the day before Ash Wednesday and starts two Fridays before that.
- If you decide to go, be sure to book well in advance as flights sell out and hotels fill up. You can check dates for future Carnivals on websites such as www.visitvenice.co.uk or www.carnivalofvenice.com.
- Most of the action is centred around St Mark's Square. The nearby waterfront of Riva Degli Schiavoni, photographically speaking, is an ideal place to be from dawn to dusk. The island of San Giorgio Maggiore across the lagoon is also worth a visit in the afternoon, along with the Bovolo Staircase and squares such as Campo Santa Maria Formosa.
- Avoid the Carnival during the weekend. The city is chaotic and controlled photography almost impossible. Monday to Friday is by far a better option.
- Don't be afraid to approach models and ask for their co-operation if you have specific ideas in mind. You could even arrange a private photo shoot at a different location by just naming a time and a place. Most Carnival participants travel to Venice with friends so you may find you have the undivided attention of half a dozen of them.
- No one expects to be paid for posing but the masqueraders do like to receive photos as a reward for modelling. To that end they usually hand out printed cards with a colour photo of their costume (so you can identify them in your shots) and an email address so you can send them any pictures.
- Venice is normally one of the safest cities in Europe, but during Carnival week it's a prime place for opportunist thieves. If you put a bag of expensive camera gear on the ground and walk away, don't be surprised if it disappears. Avoid problems by travelling light and keeping everything on your body at all times.

Join the throng

Initially the hustle and bustle can be daunting, but it doesn't take long to get into the swing of things. The key is to adapt your technique to suit the situation. If it's crowded and busy, a long lens and wide aperture will allow you to isolate the subject and throw the background out of focus (I've never taken so many pictures at f/2.8 in all my life). Depth-of-field will be minimal though, so focus carefully and always on your subject's eyes. At quieter times you can experiment, going in close with a 28mm wide-angle, using slow-sync flash to create sharp/blurred effects, and shooting into the light. Try tilting the camera to capture masqueraders from unusual angles or taking panned shots as they stroll by. You can also experiment with alternative equipment and techniques. I've used Holga toy cameras and pinhole cameras at the Venice Carnival, shot infrared images, cross-processed film…

That's the great thing about the Venice Carnival. It inspires you to be creative and, with so many different subjects all waiting to be photographed, you really can't fail to take great shots.

The hard part is knowing when to stop.

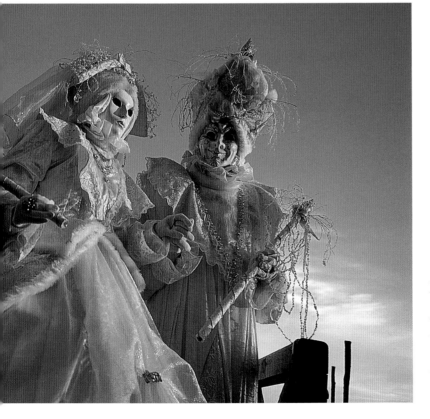

◀ VENICE CARNIVAL 2005
Although I've visited Venice many times (it's one of my favourite cities) I had never attended the Carnival until 2005. It proved to be an amazing photographic experience. Despite the crowds of other photographers – not all of them polite – and the general hustle and bustle, I enjoyed every minute, so much so that by the end of the first day I had to start rationing my film for fear of running out. The costumes were amazing, the weather remained dry and sunny and there were willing models at every turn. CAMERA: NIKON F5/LENS: 28MM, 50MM, 80–200MM/FILM: FUJICHROME VELVIA 50 AND 100F

FOOD FOR THOUGHT

Is food just fuel to you, or culinary art? I guess I fall somewhere in the middle in that I like a good feast. However, when food is prepared with passion and skill it also deserves to be appreciated for its creative beauty as well as its amazing flavours. And what better way to do that than with a camera?

I tend to be more inspired to photograph food when I'm travelling, simply because it looks more exotic and unusual. I enjoy wandering around souks and markets, photographing not only fresh produce but also things like herbs and spices. They're often arranged in a very neat, ordered way so patterns and colour contrasts are formed that make great found still-lifes. Not everyone is happy to have their wares photographed, but a polite enquiry will establish this – and is more likely to grant you a green light than if you start firing away without seeking permission first.

Use a telezoom lens to crop in tightly on an interesting arrangement, and use the foreshortening effect, where elements appear closer together, to add impact to the composition. A macro lens will also be handy for filling the frame with small subjects or for creating images that have a more abstract feel.

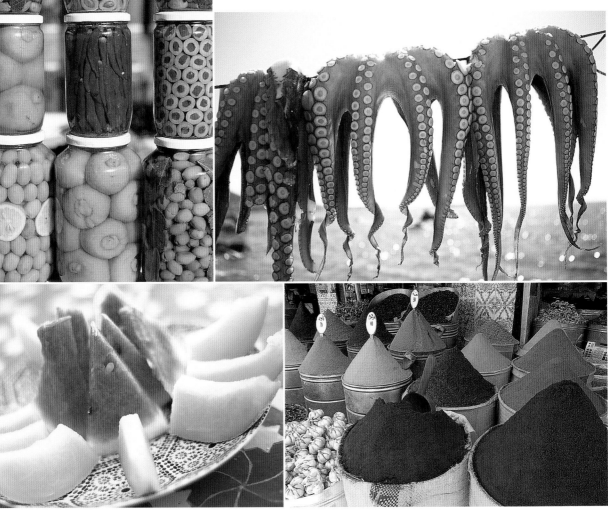

▼◀ MOROCCO, CUBA, GREECE, ENGLAND
Food is central to every nation and culture throughout the world and provides an endless source of inspiration. The colours, shapes, textures and patterns attract photographers like a magnet, and whether you shoot fresh produce on a market stall or an elaborate feast prepared by an expert chef, great pictures are guaranteed.
CAMERA: NIKON F5 AND F90X/LENS: 28MM, 50MM, 105MM MACRO, 80–200MM/FILM: FUJICHROME VELVIA

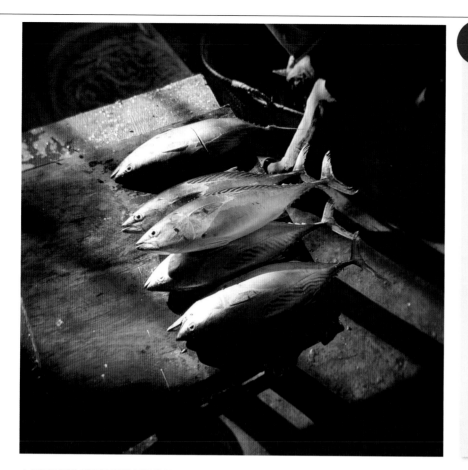

▲ FRESH FISH, STONETOWN, ZANZIBAR
I spotted these fish caught by a shaft of early morning sunlight as I
wandered around Stonetown's daily fish market. It's one of dozens of
such food photographs I've taken during my travels.
CAMERA: HOLGA 120GN/LENS: 60MM/FILM: FUJI PRO 160

ⓘ SOMETHING FISHY

I hate to admit it, but I have a slight obsession with fish. Not only do I love eating them, I love shooting them.

Maybe it's because they come in so many different shapes, sizes and colours, or the fact that they're often found grouped together in boxes and crates and form eye-catching patterns. Who knows?

I've photographed fishy still-lifes all over the world, using all kinds of camera from 35mm SLRs to Holgas and Polaroid SX70s. There are no rules. Just move in close and fill the frame and the fish will do the rest.

More often than not I work in available light, which can be incredibly atmospheric but also in short supply, so use a tripod, increase the ISO setting on your camera or brace yourself and hold your breath to minimize camera shake.

Home cooking

Of course, you don't need to travel to find interesting food subjects because there are plenty closer to home.

Markets and greengrocers are a good source of subject matter. Alternatively, take a trip to your local supermarket and buy some interesting specimens. Bright colours work well, so look for things like peppers and chillis or apples, oranges, strawberries and cherries. Exotic fruits such as lanternfruit, starfruit and lychees are becoming more popular and make great subjects. They're not only colourful but also have unusual shapes and textures that will allow you to experiment with different compositions and lighting.

One technique I use is to place my chosen subject on a sheet of white card then use another sheet of white card as a reflector opposite the window to bounce light into the shadows and produce very crisp, even illumination. I then use a macro lens set to its widest aperture so depth-of-field is almost non-existent and focus on a specific area, such as the tip of a chilli pepper, so everything else is thrown out of focus. It's a very simple technique but it works brilliantly, especially on items that have a bold shape and strong colour.

A slide projector is another handy source of illumination, producing quite hard, directional light that can be used to cast long shadows and reveal texture. The light it produces is very warm, but if you want more natural-looking results you can change the White Balance setting on your camera.

If you don't have a projector, try using a torch. A small penlight torch is ideal for painting a foodie still-life with light in a darkened room. Use a paper or card tube to reduce the spread of light from the torch so you can direct it towards very specific areas. Getting the exposure right is a little hit-and-miss but if you're shooting digitally you can check your first attempt and then increase or reduce the amount of time and light accordingly.

Finally, don't forget the humble lightbox, which is another great light source for still-life photographs. It works rather like a flash unit placed inside a softbox and produces soft, even illumination. You can place translucent objects on the lightbox so they're underlit, place the lightbox on its side and your objects next to it so they're sidelit, or use it behind your subject matter so it acts as both background and light source.

And let's not forget the most rewarding part of food photography: you get to eat all the props when you're finished. It makes my mouth water just thinking about it.

FOUR TIMES MORE FUN

As you've probably gathered by the nature of this book, my photography has been going through an experimental phase over the last couple of years. I've dabbled in pinhole photography, toyed with plastic cameras, converted a digital SLR for infrared and played with old Polaroids. However, by far the most peculiar camera I've ever had the pleasure of using is the Lomo Actionsampler.

▼ NOAH, NORTHUMBERLAND, ENGLAND
This series of three shots were all taken one after the other as my son raced up and down the beach on his bicycle. I tracked him towards the camera with the Actionsampler and tripped the shutter when he was roughly 2m (6½ft) away. The four individual exposures on each frame are made in an anti-clockwise direction starting top left and ending top right.
CAMERA: LOMO ACTIONSAMPLER

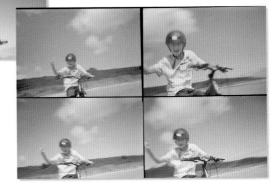

What makes this model different from all the other Lomo cameras is that it has four lenses. So, every time you trip the shutter it records four individual images on a single frame of film, rather than one. Even better, a rotating shutter inside the camera only allows one lens at a time to make an exposure, with 1/4sec delay between each. This means that if the subject is moving during exposure, or the camera, each image will be slightly different. For example, a person walking towards the camera will be closer on the fourth image than the first.

◄ Here's my shiny silver Actionsampler. A transparent version is also available if silver's too boring for you. Both models can be purchased directly from the Lomography Society – at www.lomgraphy.com. You may also find the camera for sale in museum and gallery gift shops and on eBay.

Load and fire

Despite this ingenuity, the Actionsampler is far from sophisticated. The body and lenses are fashioned from plastic, there's no metering and a pathetic flip-up rangefinder is all you have as a guide to what you're actually shooting. I've got no idea what the effective aperture is, or even the shutter speed, but I don't care. The simpler a camera is, the less you have to think about the technical side of photography and the more you can let your imagination run riot.

The only control you have with the Actionsampler is in the type of film that you load into it. Use negative rather than slide film so that you can take advantage of its wide exposure latitude to achieve well-exposed images. In sunny weather, ISO100 film will be ideal while for dull weather you'll need to load ISO400. Indoors, try ISO800 or ISO1600 film. Experiment with black and white film as well as colour.

Slide film is too exposure-sensitive for a camera like the Actionsampler. However, you could shoot slide film, then have it cross-processed in C-41 chemistry. This way you get the exposure latitude of negative film but also increased contrast and unusual colours that will add impact to your unique shot sequences.

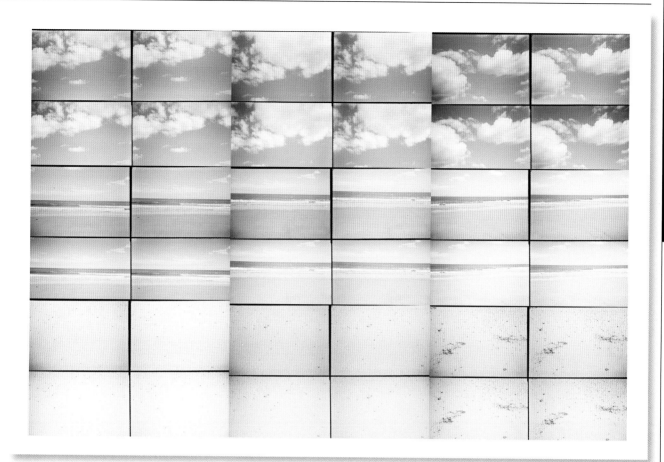

SHOOT YOURSELF

Self-portraiture is the ultimate form of self-expression, and the Lomo Actionsampler is the ultimate self-portrait camera. So, if you can't find any willing subjects to try it out on, you could always shoot yourself. Just hold the camera out in front of you and snap away while walking, jogging, jumping in the air, riding a bike or bouncing on a trampoline. Hold it at waist level and capture your reflection in a window or photograph your shadow when you're out for a stroll. Moving the camera rapidly towards your face as you trip the shutter will also produce an eye-catching sequence of images, and if you're wearing your outrageous sunglasses and pulling a funny face at the same time, so much the better.

▲ ALNMOUTH BEACH, NORTHUMBERLAND, ENGLAND
For this multi-image montage I took three different shots of the sky, three of the sea and three of the beach from the same position. Each image was then dropped one by one onto a new canvas using the Move tool in Photoshop. The images don't line up correctly and the colours are rather weird, but it all adds to the effect.
CAMERA: LOMO ACTIONSAMPLER

If it moves, shoot it

In terms of subject matter, anything goes, but the Actionsampler really lends itself to moving subjects because that's when the delayed action effect comes into its own. Use it to capture everyday action, such as your children racing around on their bikes, on swings in the park, leaping through the air or diving into a swimming pool. My own children soon lose interest when I try to photograph them using a normal camera, but when they see the Actionsampler they volunteer because they know the results will be fascinating.

The urban landscape is also an ideal environment for the Actionsampler. Stand in one spot and shoot away as people or traffic pass by. Alternatively, walk down a busy street and trip the shutter while you're moving. Or, take pictures from a moving vehicle so you grab four different snapshots of the passing scenery.

There are so many creative possibilities with the Actionsampler. Once you've shot a roll of film and seen your first results you'll be able to assess its strengths and weaknesses and then use them to your advantage.

Minimum focus is around 1m (3¼ft), but if at some point during the exposure your subject is closer to the camera than that, don't worry. A little blur won't do anyone any harm, and the transition of the image from sharp to soft may add to the effect.

So, what are you waiting for?

GO GRAPHIC

Striking photographs don't have to be of anything in particular – it's the way you compose them that counts. Bold shapes, strong lines, vivid colours and arresting camera angles can turn the most everyday subjects into exciting abstract photographs. And the further removed from reality they are, the more successful they tend to be, simply because the viewer is left wondering exactly what it is they're looking at.

WHAT YOU NEED

• ANY TYPE OF CAMERA WILL BE SUITABLE BUT I WOULD RECOMMEND A DIGITAL COMPACT
• A LOCATION WHERE THERE ARE LOTS OF STRONG SHAPES AND BOLD COLOURS
• BRIGHT SUNLIGHT AND CLEAR BLUE SKY
• LOTS OF IMAGINATION

Digital cameras can be a great ally when it comes to this style of photography because the instant feedback will inspire you to experiment further and push the boundaries of your creativity. Once you have produced one successful shot it's also much easier to see others and before you know it, a whole series of eye-catching photographs has emerged, literally out of nowhere.

I try to carry a camera with me wherever I go. Interesting subject matter is found in the most unlikely places where you would never dream of heading specifically to take pictures.

Shopping centres and retail parks are ideal hunting grounds for graphic, abstract images because modern architecture is full of striking features. Harbours and marinas are another favourite of mine. There you'll find wonderful textures in old timber and peeling paintwork, colourful buoys and fish crates, piles of lobster pots, fishing nets and so on. Finally, don't ignore your own neighbourhood. Everyday things like street signs or the apparatus in the local park can all be the source of great images.

Sunny days are best

The one thing that can make or break a great abstract image is the quality of the light. For me, nothing beats a bright, clear sunny day when the light is harsh and intense and casts short, black shadows. Such light is unsuited to such subjects as landscape and portraiture because it's far too harsh and unflattering. However, when you're shooting bold, graphic shapes and strong colours it's ideal because it adds to the stark, graphic effect you're seeking to create. Blue sky also makes an ideal background. Blue is a receding colour and it makes other colours in front of it stand out starkly.

To capture objects against the sky you will often need to shoot from a low viewpoint, so don't be afraid to get your knees dirty. You may receive a few confused looks from passersby, but don't let that bother you. They just don't understand!

What you're trying to do is create an image that lacks any reference to reality, so avoid including anything that suggests scale or is easily identifiable. Use your zoom lens to crop in on small areas of the main subject and exclude unwanted items. Try to keep the composition simple – one or two elements are all that you need.

Instead of holding the camera horizontally as you would normally do, try tilting it to an unusual angle and see how that changes the dynamics of the composition. And don't worry about any of the so-called rules of composition. Put the main subject in the centre of the frame if you like, or over to one side so the composition is unbalanced. Objects breaking out of the frame will also add tension and impact.

Post production

Once you have downloaded the images to your computer you can proceed to improve things further by manipulating them in Photoshop. Use levels and curves to boost contrast so the shadows are black and the colours really sing. Hue/saturation can also be used to make colours even richer. Remember, reality doesn't count here, so if the colours end up looking unreal that will only enhance the effect you are trying to achieve.

Finally, if a composition doesn't hit you right between the eyes, try rotating and cropping it to make the image more exciting.

◀ **BOAT DETAIL, NORTHUMBERLAND, ENGLAND ROAD MARKINGS, GATESHEAD, ENGLAND**
Once you get into the habit of looking for them, abstract graphic images can be found pretty much anywhere. The left-hand photograph here is a close-up of the timber planking on an old fishing boat, while the photograph to the right shows the markings on a newly painted parking bay outside a store.
CAMERA: SONY CYBERSHOT 6MP/LENS: FIXED 6.3-18.9MM ZOOM

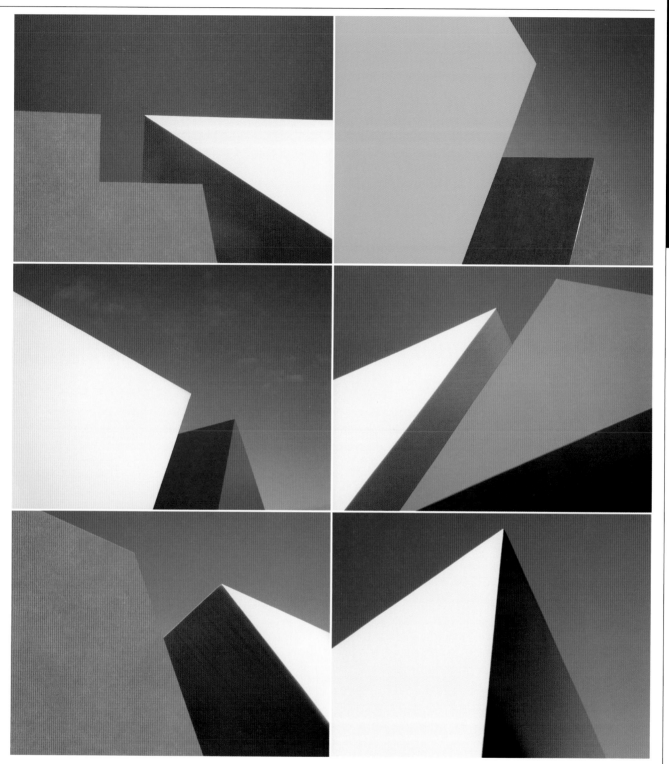

▲ **SHOP SIGN, GATESHEAD, ENGLAND**
These colourful, abstract images were all taken within a few minutes of each other
using a small digital compact camera. Each image features parts of a 3D sign
outside a large furniture store, captured in bright sunlight against blue sky. I just
wandered around, snapping dozens of frames from different angles.
CAMERA: SONY CYBERSHOT 6MP/LENS: FIXED 6.3-18.9MM ZOOM

HOUSEHOLD CHORES

The next time you're stuck indoors on a rainy afternoon and can't think of anything to do, why not set yourself a project to find interesting things to photograph around your home? Given the amount of clutter most people gather over the years there will be no shortage of subject matter, but because it's so familiar you've probably never thought of it as possible photo fodder.

The easiest way to tackle a domestic project is by shooting anything you find that looks remotely interesting. However, with such an open brief it can be difficult to know where to start and you may find yourself wandering around scratching your head. To avoid hitting a creative dead end, why not narrow down your options and be more specific in your choice of subject matter?

Do you have a collection of interesting objects, such as stamps, coins or vintage cameras? These could form the basis of a photography project. Children's toys are colourful and shapely and could be a good source of bold close-ups, while things like old silver cutlery will give you hours of fun as you try to abstract interesting shapes and patterns.

Choose a theme

If that's too obvious, concentrate on a specific colour such as red, green, yellow or blue, and then hunt high and low for it around the house. Once you start looking it's surprising how many times you'll see the same colour cropping up in clothes, book covers, drawing pins, clothes pegs, carpets, picnic sets, shoes, ties, toys or CD cases, but during your normal busy day you're unlikely to take any notice.

Shapes are another option. Look for squares, circles, triangles, diamonds, or even numbers. What about the entire alphabet, letter by letter? By working to a theme like this you can photograph anything that fits the brief. So, even though you may have to hunt around much more, finding whatever it is you're looking for will be fun and rewarding and I'm certain the pictures you produce will make the effort worthwhile.

How you shoot is up to you. You could set yourself a time limit to gather as many different objects together then photograph them one by one, or wander around the house with a camera and tripod and photograph things in situ. Both approaches can work well, though the latter will give you more control over lighting and composition. If you use the same type of lighting it will make the set of images more cohesive.

Light, camera, action

Light from a window is as good a source of illumination as anything else. Either use a tabletop by a window as your mini studio, or move one into position close to a large window. A large sheet of white card can be used as a background if you want to keep things really simple. Another sheet placed opposite the window will act as a fill light and soften any shadows. Ideally you don't want direct sunlight, though. Because this is likely to be a rainy-day project there won't be any sun anyway, and the light coming through the windows of your home will be nice and soft thanks to all that cloud.

If you're shooting digitally and find that the images appear a little flat, give them a boost by adjusting contrast either when you process the RAW files or when you open the image in Photoshop. Other controls such as vibrancy, clarity and saturation can be adjusted to increase impact.

Once you've completed one project, chances are you'll have enjoyed it so much that you'll be wishing for bad weather so you have the perfect excuse to start another one. But that's no bad thing, because when the sun does finally come out again, your eye for a picture will have improved no end, and you can take advantage of that when you head back into the great outdoors.

◀ GOING ROUND IN CIRCLES
This montage was created from nine individual photographs of circular objects I found around my home. I raided cupboards, the fridge, the larder, the loo and the fruit bowl and gathered everything together. Then I spent half an hour photographing them one by one on white card using only light from the window, except for the orange and lime slices, which I placed on a lightbox and backlit. Once the images were downloaded to my computer I made copies, cropped and resized so they were all the same size. Then I used the Move tool in Photoshop to drag them one by one onto a new canvas. Just in case you're wondering, the objects are, from left to right on each row, battery, mushroom, wine glass, orange slice, tealight, candle, garlic bowl, loo roll, lime slice!
CAMERA: CANON EOS 1DS MKIII/LENS: 24-70MM

▲ COD LIVER OIL CAPSULES
Once you start experimenting it's surprising how the most obscure objects can be a great source of ideas and inspiration. These three images are of cod liver oil capsules I found in a bottle in our medicine cabinet. Initially I spilled them onto a lightbox and experimented with different compositions. I then arranged them on a sheet of white card and lit them with a slide projector, which cast long shadows and added an unusual glow to the translucent capsules.
CAMERA: NIKON F90X/LENS: 105MM MACRO/FILM: FUJICHROME VELVIA 50

IN ISOLATION

Isolating a single element in a scene so all attention is drawn towards it is a powerful tool that can produce simple, striking images. We tend to do this as a matter of course when shooting portraits: the background is thrown out of focus so the main subject stands out and becomes the centre of attention. But you needn't just limit this technique to portraiture. It can work on any subject because what you see is what you get.

Differential focusing is the name given to the technique of using minimal depth-of-field to isolate a small area of a scene and make it stand out in bold 3D.

Achieving it is easy. All you need is a telephoto or telezoom lens set to its widest aperture. My first choice is an 80–200mm zoom set to f/2.8, which is ideal for landscapes, architecture and general use. I also use a 105mm macro lens at f/2.8 for close-ups and a 50mm f/1.4 for details and portraits.

Near and far
How little depth-of-field you end up with is dependent on the focal length of the lens, the aperture you set it to and, just as importantly, how close to the camera your subject is. If I use an 80–200mm zoom set to 200mm and f/2.8 and focus on an object 2m (6½ft) away, the fall-off in sharp focus will be almost immediate,

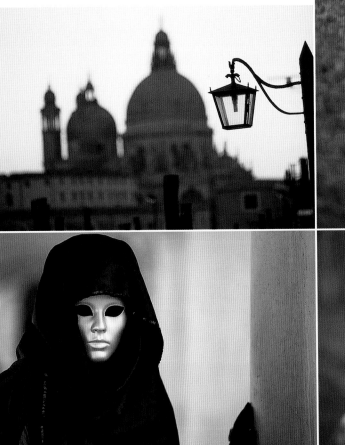

with everything beyond that 2m (6½ft) point completely blurred. However, if I use the same focal length and aperture but focus on something 10m (33ft) away, the fall-off will be less obvious so the subject won't stand out as clearly against the background. Differential focusing is therefore much more obvious when the point of focus is close to the camera and becomes less apparent as the focus point moves further into the distance.

Getting closer

Macro lenses take differential focusing to an extreme. Depth-of-field is always limited when shooting close-ups, even at small apertures such as f/16 or f/22. However, open up your lens to f/2.8 and it's almost non-existent, down to just a few millimetres.

◄ **VENICE AND TUSCANY, ITALY**
HAVANA, CUBA
Here are four different images that all show how differential focusing can be used to isolate a subject from its background or foreground, or draw attention towards a specific area. For the Venice shot I focused on the lamp but the church in the background is still clear enough to be identifiable. For the poppy field I focused on the tree in the distance so the foreground poppies were reduced to out-of-focus blobs of colour. When shooting the Cuban car I focused on the door handle and let everything else in front of and behind it drift out of focus. Finally, for the masked figure I focused on the mask, knowing that the wall in the background would be nice and blurred. All four shots were taken with the same lens at f/2.8.
CAMERA; NIKON F5/LENS: 80-200MM/FILM: FUJICHROME VELVIA 50

▲ **STARGAZER LILY**
This dreamy close-up shows the petals of a lily photographed using the light from a window on a dull day. I was more interested in creating abstract images than flower portraits so I set my macro lens to f/2.8 and explored the wonderful shapes and colours the flower offered. Using minimal depth-of-field added a sense of mystery.
CAMERA; NIKON F5/LENS: 105MM MACRO/FILM: FUJICHROME VELVIA 50

This dramatic fall-off can look stunning when used on colourful subjects like flowers. You can have hours of fun and take dozens of different dreamy abstract pictures of just a single bloom. This is because even slight changes of camera position and small adjustments in focus will completely change the look and feel of the image, blurring areas that were clearly defined beyond recognition and highlighting others. Elaborate flowers like lilies work well because the variations in shapes and colours give you lots of options.

If you're using a single lens reflex (SLR) camera, it's easy to gauge how the final image will look when shooting at maximum aperture. That's because, no matter how the aperture ring is set, until you release the shutter the interchangeable lenses are always at maximum aperture so that the viewfinder image is nice and bright. So, when you look through the viewfinder, you're also looking through the lens with the aperture at f/2.8, f/4.5 or whatever its widest setting is and the depth-of-field you see when you focus on your subject is the depth-of-field as it will look in the final picture.

INSTANT GRATIFICATION

Although digital technology offers the ultimate in instant imaging, the idea of being able to see a photograph moments after taking it isn't new. In fact, it's almost as old as photography itself, dating back to 1857 when Bolles and Smith of New York patented and produced the world's first instant camera. Others tried to bring in-camera development to the masses, but it wasn't until 1947 when American scientist and inventor Edwin Land (1909–1991), founder of the Polaroid Corporation, launched his first Land Camera that instant photography finally became a viable proposition.

From then on, Polaroid cameras took the world by storm and the Polaroid brand became synonymous with instant photography.

Over a period of 50 years, dozens of innovative Polaroid cameras were created that used both peel-apart and instant-integral film. Though they were designed primarily for mass production, many Polaroid materials were embraced by serious photographers and artists for their unique, fine-art characteristics.

The future of Polaroid at this time is in the balance. Production of Polaroid cameras ceased several years ago, and in February 2008, Polaroid announced that production of all instant film would end. Sadly, the meteoric rise in popularity of digital imaging and a huge drop in film sales have taken its toll. Soon, one of the biggest names in photography may be gone forever.

For the time being, however, it is still possible to get hold of various types of Polaroid film. Auction sites such as eBay will also continue to be a useful source for months or years to come. So, if you've ever thought about experimenting with Polaroid instant film it is still possible, but don't think about it for too long.

Have camera, will travel

My love affair with the Polaroid began back in March 2007. I'd picked up a Polaroid SX70 camera a few months earlier for a bargain price and decided to take it with me on a trip to Cuba. Soon afterwards it accompanied me to Morocco and since then I've been hooked on instant photography.

Given the quality that can now be achieved with the latest digital SLRs, this may seem a strange choice of camera. However, over the last couple of years, as digital technology has advanced, I've found myself looking backwards rather than forwards and reassessing what it is that makes me so passionate about photography.

The answer, it seems, is simply the art of making pictures. I get a particular buzz out of doing that with low-tech equipment and traditional photographic processes simply because the results are harder won and the sense of achievement is greater.

Each and every image is a unique and complete work of art. There's no need to play around with it in Photoshop because nothing you could ever do would make it more beautiful than it already is. SX70 prints have a wonderful quality about them that cannot be faked. The colours have a softness and delicacy that no amount of post production could replicate. Every picture looks as

▼ CHEFCHAOUEN, MOROCCO
These Polaroids form part of a larger collection that were all shot over a two-day period during a trip to northern Morocco in 2007. The town of Chefchaouen in the Rif Mountains is renowned for its blue walls and doors and I found my Polaroid SX70 perfect for capturing the soft colour and faded character of the town.
CAMERA: POLAROID SX70 SONAR AF/LENS: FIXED 116MM/FILM: POLAROID TYPE 779

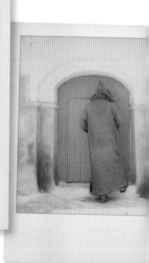

ℹ THE AMAZING SX70

The Polaroid SX70 was originally launched in 1972, years ahead of its time in terms of technology and innovation.

Not only was it the world's first instant SLR (previous Polaroid cameras were all rangefinder models), it was also the first folding SLR. In addition, it was the first Polaroid camera to use instant integral film, where the print develops before your eyes. While earlier models were manual-focus, later incarnations of the SX70 also incorporated innovative sonar autofocusing, making them the world's first AF SLRs available to consumers.
If that weren't enough, you also got:
- A four–element 116mm f/8 glass lens
- Minimum focus of just 10.4 inches
- Electronic shutter with programmed automatic exposure.
- Shutter speeds from 10 seconds to 1/175 of a second
- Aperture range from f/8 to f/22
- Exposure compensation
- Auto-flash exposure with accessory flashguns
- A socket for electronic remote release

Later models had a tripod bush but earlier models needed an optional attachment so they could be tripod-mounted. No batteries were required as they were built in to each film pack.

Back in 1972, the original SX70 retailed at $180 while the Sonar OneStep cost $250, which was a lot of money then. Fortunately, today you can pick up a decent SX70 for next to nothing. Sonar AF models, which are more widespread than earlier SX70s, cost anything from £15 to £50 in full working order.

▲ This is my 1970s Polaroid SX70 Sonar, open and ready for use (top) and folded (bottom).

FILM FOR THE SX70
All SX70 cameras were designed to use SX70 film or Time Zero film, neither of which are made today.
Polaroid Type 600 film is still easy to get hold of but to use it in an SX70 camera you need modifications.
- First, you'll need to put a 0.6 neutral density filter over the lens to avoid overexposure because 600 film is rated at ISO640 and all SX70 cameras were designed for use with ISO125 film. You can buy a proper Polaroid ND filter from www.unsaleable.com, but I purchased a Lee Filters 0.6ND gel and cut a small circle from it with scissors, then attached it to the lens with small strips of double-sided tape.

- Second, the film cassettes for 600 type film have two small plastic ridges on the base, which make it difficult to load them into an SX70 camera. One solution is to slice these ridges off with a sharp knife. However, a safer option is to place a credit card or similar flat object inside the mouth of the film chamber to cover the grooves inside it. Push the film cassette into place, remove the credit card and close the film chamber.

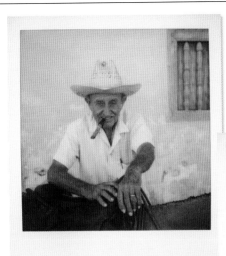

▲ HAVANA AND TRINIDAD, CUBA
Polaroid cameras are ideal for travel portraits because you can shoot one for yourself and one for your subject as a thank you for their co-operation. In countries where cameras are a luxury few can afford, this will be welcomed with open arms. Don't be surprised if you find yourself surrounded by willing subjects.
CAMERA: POLAROID SX70 SONAR AF/LENS: FIXED 116MM/FILM: POLAROID TYPE 779

if it could have been shot in 1977, and the cross-hatched white border instantly identifies it as a Polaroid original.

To me there's also a purity about working with cameras like the Polaroid SX70. They strip photography back to its most basic form where composition and subject mean everything. You point, focus and shoot and the picture either works or it doesn't. There are no filters or fancy techniques to shore it up.

Also, success doesn't have to mean pin-sharp, super-saturated, technically perfect pictures that you can enlarge to the size of a small house. Imperfections give a photograph character and expression. They make it uniquely yours. And there's something quite special about an original Polaroid print, even if it does only measure just 82 x 108mm (3½ x 4¼in).

Who said small can't be beautiful?

i SCANNING AND PRINTING

The original SX70 prints are works of art in their own right. However, I tend to scan my favourites using a flatbed scanner so I can safeguard the originals, make copies and supply the images for publication.

I normally scan to an output size of around 70Mb, which allows me to print up to 41 x 30.5cm (16 x 12in) at 300dpi. The prints are best made on gloss or semi-gloss paper to replicate the finish of the original print. A great way to display them is sandwiched between sheets of acrylic or bonded to sheets of aluminium such as Dibond.

▲ POINT HOTEL, EDINBURGH, SCOTLAND

The great thing about Polaroid cameras is you can take them anywhere and photograph anything. These three images were made while my wife and I were in Edinburgh for the night. I'd read that the hotel we were booked into had some colourful interior lighting, so I took my SX70 along to record them.
CAMERA: POLAROID SX70 SONAR AF/LENS: FIXED 116MM/FILM: POLAROID TYPE 779

▼ BLYTH PIER, NORTHUMBERLAND, ENGLAND

One of the most revered kinds of 'fine-art' Polaroid film is Type 55. This 5 x 4in black and white peel-apart material not only gives you a 5 x 4in glossy print, but a large-format negative that can be enlarged or scanned to produce prints with a wonderful tonality and unusual border. I mainly use Type 55 in a 5 x 4in pinhole camera, though I also have a modified Polaroid 95A camera that will accept Type 55 film.
CAMERA: ZERO IMAGE 45/FOCAL LENGTH: 75MM/FILM: POLAROID TYPE 55

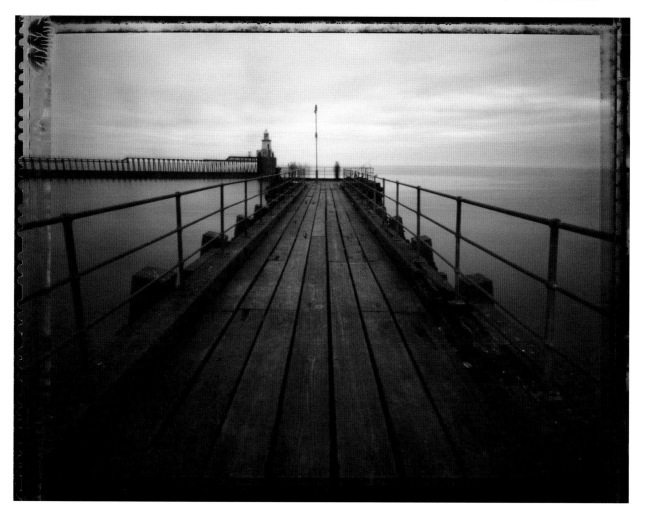

IT'S IN THE DETAIL

When visiting new places there's always a great temptation to seek out and shoot exactly the same scenes and subjects as everyone else. If it's Paris it has to be the Eiffel Tower and the Arc de Triomphe. In London we make a beeline for Big Ben, St Paul's Cathedral and Tower Bridge. In Venice, gondolas gliding along peaceful canals and the bustling Rialto Bridge are top of our shot list.

I'm as guilty of doing this as the next photographer. However, while bagging great shots of iconic scenes is always satisfying, it's not exactly original. So, as well as taking the obvious pictures, I also make an effort to look for details that offer clues as to where I might be. From a creative point of view, this offers endless scope for experimentation and in interpretation and also results in images that are less clichéd and therefore visually refreshing.

Draw up a hit list
One solution to help avoid the clichéd image is to make a list of the things that are characteristic of a location. In London it might be the Union Jack flag flapping in the breeze, black taxi cabs, red double-decker buses and Coldstream Guards in their distinctive red and black uniforms. In Paris, ornate Métro signs, street cafés, shop windows and model Eiffel Towers on souvenir stands have similar symbolic value. You could also photograph things that contain the name of the place, such as t-shirts and posters, graffiti, hoardings, toys, car number plates and so on.

As well as shooting these things in a literal way, think about how you can make your pictures more interesting artistically. Instead of capturing a London bus as it races by, shoot the reflection of one in a window or puddle. Instead of photographing a Coldstream Guard from eye-level, get down low with a wide-angle lens or concentrate on smaller details in his uniform, such as the black fur Busby, the polished belt buckle or the gleaming sword. It is the same subject, just a different interpretation of it. Alternative cameras, such as Holgas and Polaroids, can also be pressed into service to create images with an unusual look and feel.

If you can't resist photographing the more obvious scenes and subjects, think about how you can interpret them in an original way.

Use a telezoom lens to home in on small areas that identify the subject but are much simpler. This is a handy technique with buildings and monuments. Rather than make your subject the main feature in the composition, relegate it to the background. Focus on something else closer to the camera and set an aperture that's wide enough to throw the background elements out of focus but not so wide that they're blurred beyond recognition. Look for reflections of the subject in windows, parked cars and puddles. Or, step inside a building that offers a good view of your chosen subject and shoot it through the window. By working in this way your subject becomes a secondary detail in the composition rather than completely dominating it and this makes the final image much more interesting.

Finally, don't assume that the details you photograph have to scream out the destination. They can be subtle rather than obvious, but gathered together as a collection they will paint a fascinating picture of the place.

ⓘ BACK TO BLACK

Though your first instinct when shooting travel details is to work in glorious colour, don't be misled into thinking that doing so is always the best option. Colour is realistic and reassuring, but realism doesn't necessarily produce strong images. By switching to black and white you immediately strip the subject back to its bare essentials and produce simpler compositions that concentrate on shape and form. The quality of light also becomes less important with colour removed from the equation. I often find myself shooting in black and white on dull days when colours appear flat and muted, but the soft light produces a wonderful tonal range.

▶ VENICE, ITALY
Gondolas are symbolic of Venice and unique to the city, so this shot couldn't really have been taken anywhere else (other than Little Venice in Las Vegas, perhaps). Despite being a much-photographed subject, my treatment of it makes use of strong shapes and opposing diagonals to create a fresh, simple, graphic image.
CAMERA: HOLGA 120GN/LENS: FIXED 60MM/FILM: ILFORD XP2 SUPER

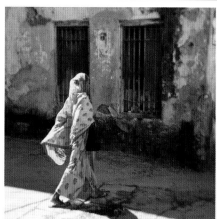

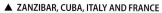

▲ ZANZIBAR, CUBA, ITALY AND FRANCE
Can you identify the location depicted in any of these images? Some are obvious, such as the Leaning Tower of Pisa (Pisa, Italy) and the Métropolitain sign (Paris, France). Che Guevara's wall-mounted portrait is also a fairly easy guess (Havana, Cuba) while the double bass also hints at Cuba (Cienfuegos). The chair (Vinales, Cuba) is more tricky but is very representative of the town, while the pair of feet (Jambiani) and the lady in orange (Stonetown) have a distinctly tropical, African look that reflects the character of the spice island of Zanzibar.
CAMERAS: VARIOUS

JUST ADD WATER

Few photographers think of water as a self-contained subject, like portraiture, landscapes or still-life, but when you look at the many permutations on offer it's unbeatable as a source of great pictures. And, as most parts of the world are generously supplied with water, the majority of photographers can take advantage of it.

If you live in the heart of the countryside you'll be spoilt for choice, with rivers, lakes, streams and waterfalls set in beautiful scenery. Townies will have plenty of options too, in the form of canals, boating lakes, ornamental ponds and fountains in public parks or gardens. Even puddles on a wet pavement can make great subjects.

◀ ISLE OF LEWIS, OUTER HEBRIDES, SCOTLAND
Waterfalls are hard to resist. Even though photographing them in this way has become something of a cliché, there's no denying that the effect of using a slow shutter speed, in this case four seconds, works brilliantly, capturing the grace and flow of moving water to create beautiful images.
CAMERA: MAMIYA 7II/ LENS: 43MM/FILTERS: POLARIZER/FILM: FUJICHROME VELVIA 50

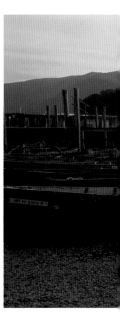

Water is at its most powerful and exciting when it's on the move in rivers, waterfalls, tidal estuaries or the sea, and the most effective way to show this movement is by using a slow shutter speed. The water will record as a graceful, atmospheric blur flowing effortlessly around rocks, or plummeting earthwards in gaseous streaks.

This technique is very easy to master and works brilliantly every time. Mount your camera on a sturdy tripod, compose the shot, then use a slow shutter speed to capture the water as it rushes by. The longer the exposure, the greater the degree of blur. Anything over one second will do the trick with waterfalls, while more slowly flowing rivers will benefit from an even longer exposure of perhaps even five seconds.

Overcast days provide the best conditions for waterfall shots because the light is soft and contrast is low. You won't have bright highlights on the water or deep shadows to contend with. Light levels will also be much lower than in bright sunshine, so by choosing a slow ISO and stopping your lens down to f/11 or f/16, you should manage to get a shutter speed of at least one second. This is especially the case if you're shooting in woodland where light levels are lower.

If not, you can increase the exposure time by using a neutral density filter, which will reduce the light entering your lens. A 0.6ND filter will require a two-stop exposure increase and should be strong enough in most situations, while a 0. 9ND filter will lose three stops and a 1.2ND filter four stops.

Alternatively, use your polarizing filter, which will cut the light by two stops. An added benefit of a polarizing filter is that it will also remove glare from any foliage in your pictures so colour saturation is increased, and reflections are eliminated from the wet rocks.

Water world

Water in the landscape can be used to make your compositions appear more powerful. A river winding its way into the distance, for example, will carry the viewer's eye through the scene. Alternatively, you can use a lake or pond in the foreground to add depth and scale to your pictures.

Wide-angle lenses are invaluable here. You can move in close to capture rocks on the lake shore, or fill the whole foreground with water and capture a mirror image of the surrounding scenery.

Because of the way that they stretch perspective, wide-angles are also handy for utilizing small areas of water. If you move in close and low with a 24mm or 28mm lens, for example, even a puddle or tiny pond will look like Lake Superior. With a telephoto or telezoom lens you can compress perspective and emphasize the bends in a meandering river or stream to create a dramatic composition. This effect works particularly well at sunrise or sunset, when the river reflects the warm colour in the sky and snakes into the distance like a ribbon of gold.

Reflections are another great subject to look for in rivers, lakes, harbours, puddles and anywhere else where you also find water.

For the best results, shoot in sunny weather and keep the sun behind or to the side of the camera. Calm weather will reward you with crisp reflections full of detail, while the slightest breeze will ruffle the surface of the water to produce colourful abstracts.

▼ **DERWENTWATER, LAKE DISTRICT, ENGLAND**
Dawn and dusk are the ideal times of day to photograph scenes containing water. Calm weather, soft colours and gentle reflections are an unbeatable combination and you really can't fail to take great pictures.
CAMERA: FUJI GX617/LENS: 90MM/FILTERS: 0.3 CENTRE ND AND 0.9ND HARD GRAD/FILM: FUJICHROME VELVIA 50

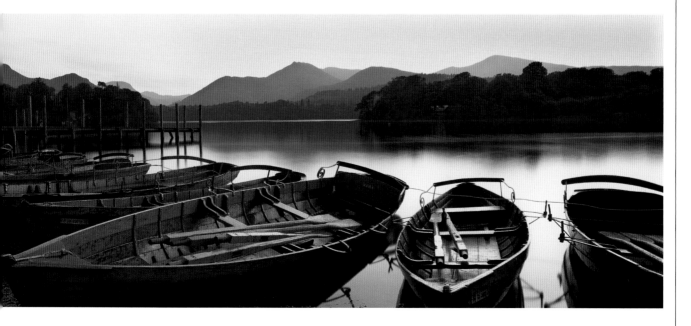

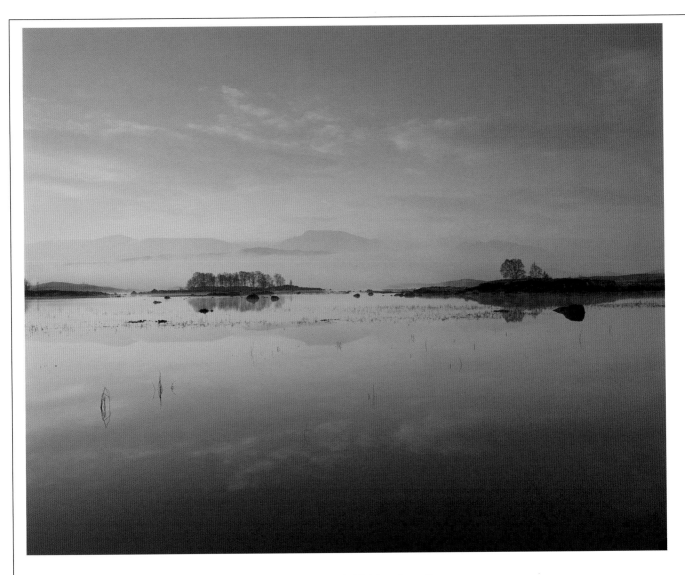

▲ LOCH BA', RANNOCH MOOR, SCOTLAND
This photograph is totally reliant on water for its success. The serenity is created by the mirror image of the scenery, the sky and the wonderful colours. Try to imagine the same scene with drab moorland filling the foreground. Its mood would be completely different and the resulting image far less evocative.
CAMERA: PENTAX 67II/LENS: 45MM/FILTER: 0.45ND HARD GRAD/FILM: FUJICHROME VELVIA 50

Use a wide-angle lens to fill the foreground with reflections, or a telephoto to home in on smaller areas for more abstract effects. Always focus on the reflection itself rather than the surface of the water to ensure that it will come out in sharp focus.

A polarizing filter will come in handy for removing surface glare so the colours of the main reflection are more deeply saturated. If you're photographing a scene where the reflection fills the foreground, it's also a good idea to use an ND grad filter. This is because reflections always come out darker than the scene being reflected. By using a 0.3 or 0.45ND grad to cover the top part of the scene, you can balance things out.

Light and weather

The appearance of water is determined mainly by light quality and sky colour, so by shooting at different times of day or in different weather conditions a variety of results can be created.

In bright, sunny weather rivers and lakes tend to appear very blue, whereas early or late in the day they take on an attractive warm cast. Similarly, in dull weather water tends to look grey, boring and lifeless – as you'll discover if you look at the sea during the winter.

The position of the sun also plays an important role. When it's almost overhead around midday a glassy, highly reflective finish is produced, with lots of tiny highlights dancing on the water's surface. But during the morning or afternoon, when the sun is at a low angle, light rakes across the water's surface, so texture is revealed and you get much better results.

The most photogenic times of day to photograph water in lakes, rivers or oceans are at sunrise, sunset and twilight, when the colours in the sky are mirrored by the water's surface. No matter where you are, you cannot fail to take winning pictures.

ⓘ KEEP IT DRY

Heavy rain and the fine spray from waterfalls, fountains and crashing waves can damage your delicate cameras and lenses. This is especially the case with modern digital SLRs, which are packed with electronics.

To avoid problems, either buy a purpose-made rain cover or place your camera and lens in a polythene bag, with a hole cut in it for the lens to poke through. Fit a skylight or UV filter to the lens, so the front element is protected, and secure the polythene around the front of the lens barrel using a rubber band. Keep your other gear zipped away in a gadget bag or backpack.

If the water is splashing or spraying, check the front of the lens every few minutes and wipe away any water that has settled on the filter. If you don't it will degrade image quality and increase the risk of flare in sunny weather.

▲ **VENICE, ITALY**
Towns and cities come to life after a heavy downpour, with wet surfaces and puddles adding an extra dimension to normally dull scenes. This alleyway wouldn't normally warrant a second glance. However, a quick shower has transformed it into an eye-catching study in light and form.
CAMERA: LUBITEL TLR/LENS: 75MM/FILM: ILFORD XP2 SUPER

▼ **PETERBOROUGH, ENGLAND**
Water droplets offer loads of photographic potential. In this case I used a macro lens set to its widest aperture (f/2.8) to minimize depth-of-field. I shot it from an acute angle so only a narrow zone came out sharp while the rest of the droplets recorded as shimmering highlights. The warmth of the image comes from evening sunlight striking the window where the droplets had formed.
CAMERA:NIKON F5/LENS: 105MM MACRO/FILM: FUJICHROME VELVIA 50

KEEP IT SIMPLE, STUPID

I'm a great believer in the KISS approach to photography: Keep It Simple, Stupid. Life's complicated and cluttered enough as it is, so the last thing you want to do is burden your images with too much information. Always remember that less is more.

Once you do start making an effort to strip back your compositions to the bare bones you'll quickly realize how little is actually required to create an artistic masterpiece and how many opportunities there are out there to produce minimalist compositions.

Weather conditions can make a huge difference. On clear, sunny days the senses are bombarded with colour and detail. The world looks sharp and shiny, and visibility seems to go on forever. There's just too much to take in. But throw some mist or fog into the equation and it's a different story. Scenes are simplified. Fine detail is lost, visibility reduced to just a few feet in some cases and only the boldest features stand out.

Just go for a stroll and you'll find endless subjects to shoot. Watch out for lampposts, trees, church spires and telegraph poles peering out of the gloom. Don't shoot a whole bunch of them, though – just the one will be enough. Bridges, roads, paths and fence lines work well because as you look along them they slowly fade to nothing – they literally vanish. The same is true of lakes and lochs. Often you can't see the far bank because grey water merely merges with grey mist.

▼ **VENICE, ITALY**
This photograph was taken from a ferry as it plied the Venetian lagoon on a very dull, grey day. The single post rising from the gloom helps to capture the sense of isolation and emptiness of the place. Setting the post centrally in the frame also simplifies the composition by making it static and symmetrical. Anything more in the scene would have complicated it and diluted the message.
CAMERA: LOMO LC-A COMPACT/LENS: FIXED 32MM/FILM: ILFORD XP2 SUPER

▶ **GRASMERE, LAKE DISTRICT, ENGLAND**
I arrived at this location with a group of photographers I was instructing during a photo workshop, hoping to shoot dawn breaking over the lake. As you can see, we didn't manage it. The mist was so dense we could barely see the water's edge, let alone the far shore. However, once my initial desperation had subsided and I started to explore the shoreline, I realized that there were still some great shots to be taken – just simpler ones than I had anticipated. In this composition it's impossible to see where the lake ends and the sky begins. Consequently, the stones appear to be floating in space.
CAMERA: MAMIYA 7II/LENS: 80MM/FILM: ILFORD XP2 SUPER

What you see

You can use lenses to help create minimalistic compositions. A telephoto or telezoom lens allows you to home in on selected areas and exclude anything else from the composition that over-complicates it. The longer the focal length is, the narrower the angle of view and the more selective you can be.

Subjects? Anything and everything, really.

Architecture is a good one to start with, especially modern architecture, which tends to be quite minimalistic these days and full of amazing shapes. In fact, towns and cities in general are good hunting grounds for simple shots.

Out in the countryside you need to be more careful. A misty or foggy day will make life easier, for the reasons already explained, but in clear weather you need to change your approach.

Look for simple scenes, for example, a single tree on a hillside. You can't get much simpler than that. But instead of composing it so the foreground fills most of the frame, tilt the camera up and let the sky dominate. Cloudless blue sky (or a grey overcast sky if you're shooting in black and white) is ideal because it's plain and simple. Clouds are okay in small doses. One or two drifting along won't upset anyone, but a sky full of fluffies spells clutter, which is just what you don't want.

In order to see simple pictures you need to de-clutter your own head and look at the world through a fresh pair of eyes. Think of it as Zen and the art of photography.

It takes practice, but you'll get there in the end. And when you do, every picture you take from that point on will benefit. Even if the end result is far from simple, you will have consciously considered everything that has been included and made the judgment that it deserved a place.

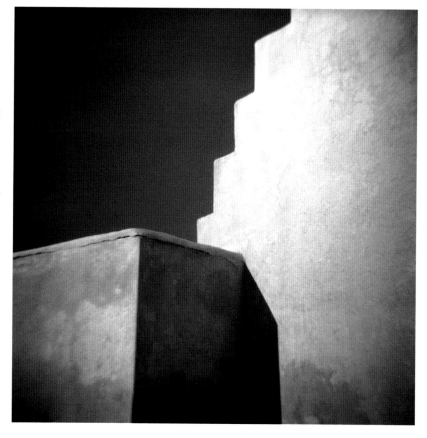

▶ **FIRA, SANTORINI, GREECE**
Architecture makes ideal subject matter for minimalistic images. Just concentrate on simple, bold features. This shot was taken during a family holiday while I was wandering around with a toy camera (see page 142) snapping anything that caught my eye. The simplicity of the Greek architecture combined with harsh sunlight and a clear blue sky had a big influence on what I photographed and, more importantly, how I photographed it.
CAMERA: DIANA F/LENS: FIXED 75MM/FILM: ILFORD HP5 PLUS

LAST LIGHT

If you really can't cope with the prospect of rising in the middle of the night to catch the dawn light (see page 24), maybe the end of the day is a better proposition for you.

The good thing about shooting at dusk compared with dawn is that you're already up and about and you can react to the light as it changes and improves. The longer you stay out, weather permitting, the warmer the fading light and the better the photography gets.

At dawn the opposite applies. You start out with little or no light, and then you have to anticipate what's likely to happen as sunrise approaches. You have to second-guess the light rather than react to what you see. In addition, once the sun does rise, the quality of light quickly deteriorates as its colour fades and intensity increases. This is why so many photographers struggle with the idea of dawn photography: you may have dragged yourself out of bed for nothing.

I like to burn the candle at both ends. In the Western Isles of Scotland in June 2008, not only was the sun rising at 4.14am, but it wasn't setting until 10.40pm. On the days when dusk was worth staying out for, I was still shooting at 11pm, finally getting to bed around midnight. Then I was rising with the alarm again at 2.50am to check the weather. Winter is so much easier. Sunrise at 7.30am, sunset at 4.30pm: job done.

What you will notice if you shoot at both dawn and dusk is that the light at dusk is richer and more sumptuous. This is because at the start of the day the sun rises into a clean atmosphere over a cold Earth. As the day progresses the Earth warms and the atmosphere clogs with haze, which scatters the light rays from the sun. This filters out more of the blue wavelengths so the redder end of the spectrum is left to perform its magic.

You don't really see this until about 30 minutes before sunset, by which time the sun is low in the sky. The lower it falls, the warmer the light gets. In the final few minutes it simply glows and anything caught by those dying rays of light looks truly magnificent.

Planning ahead

To make sure you catch them, you need to plan ahead and decide exactly where you need to be. Being in the right place at the right time, and having the vision to predict how a scene will look when the light peaks, is the real art of landscape photography. It takes effort and judgement, but the more you do it, the better you get. And I'm not just talking about generally being in the vicinity of

▼ BRYCE CANYON, UTAH, USA
I had just arrived at the canyon with some friends that afternoon. I didn't expect to get any dusk pictures as cloud cover had all but snuffed out the sun. Our equipment was packed away. We were standing and chatting by this viewpoint when suddenly the cloud began to break and the sky flared with colour. It was totally unexpected. Fortunately the cameras and tripods were just metres away so we made a mad dash, set up and managed to catch the limestone canyon basking in the amazing afterglow of the setting sun. It lasted no more than five minutes, but that was long enough.
CAMERA: FUJI GX617/LENS: 90MM/FILTERS: 0.6ND HARD GRAD AND 0.3 CENTRE ND/FILM: FUJICHROME VELVIA 50

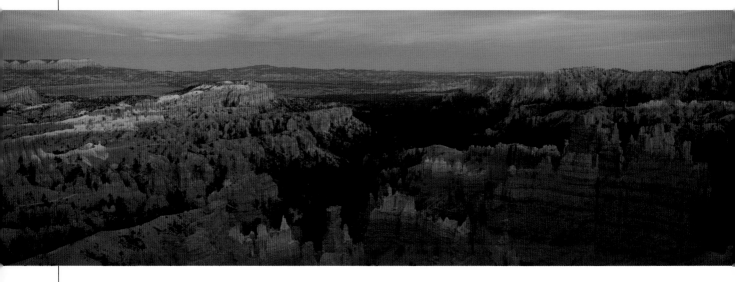

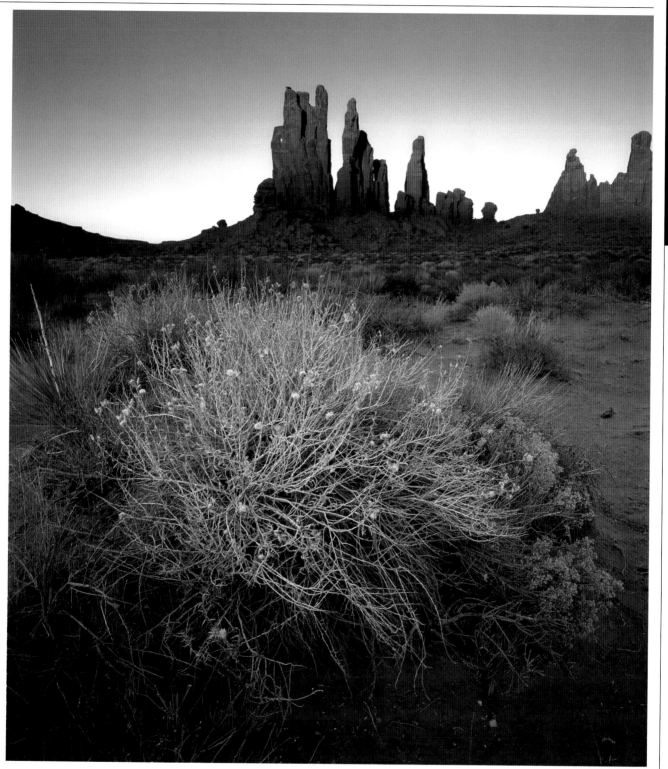

▲ MONUMENT VALLEY, UTAH, USA

I arrived at this location an hour or more before sunset and photographed a series of views as the sun slowly sank in the sky. However, as good as the light was, in a sense, there was too much of it. The whole landscape was bathed in a voluptuous glow and everything looked the same. It was only when the sun started to dip below the horizon and the foreground was thrown into shade that the scene came to life. The scrub in the foreground, lit by reflected light from the blue sky overhead, took on a strange luminescence while the distant sandstone pinnacles (my focal point) glowed in the dying light of the setting sun. It was a truly magical moment.

CAMERA: MAMIYA 7II/LENS: 43MM/FILTERS: POLARIZER AND 0.9ND HARD GRAD/FILM: FUJICHROME VELVIA 50

where you might get a decent shot or two, but establishing The Spot. By this I mean the magical place where you can put down your tripod and, when all the elements come together as planned, you produce a masterpiece. That is always my goal, to produce an image that I want to blow up and hang on my wall. Anything less and I've failed.

The technical side of photography shouldn't be underestimated, but in reality you need few skills to produce great landscapes. These include the ability to compose an interesting shot, control depth-of-field so you get everything in sharp focus and use ND grad filters to balance sky and land. That's pretty much it – just the three. These come with practice and, once mastered, are never forgotten. I was also going to list exposure and metering as well, but modern cameras are so good these days that there can be no excuse for a poorly exposed image, especially if you're shooting digitally.

Day's end

Of course, the quality of light at the end of the day is completely at the mercy of prevailing weather conditions. If it's a clear day, the sun will blast the landscape with amazing light right up to the second it dips below the horizon. But such days are the exception and, to be honest, I'm not sure I'd really want too many of them.

Why? Because when the sun sets in a clear sky it usually spells the end of the day's photography. There's unlikely to be much going on after that. You might get something of an afterglow, but quite often the sun goes down, any traces of colour disappear with it and that's your lot. Time for supper.

What you really need is cloud above the western horizon, but not too much. Dense cloud is a sunset killer, while broken cloud has gaps that let the light of the setting sun through. And once it does set, ideally, the sun will underlight those clouds so the sky fills with colour, bringing the day to an end in a blaze of glory.

From there it's downhill all the way as light levels fade and nightfall approaches, but keep shooting because twilight can be just as productive as sunset. I personally prefer the very end of the day because colours are more subtle and the light, which is reflected from the sky, is softer. It's a great time to photograph coastal views or scenes containing water because the delicate colours in the sky will be reflected, and you can also use long exposures to record motion (see page 136).

Alternatively, head for the bright lights of the big city and shoot the urban landscapes as they bask in the multi-coloured glow of man-made illumination (see page 78).

◀ ISLE OF LEWIS, OUTER HEBRIDES, SCOTLAND

It was my first evening on the island, and after an early dinner I decided to head up onto the nearby coastline to check the views. The weather looked very unpredictable, so I wasn't expecting to get anything, but as always I took my backpack and tripod. It was just as well that I did because I had barely reached this high point when the sun dropped below the cloud and bathed everything in golden light. Amazing. There was no time to scout for a better viewpoint as the light could go at any minute, so with my heart thumping, I quickly set up and started shooting. Instinct took over as I set hyperfocal focus to maximize depth-of-field, stopped the lens down, attached a grad filter and took a meter reading. Minutes later it was all over. The sun had dropped behind cloud and rain was lashing in from the Atlantic. Just a few short hours later I was photographing sunrise at Callanish Stone Circle (see page 24). It's a hard life.
CAMERA: FUJI GX617/LENS: 90MM/FILTERS: 0.75ND HARD GRAD AND 0.3 CENTRE ND/FILM: FUJICHROME VELVIA 50

▲ ISLE OF HARRIS, OUTER HEBRIDES, SCOTLAND

I had almost given up on this evening. Gathering cloud looked set to kill the sunset and it had been a long day that had started 18 hours earlier. Then, a mere five minutes before the sun was due to set (around 10.40pm) the sun dropped below the cloud base and lit up the sky. In situations like this it's so tempting to pack up and head for home. Whenever you reach that point of giving up, just allow yourself another ten minutes, because you never know what might suddenly develop.
CAMERA: CANON EOS 1DS MKIII/LENS: 16-35MM/FILTERS: 0.9ND HARD GRAD

LIFE THROUGH A LOMO

The Lomography Society is perhaps the world's biggest photography club, with thousands of members spread across the globe and a reputation for creative image-making that has reached cult status. The whole Lomo ethos is about making photography an integral part of daily life, having fun, stretching your imagination and shooting anything, anytime, anywhere!

The origins of the movement can be traced back to the early 1990s, when a group of Austrian students discovered an obsolete Russian 35mm compact camera known as the Lomo LC-A while spending the summer in Prague and then used it to document their holiday. The results were unique and so unusual that everyone who saw them wanted a Lomo camera of their own. Subsequently, in 1992 the Lomography Society was born to spread the Lomo gospel to a wider audience, several years after the LC-A ceased production.

The Society quickly mushroomed into a global movement complete with Lomo embassies dotted around Europe and even Lomo shops. In 1997 www.lomography.com was launched to provide a home base for lomographers and since then it has gone from strength to strength with thousands of members, a World Archive that contains over 32,000 images, exhibitions, competitions and workshops.

The on-line shop also sells books of Lomo images, accessories and a range of alternative cameras that have been embraced by Lomographers because they're different and cool – Holgas and Dianas (see pages 142–147), Fisheye cameras, Actionsamplers (see page 42), pinhole cameras (see page 90), Russian TLRs (see page 151) and rangefinders, panoramic cameras – and, of course, the Lomo LC-A+ which is the modern equivalent of the LC-A, the camera that started it all.

Love my Lomo

The LC-A's cult status (and the emergence of the Lomography Society) came about because a growing number of photographers felt uneasy about the way technology had taken the unpredictability, anticipation and surprise out of taking pictures. I share that sentiment completely, which is why I found myself owning and using a number of cameras being championed by the Lomo movement long before I even knew it existed.

The one camera I didn't have, though, was the Lomo LC-A itself, and once I was aware of its legendary status, curiosity got the

ⓘ 10 GOLDEN RULES OF LOMOGRAPHY

01 Take your camera everywhere you go

02 Use it any time – day and night

03 Lomography isn't an interference in your life, but part of it

04 Try the shot from the hip

05 Approach the objects of your lomographic desires as close as possible

06 Don't think

07 Be fast

08 You don't have to know beforehand what you captured on film

09 Afterwards either

10 Don't worry about any rules

better of me. I had to have one and see what all the fuss was about!

Luckily, I managed to acquire an LC-A for nothing. Having tried and failed several times to obtain one on eBay, I mentioned my plight to a fellow photographer. She very kindly offered to donate hers, which hadn't seen the light of day for years.

The best source of decent LC-As is still eBay. At any given time you will usually have a dozen or so to choose from and, being built of stern Soviet stuff, they're usually a safe bet. Don't expect to get one for pennies, though. The Lomo cult is spreading like wildfire so good LC-As will always command high prices.

The alternative is to buy a brand new Lomo LC-A+. This is a Chinese replica of the LC-A, which is manufactured for the Lomography Society and is available on-line at www.lomography.com. It's virtually the same camera as the LC-A, with some additional features, but it costs more than double what you'd expect to pay for an original LC-A.

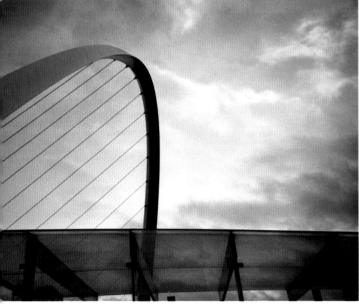

▲ **Above and previous page LIVING THE LOMO LIFE**
This set of images was produced using a Lomo LC-A compact and shows the diversity of subjects it can be used to photograph. All the shots were taken hand-held, one or two with the aid of a small electronic flashgun slipped onto the hotshoe. The LC-A can be mounted on a tripod, but going to the effort of setting one up somehow doesn't sit well with the see it, shoot it ethos of Lomography.
CAMERA: LOMO LC-A/LENS: FIXED 32MM/FILM: ILFORD XP2 SUPER

Back to basics

Compared to a modern digital compact, the LC-A leaves a lot to be desired. But that's the whole point. It's not meant to be modern, sleek and sophisticated. It's simple, solid and honest. It is intended for photographers who aren't bothered about seeing their images until it's too late to rectify mistakes, photographers who actually like making mistakes because they lead to images they would never have thought about taking in the first place.

I fall into this camp. I relish the challenge of working with low-tech cameras that stamp their own unique character on every

ALL ABOUT THE LOMO LC-A

The LC-A is a black, die-cast aluminium 35mm compact with a fixed 32mm lens. It's built to last, like all Soviet cameras, and dispenses with unnecessary features and frills that serve only to complicate life and increase the price.

At its heart is a 32mm f/2.8 lens, the legendary Minitar 1 designed by Professor Radinov of the Leningrad Optical Mechanical Amalgamation (LOMO) in St Petersburg. It's a sharp and contrasty optic with a moderate wide-angle field of view (63°) and though it does tend to vignette a little at the corners, this only adds to the character of the images. The lens and viewfinder window are protected by a sliding metal cover that you can retract using a switch on the base of the lens housing. If the cover is in place, the shutter locks so that you don't waste any film.

Focusing is achieved using a series of distance zones, including 0.8m, 1.5m, 3m and Infinity. Before taking a shot you need to estimate camera-to-subject distance and flick a switch to the appropriate setting. Remembering to do this is the tricky part – I ended up with quite a few out-of-focus images when I first used the camera. Luckily, there are symbols in the viewfinder representing each distance setting and as you move the switch a needle in the viewfinder also moves to indicate which setting you've selected.

The LC-A takes 35mm film, which is loaded the same way as any simple 35mm camera. Care needs to be taken when loading film, though, because once the back has been closed there's no indication of whether or not the film has actually been taken up. You also need to remember to set the correct film speed. The options are ISO25, 50, 100, 200 and 400.

Metering is automatic. You can set the lens to specific f/stops when using flash, but for general use the metering switch is left at 'A'. The camera sets both aperture and shutter speed automatically, with no indicators to tell what either value is. This is all part of the fun and unpredictability of Lomography.

All you do know is that the aperture will be somewhere between f/2.8 and f/16 and the shutter speed could be as fast as 1/500sec or as slow as several seconds. The instructions suggest the slowest shutter speed is two seconds but I've taken shots where the shutter remained open for longer than that.

One useful feature is an LED that glows in the viewfinder when the shutter button is partly depressed to indicate that light levels are low and a slow shutter speed will be set. Then it's up to you to decide whether you mount the camera on a tripod or brace yourself and hope for the best. The longer the interval between first and second clicks when you trip the shutter, the longer the exposure. Trying your luck and hand-holding can produce surprising results, as can intentionally waving the camera around when shooting in low light.

Loading the Lomo with negative film means that you can take advantage of its wide exposure latitude and beyond that it's down to imagination, creativity and keeping your eyes open for subjects that suit the Lomo.

picture produced. You could create a Photoshop action to turn digital images into convincing Lomo pictures. But if you did that you would be missing the point, just like the photographers who use a digital SLR costing thousands, and then crop and manipulate their pictures so they look as if they were shot with a Holga, or add a white border to make them look like Polaroid prints.

I've tried faking it, but in doing so I realized that using cameras that do this for real is central to the whole experience, like driving a classic car that backfires, leaks oil and doesn't guarantee to get you to your destination without a bit of roadside tinkering with the engine. If you want a smooth ride, buy a new car, but don't expect the journey to be memorable.

LONG-TERM PROJECT

Photographs are valuable historical documents. They record people and places, fashions and trends. They capture change and freeze moments in time forever. It's unlikely that you consider this when you raise a camera and press the shutter release. But one day, when you're long gone, your photographs will live on and remind future generations of a particular period in history.

With that in mind, why not consider working on a long-term photographic project and documenting something close to you or important to you over an extended period of time? Not only will this result in a fascinating historical record, but it will also give you a purpose to pick up a camera and take pictures when you're struggling to find inspiration.

The subject can be anything. You could take regular photographs of the place you live – your street, neighbourhood, town or city. The urban landscape is forever changing, especially in big towns and cities where redevelopment continually alters the skyline. Why not find a location where you get a clear view over a town or city and then take a photograph every month from exactly the same spot? As the years roll by and the scene changes, your photographic record will become more fascinating and important.

Studying a location

Any location could be the basis of your project. Devon-based photographer Andrew Nadolski photographed Porth Nanven beach in Cornwall over a ten-year period and the end result was not only a beautiful book entitled *The End of the Land,* but a valuable record of the ever-changing geology of the beach.

In a similar vein, I have been photographing the remote Hebridean island of Taransay for the last four years. Every summer, my family and I holiday there so I use the opportunity to take a few photographs during each stay. Photography doesn't take priority, but already I am seeing a collection of images emerge that paints a telling portrait of the island's beautiful coastal landscape, its bleak, hilly interior and its fascinating history and archaeology.

Though deserted today, the island was inhabited almost continuously from 300 CE – probably much earlier – until the 1970s. Evidence of every period in history during that time is still evident on the island. On one visit, we even discovered human bones and skulls that had been washed from ancient graves by winter storms.

The project has no end at the moment, though I like to think that one day I too may publish a book and exhibit the images.

American photographer Jim Brandenburg set himself a more intense project a few years ago, which resulted in the book *Chased by the Light.* For a 90-day period between the autumn equinox and winter solstice, he took just one photograph each day. That doesn't mean he chose one image from the many he'd taken that day, but that he only allowed himself to expose one frame of film each day for 90 days. The resulting collection captures the amazing cycle of nature around his home in the northwoods of Minnesota.

The face of change

Of course, you needn't travel to find a subject for your project and it needn't involve photographing a place. People are just as important. Why not document the people in your community – the milkman and postman, farmers, local characters, tradespeople, as well as family and friends – going about their daily lives?

If there are local events, even something like a market day when the community comes out in force, take your camera along and document the people. It's surprising how many of them will welcome you into their lives once they know what you're doing. Over the years your picture collection will be a source of fascination to everyone who sees it, especially those you have photographed.

Two projects immediately spring to mind that you could use as a source of inspiration.

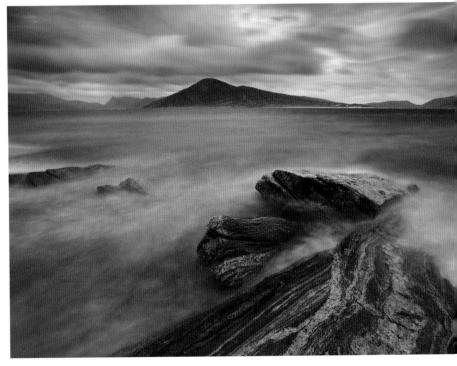

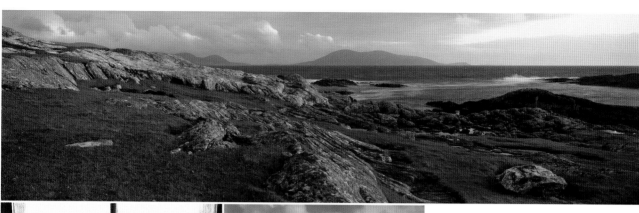

◀ ▲ **TARANSAY, OUTER HEBRIDES, SCOTLAND**
Here are just a few of the many photographs I've taken
during visits to Taransay over the past four years. They
capture everything from the island's landscape and
coastline to details of its history, including ancient
human remains and pottery fragments washed down
from the dunes.
CAMERA: MAMIYA 7II AND FUJI GX617 PANORAMIC/LENS:
43MM AND 80MM ON MAMIYA, 90MM ON FUJI/FILM:
FUJICHROME VELVIA 50

Photographer John Minihan was born in the small Irish village
of Athy but moved to London as a child. Two decades later and a
successful press photographer, Minihan began returning to Athy
every year to photograph the people and he has continued to do
so for more than 40 years. His images offer a fascinating insight into
the changing face of a small rural town and the lives and deaths of
the people who inhabit it.

In a similar vein, since 1975, photographer Chris Chapman
has been photographing the people of Dartmoor in Devon. His
subjects are mainly smallholders living and working in one of
England's remotest areas and trying desperately to cling on to
tradition in a changing world. Chapman's poignant images capture
a period in history that has gone forever.

The fascinating thing about projects like this is that the most
ordinary, everyday events become extraordinary with time because
photographs document change. Babies are born, children become
adults, adults grow old, old people die, couples get married,
fashions come and go. One, two or three decades can pass in the
blinking of an eye and so much is forgotten, but photographs
don't allow us to forget, and they remind future generations what
life was like.

So never take the ordinary for granted. Do the opposite –
celebrate it; photograph it.

ⓘ WORK IN PROGRESS

Have a look at these websites to see how other photographers have
approached long-term projects.

- www.nadolski.com – images of Porth Nanven, Cornwall
- www.johnminihan.com – the people of Athy, Co Kildare
- www.chrischapmanphotography.com – Dartmoor people over
 three decades
- www.jimbrandenburg.com – one photograph per day for 90 days

MAKE A MONTAGE

I have often felt that photographs gain power in numbers. Collections of images linked by subject, theme or location can be much more capable of delivering a strong message than one image on its own. And though by no means an excuse for producing or accepting second-rate work, images that aren't particularly special when viewed in isolation suddenly take on a different meaning when they form part of a group – the whole becomes greater than the sum of its parts.

This theory is put to the test, hopefully with success, in various chapters (Colour Coded on page 20, Go Graphic on page 44, Rock Stars on page 102, Shoot a Theme on page 118). The question is, what do you do with the images once you've taken them? Unless you're able to show them off to a wider audience, you may feel your hard work will have been in vain.

One option I've been experimenting with lately is creating colourful montages using collections of images linked by a common theme. If you're working with digital images simply take the first image you want to add to the montage, increase its canvas size using Image>Canvas Size, and then drag and drop additional images using the Move Tool until you're happy with the final montage. The blue series shown here was created in this way. I added my signature by signing a piece of white paper, scanning it, and then dropping the image of my signature onto the

▼ **Linking images of different subjects by a single colour creates a dramatic effect and the completed artwork really screams out for attention. Although this montage looks as if it was made using a set of Moo cards, I created it digitally using a set of images that had been cropped to a panoramic format to mimic Moo Minicards and dropped onto an enlarged canvas. Working in this way, you can keep going forever until you run out of suitable images – though the same image can be used more than once in different parts of the montage.**

▲ What you do with the cards is up to you. Here's a montage in the early stages of its creation.

▲ This eye-catching montage was created using a full set of 100 Moo Minicards and is ready for framing.

canvas to make it look more hand-made. If you prefer to create an analogue montage, all you do is make small prints of each image. Alternatively, have a set of images commercially printed.

I prefer this latter approach, and use minicards from a company called Moo (www.moo.com). They come in packs of 100, cost very little to produce but look fantastic. They're absolutely ideal for creating stunning montages (see panel). You simply stick the cards or prints down on large sheets of white card using PVA glue or spray-mount adhesive.

There are no rules to follow here other than using your imagination. You can create a small montage with just a handful of cards. Equally you could use a whole pack of 100 cards on one artwork, or several packs to create a giant montage. Alternatively, why not take a large image file and create a set of minicard cards that covers the entire image piece by piece so that you can reconstruct it as a joiner?

Subject matter is down to you. Images can be linked by colour or subject, or could simply be a random selection. Once you've finished the montage, all you need to do is window mount and frame it. You will have a unique piece of art that can be hung on the wall for all the world to see.

ℹ MOO TO YOU

Moo Minicards come in boxes of 100. Each card measures 28x70mm and is made using 350gsm board with a matt finish. As well as an image on the front, you can also have text printed on the back of each card so they can be used to send messages, if you're moving house, for example, or handed out as business cards with your contact details on the back.

What makes Moo Minicards so versatile is the fact that you can vary the number of different images you have printed on the cards up to a maximum of 100. If you like, you could have 100 cards made from the same image, ten images on ten cards each, 25 images on four cards each, 50 images on two cards each or 100 cards each with a different image.

The ordering process is all done on-line at www.moo.com. You select Minicards as the product, and then you're given the option to upload images from your computer or import them from galleries you may have on websites such as Flickr, Bebo or Facebook.

Information about pixel dimensions and file formats is given, so everything is straightforward. You don't have to use a whole image – areas can be cropped out for more abstract results.

Once the images are uploaded you simply place your order and pay for it by credit card. A few days later, a small plastic box drops through the letterbox containing your minicards and you're ready to start assembling a montage.

If the Moo products don't appeal to you, just do an on-line search for alternative printers of business cards, photo cards and self-adhesive labels.

▼ A set of colourful Moo minicards is what you start out with.

MEASURED DARKNESS

Photographs are created by the action of light on the sensitive silver halides in the surface of film and photographic paper or – as is increasingly the case – on the charged-coupled devices (CCDs) in the sensor of a digital camera.

Usually it takes just a fraction of a second to create that image. Shooting on 1/60sec, 1/125sec or 1/500sec is commonplace and we do it without thought. The only time this changes is when light levels are very low and then we're forced to use exposures of seconds, or even minutes.

A side-effect of using long exposures is that, as well as recording how a scene looks, it also records the passing of time. Long exposures pick up the movement of the clouds, the motion of the sea, the swaying of a tree in the breeze and people or traffic moving through the scene.

We expect these things to happen when we're shooting in low light; they're unavoidable. However, when the same thing happens on pictures taken in the middle of the day they seem at odds with the laws of physics because we expect everything to be sharp and shiny. Consequently, the visual effect is more powerful because it stops us in our tracks and makes us take a second look.

▼ **BLYTH PIER, NORTHUMBERLAND, ENGLAND**
Bold structures such as piers, jetties and slipways make ideal subjects for long exposure images as their solidity contrasts well with the softness of blurred water clouds. So don't be afraid to explore more industrial locations such as ports and busy harbours. This panorama is a single image that I cropped to the letterbox format as I felt it improved the composition.
CAMERA: CANON EOS 1DS MKIII/LENS: 70–200MM ZOOM/85MM/FILTERS: B+W 3.0 ND AND 0.75ND HARD GRAD/EXPOSURE: THREE MINUTES AT F/11

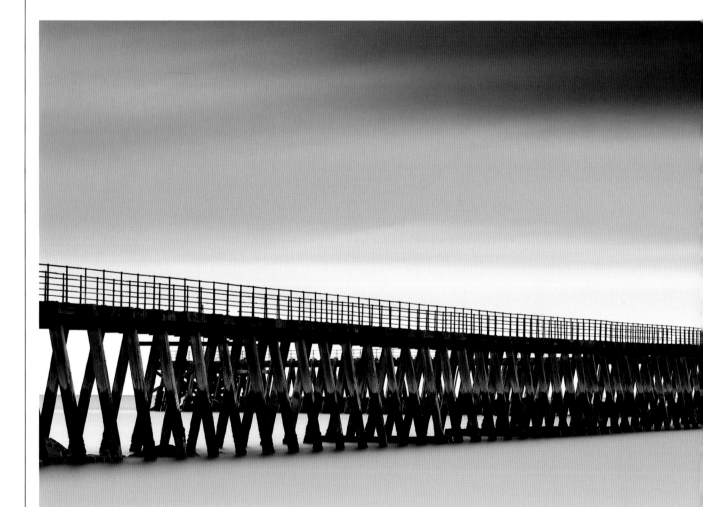

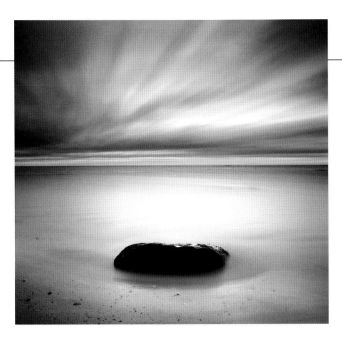

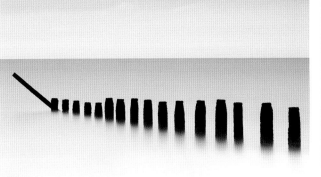

▲ ALNMOUTH BEACH, NORTHUMBERLAND, ENGLAND

I tend to crop my long exposure images to a square format and also convert them to black and white as this enhances the simplicity of the composition and the tranquil mood created by the long exposure itself, which at a soft milkiness to moving water and records clouds as delicated brush strokes across the sky.

CAMERA: CANON EOS 1DS MKIII/LENS: 24-70MM ZOOM/24MM/FILTERS: B+W 3.0 ND AND 0.9ND HARD GRAD/EXPOSURE:TWO MINUTES AT F/11

▲ BLYTH BEACH, NORTHUMBERLAND, ENGLAND

Most of my long exposure images are made on the coast as I find it to be a good source of subject matter, and the sea and sky are constantly-moving elements that I need to record motion. These concrete posts showed promise, but when I arrived at the location they were sitting high and dry so I had to wait patiently for the tide to come in and wash around them.

CAMERA: CANON EOS 1DS MKIII/LENS: 70-200MM ZOOM @ 120MM/FILTERS: B+W 3.0 ND

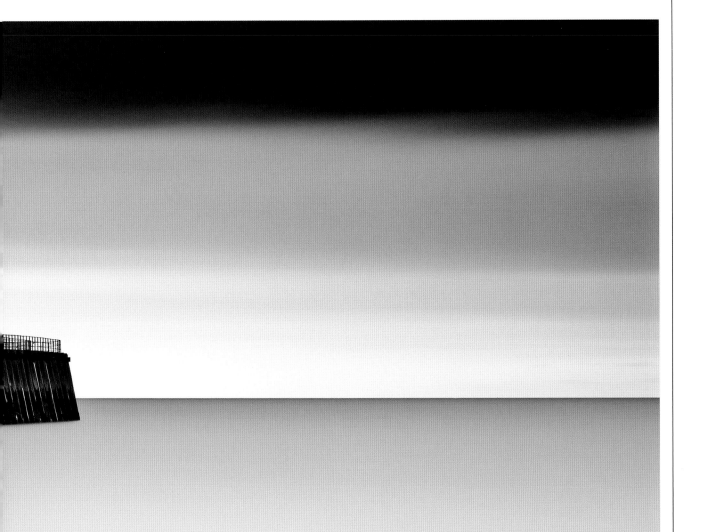

I've been experimenting with this idea recently, using strong neutral density (ND) filters to extend exposures. The majority of ND filters available will only increase the exposure by a few stops, for example, a 0.6ND by two stops and 0.3 by three stops. However, German filter manufacturer B+W goes much further and produces a 1.8ND that forces a six-stop exposure increase and a 3.0ND with a filter factor of 1000x and gives you a 10-stop increase.

To put things into perspective, if the correct exposure without any filters was 1/30sec, with a 3.0ND on your lens it would become 32 seconds, and with extra added to compensate for reciprocity failure, which occurs when shooting at such long exposures, you could find yourself holding the shutter open for close to a minute. That's a huge difference, and allows you to record motion even in bright sunlight.

▲ DERWENTWATER, LAKE DISTRICT
Here is another bad-weather shot that has benefited from the use of a strong ND filter to extend the exposure and record the gentle lapping of the water in the lake as a delicate mist. The original was taken on colour film then scanned and converted to black and white in Photoshop CS3.
CAMERA: MAMIYA 7II/LENS: 80MM/FILTER: B+W 3.0ND/FILM: FUJICHROME VELVIA 50/EXPOSURE: 60 SECONDS AT F/22

 # FILTERS, FACTORS AND EXPOSURE

The chart below gives you an idea of the exposure times you can expect when using different ND filters.

EXPOSURE TIME

No filters	0.6ND	0.9ND	1.2ND	1.8ND	3.0ND
1/500sec	1/125sec	1/60sec	1/30sec	1/8sec	2secs
1/250sec	1/60sec	1/30sec	1/15sec	1/4sec	4secs
1/125sec	1/30sec	1/15sec	1/8sec	1/2sec	8secs
1/60sec	1/15sec	1/8sec	1/4sec	1sec	16secs
1/30sec	1/8sec	1/4sec	1/2sec	2secs	32secs
1/15sec	1/4sec	1/2sec	1sec	4secs	64secs
1/8sec	1/2sec	1sec	2secs	8secs	2mins
1/4sec	1sec	2secs	4secs	16secs	4mins
1/2sec	2secs	4secs	8secs	32secs	8mins
1sec	4secs	8secs	16secs	64secs	16mins

Two or more weaker ND filters can be combined to give you a stronger effect, but unless they're made of high-grade glass or resin, the quality of the image will suffer.

Remember also that once exposures get beyond 10secs there is a serious risk of underexposure due to reciprocity failure. The solution is to increase your calculated exposure to compensate. For example, if it's 10–30secs, increase by 1/2 stop, and beyond 30secs double it.

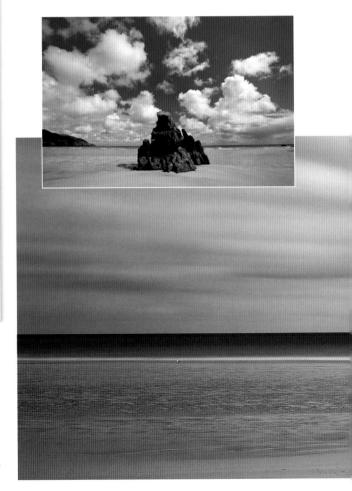

▶▲ TOLSTA, ISLE OF LEWIS, OUTER HEBRIDES, SCOTLAND
These two photographs were taken within a few minutes of each other and show the huge difference a strong ND filter makes to a normal scene. The sky and sea appear almost textureless as a result of the long exposure while the stationary rock stack stands out strongly against it. The warm cast on the long exposure shot is caused by the ND filter, which is more sensitive to light at the red end of the spectrum.
CAMERA: FUJI GX617/LENS: 180MM/FILTERS: B+W 3.0ND /FILM: FUJICHROME VELVIA 50/EXPOSURE: 4 MINUTES AT F/45

▶ **ALNMOUTH BEACH, NORTHUMBERLAND, ENGLAND**
Although I prefer to convert my long exposure shots to black and white, occasionally they work well in colour as well. This partly-submerged treewas photographed on a dull, cloudy day, but the warm cast that my B+W ND filter introduced made it look like it was taken at sunrise, so IO decided to leave it as a colour image.
CAMERA:CANON EOS 1DS MKIII/LENS: 70-200MM ZOOM/120MM/FILTERS: B+W 3.0 ND AND 0.9ND HARD GRAD/EXPOSURE:TWO MINUTES AT F/13

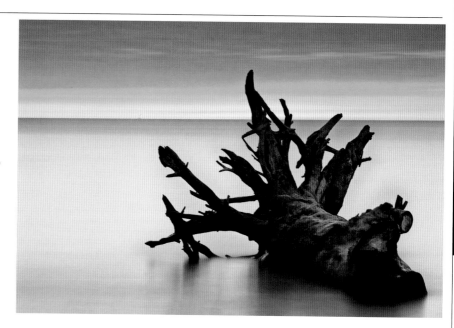

Now you see it, now you don't

The only tricky thing about using such strong ND filters (which are really designed for the observation of industrial processes that involve extreme brightness, such as those to do with steel furnaces, for example) is that they are so dark you can barely see through them. This means that you need to mount your camera on a tripod and compose the shot without the filter in place. You only attach it to the lens when you're ready to shoot.

I have also found that a 10-stop filter tends to confuse my camera's metering system if I try to meter with it on the lens, so I take an exposure reading without the filter in place then apply the filter factor in order to calculate the required exposure. Shooting digitally it's easy because a shot can be taken at the calculated exposure and if it proves to be too long or, more likely, too short, adjustments can be made and the shot taken again. If you're working with colour transparency film and don't have the benefit of instant feedback, bracketing exposures is vital. For example, if the calculated exposure is 30 seconds, I would take one shot at 30 seconds, a second at 45 seconds and a third at 60 seconds, just to be on the safe side.

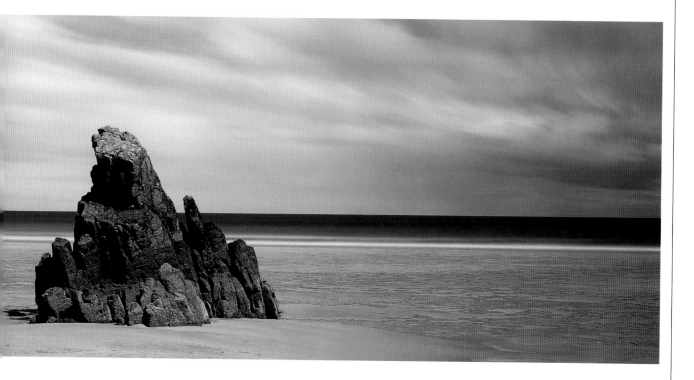

NIGHT MOVES

Many photographers see the setting of the sun as the end of their day's picture-taking. In some cases, however, it can just be the start because once the curtains of night begin to close in, the world is transformed into a dazzling display of colour and light as daylight fades and man-made illumination takes over.

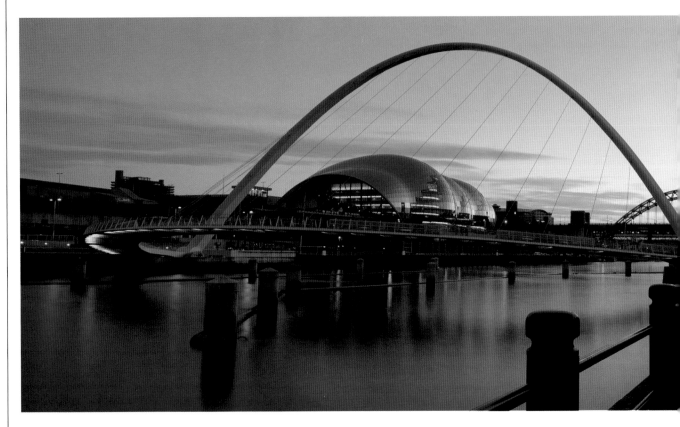

▼ **BIG BEN, LONDON, ENGLAND**
Light trails created by moving traffic add colour and impact to night shots. Here I not only managed to record the trails left at road level by passing cars, but also the higher streaks left by buses which slice through the image, creating strong converging lines that add an extra element to the composition. The shot was taken in winter at 5pm, a safe time to be on the streets and also a busy one on the roads if you want to shoot traffic trails.
CAMERA: NIKON F5/LENS: 20MM/FILM: FUJICHROME VELVIA 50

I cut my photographic teeth shooting night and low-light scenes. From the very beginning I was fascinated by the vibrant colour contrasts created by artificial lighting and how scenes or subjects that wouldn't merit a second glance by day took on a whole new look and feel by night.

Moving to a bustling seaside resort just as my passion for photography took hold undoubtedly helped. The resort was full of neon signs, floodlit buildings and multi-coloured illuminations. Since then, working the late shift has been a natural part of my photographic timetable when exploring towns and cities, no matter how early my day started.

Crossover lighting

The prime time to shoot night scenes isn't really at night at all but during the crossover period between day and night. At this time there's still colour in the sky (and enough light from the sky to show details in the shadows) but it's dark enough for man-made illumination to cast its magic spell. This period lasts longer in summer when you may have upwards of an hour to shoot in clear weather, but in winter it can be as brief as 15 or 20 minutes, especially on a dull, cloudy day.

▼ QUAYSIDE, NEWCASTLE-UPON-TYNE, ENGLAND

▼ QUAYSIDE, NEWCASTLE-UPON-TYNE, ENGLAND
Newcastle is the nearest city to my home and also happens to be a highly
photogenic one – especially the quayside along the River Tyne, home to a
series of magnificent bridges and stunning architecture that come to life every
evening. This panorama was shot in early September at around 7:30pm, when
the quayside was still busy with locals and tourists.
CAMERA: FUJI GX617/LENS: 90MM/FILTERS: 0.3 CENTRE ND AND 0.6ND HARD GRAD/FILM:
FUJICHROME VELVIA 50

▲ CHEFCHAOUEN, MOROCCO
Once all traces of colour in the sky are lost, turn your attention to smaller
details and exclude the sky from the frame. This tree looked rather surreal
against an old mud wall and bathed in orange light so I moved in closer and
concentrated on the interesting shapes.
CAMERA: POLAROID SX70 SONAR AF/LENS: 116MM/FILM: POLAROID TYPE 779

Other than restricting your shooting time, don't be put off by
bad weather. The sky may have been grey all day long, but that
greyness often records as vibrant deep blue when shooting in the
evening afterlight. This is due to long exposures causing reciprocity
failure and the colour temperature in the sky being abnormally
high. I've been in situations where I haven't made a single exposure
all day long because of bad weather, but have managed to get
some fantastic images at night.

Once the sky appears black to the naked eye, there's no point
continuing to shoot wider night scenes where sky appears in the
composition. This is partly because contrast is much higher, with no
light from the sky filling in the shadows, and also because black sky
is visually unappealing. Instead, concentrate on such smaller details
as neon signs, pools of yellow light from streetlamps casting an
eerie glow, shop windows, reflections in puddles and so on.

Steady on

Obviously, you're going to need a sturdy tripod to keep your
camera steady and ideally a remote release to fire the shutter. Don't
assume that hiking up the ISO to 1600 or 3200 will negate the need
for a tripod. Even if it does, digital images will suffer badly from

noise, film will be very grainy and, in both cases, the images you
end up with will be compromised.

One other accessory you will find useful is an ND grad filter. If
you shoot a scene where the foreground is unlit, in order to record
a little detail in it you'll need to use a 0.6 or 0.9 ND grad to cover the
sky and any parts of the scene that are more brightly lit.

Other than that, night photography is no different from daytime
photography. Metering systems in the latest SLRs are more than
capable of coping with the contrast in a typical night scene and
you will probably find that exposures are spot on without the need
to dial in lots of compensation.

If you've never ventured outdoors with a camera at the very end
of the day, now's the time to change all that. I guarantee that once
you do, it will be the first of many journeys into the twilight zone.

ⓘ BE SAFE, NOT SORRY

It's a sad fact of life that our towns and cities are becoming more
unsafe for individuals to wander around at night – especially
carrying expensive camera equipment – so be aware of the risks
and use your common sense.

Ideally, group together with other photographers rather than
going alone. Avoid straying into unlit areas off the beaten track
where you will be less visible and more vulnerable. The safest time
of year to shoot night pictures is when rush hour coincides with
dusk, simply because there will still be lots of people around and
traffic on the streets so you're less likely to be confronted.

OFF THE WALL

Wherever you go in the world, walls serve the same purpose. They support the roof over our head, protect us from the elements and provide shelter and security. Walls are a reassuring and safe protective barrier that we can hide behind and conduct our daily lives in private, away from prying eyes.

Despite this basic function, walls are also infinitely variable. They can be high, low, smooth or rough, thick, thin and every colour conceivable. They can be constructed from brick, stone, glass, metal, concrete, wood and even mud.

Photographically this variety offers enormous creative potential. Whenever I'm in a new location, especially while travelling overseas, I love to spend a few hours wall watching.

This may sound like an odd pastime, but it's amazing how much walls say about the culture, the climate, the people and the economy of a place. Not only that, they have enormous visual appeal. Walls are full of patterns, textures and colours. Painted murals and graffiti offer further potential for interesting images, and you can shoot them on both a large and small scale because the closer you get, the more abstract the pictures become.

▼ ▶ **HAVANA, CUBA**
SCARBOROUGH, ENGLAND
ALNWICK, ENGLAND
WHITLEY BAY, ENGLAND
ISLE OF LEWIS, SCOTLAND
You can see from the locations listed above that these images have been gathered from all over the world, simply because wherever I go with a camera I can't help photographing them. From colourful abstracts and eye-catching details to wonderful textures and regimented patterns, every wall is a work of art once you take the time to look.
CAMERA: HOLGA 120GN, POLAROID SX70, MAMIYA C220, NIKON F5/LENS: 60MM, 116MM, 80MM AND 50MM/FILM: FUJI NPS160, POLAROID TYPE 779, FUJICHROME VELVIA 50

Light and shade

The quality of light plays an important role in determining how walls appear.

On an overcast day, for example, textures are subdued but fine details are clearly defined and colours appear well saturated.

In full sun, walls take on a more abstract quality. White light striking from an acute angle reveals texture and casts shadows from anything mounted on the surface of the wall such as a lamp, window grilles or signs.

In this respect, overhead sunlight can be just as useful as morning or evening light because it glances down onto the vertical face of the wall, casting shadows and highlighting the slightest imperfection in the surface.

Walls also take on a totally different look and feel at night, when they're bathed in the colourful glow of artificial lighting. Sodium vapour creates a deep yellow cast while fluorescent light turns everything a lurid green.

Patterns and texture

Look for interesting patterns in the materials that were used to build the wall, such as the regimentation of brickwork or the contrasts between rusting iron sheeting and rough timber. Observe the faded glory of crumbling stone and peeling paint, or the vibrancy of painted murals.

Windows and doors are of course common features in walls and they can make fascinating subjects in their own right, as demonstrated on page 118. There are infinite designs, styles and colours that vary not only with the location but also the period of

the building. In cities that are visited by large numbers of tourists you will even find posters on sale depicting 'Doors of . . .' Though this may seem rather gimmicky, the images are usually very effective and show that the most familiar features can be a source of great pictures.

Something else you'll find in every town and city is graffiti, from crude slogans daubed with a brush to amazing murals that exhibit great skill and experience. Some see graffiti as a criminal act, others as art, but whatever your view you can't deny its visual impact, nor its photographic appeal.

ON REFLECTION

Reflections are a common phenomenon in the world around us. We use mirrors every day to check our own reflection, or to keep an eye on the road behind us while driving. We marvel at the mirror-image of a beautiful scene reflected in calm water, and stand back to admire the reflections in our car's bodywork after polishing it up to a high shine. Reflections are positive and reassuring because they repeat and multiply, echoing light and colour.

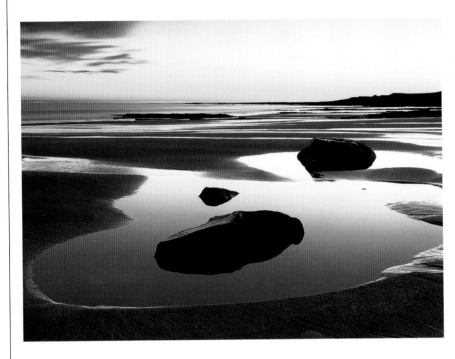

◄ **EMBLETON BAY, NORTHUMBERLAND, ENGLAND**
The creative potential of water and reflections is evident in this abstract dawn shot. There simply wouldn't have been a photograph if you imagine the scene without the rock pool in the foreground. Though the colours appear out of this world, they are totally natural. The only filter I used was an ND grad to retain the orange glow in the sky.
CAMERA: MAMIYA 7II/LENS: 80MM/FILTER: 0.9ND HARD GRAD/FILM: FUJICHROME VELVIA 50

Photographically, reflections have enormous creative potential. In the countryside, reflections in water provide foreground interest and add a sense of tranquillity and balance to a composition. In still weather, scenes are reflected in perfect symmetry while the slightest breeze ruffles the surface of the water to create an ever-changing kaleidoscope of abstract patterns and colours. Rock pools left behind on beaches by the retreating tide reflect the sky overhead and look stunning at dawn or dusk when striking colour contrasts are formed.

Head for the big city and you have more options. Modern architecture reflects clouds drifting across the sky, or mirrors other buildings across the street. Puddles pick up reflections of anything nearby, as do parked cars and shop windows. You could spend the whole day shooting reflections in the urban landscape on both a large and small scale and only ever scratch the surface.

Fill the frame

Reflections are mesmerizing. They allow us to set free our imagination and dream, just like Alice and her Looking Glass. So, instead of making the reflection part of the picture, make it the whole picture. Use your lenses and your feet to close in and fill the frame so all extraneous information is excluded. Forget about reality. Look at the reflection for what it is – an arrangement of

shapes and colour or shapes and tones – and let them take centre stage instead of being a mere prop in a bigger picture. That way the viewer really gets to see the reflection and lose themselves in it.

Leaping back to reality for a moment, there are a few factors to consider when photographing reflections.

One: Always focus on the reflection itself rather than the reflective surface, otherwise you may find that your reflection isn't quite sharp and its impact will be diluted.

Two: The angle you shoot from can make a big difference to how the reflection appears. If you're standing next to a puddle or pool the reflection you see will be totally different if you crouch down. Always experiment with angles before shooting.

Three: If you want to capture clear reflections in water you need calm weather. Early morning is a good bet. Before sunrise the air is often nice and still, but once the sun appears it's surprising how a breeze tends to follow it.

Four: You don't have to shoot reflections in colour. Black and white works just as well and, in some cases, can be more effective because it simplifies the image even further.

Five: Forget about reality. Your aim isn't to capture perfect reflections that mirror the real world but to make the reflection the subject. It doesn't matter if what's being reflected happens to be identifiable or not.

Six: Watch your exposures. Reflections by their very nature are created in surfaces that reflect a lot of light, so your camera's metering system may be fooled into underexposure. If you're shooting film, always bracket over the metered exposure by ½ and 1 stop. If you're shooting digitally, check the histogram and increase the exposure if necessary because slight overexposure is preferable to underexposure.

MAKE YOUR OWN REFLECTIONS

Cross-polarization is a technique that allows you to reveal the colourful reflections in clear plastic and is a great way of creating abstract images. You need two polarizing filters, one placed beneath the plastic you want to shoot and a second on your lens. I use a sheet of polarizing gel to place objects on; it's like a studio lighting gel. If you can't get hold of any, a large polarizing filter will do. Place your gel or polarizer on a slide-viewing lightbox, which acts as the light source. Then place your clear plastic object on too. Things like filter boxes or CD jewel cases work well. Next, focus on the object then slowly rotate the polarizing filter on the front of your lens to reveal the amazing reflections. It's that simple, but as you can see, the results are fantastic.

▶ CROSS-POLARIZATION
This colourful abstract was created by breaking an old plastic CD jewel case with a hammer to create stress patterns in the fragments of plastic, which cross-polarization revealed.
CAMERA: NIKON F90X/LENS: 105MM MACRO/FILTER: POLARIZER/FILM: FUJICHROME VELVIA 50

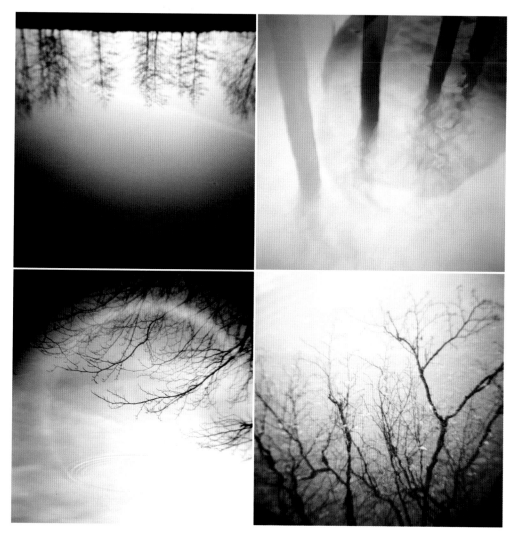

◀ RIVER COQUET, NORTHUMBERLAND, ENGLAND
GRASMERE, LAKE DISTRICT, ENGLAND
VENICE, ITALY
Reflections in water are like visual poetry. They're delicate and dreamy and inspire positive thoughts. These images were all made at different times and in different places but they share the same feel, partly thanks to the natural softness of the lens on my old toy camera, but also because wherever you go in the world, water has the same magical, dream-like qualities.
CAMERA: DIANA F/LENS: FIXED 75MM/FILM: ILFORD XP2 SUPER

PHONE A FRIEND

If any modern gadget symbolizes the way technology has advanced in the last decade or so, it has to be the mobile phone (cellphone). I still remember the days when only the rich and successful could afford one, and they were so big you practically needed a wheelbarrow to transport them. Today, they're small, light, cheap to own, and so, far from being an expensive luxury, they're now considered to be an essential accessory. Almost everyone owns one – even my 11-year-old son.

Of course, they are no longer just phones. They're multi-media consoles that allow you to listen to music, surf the net, send and receive e-mails, find your way from A to B and, you've guessed it, take pictures.

Their photographic potential is phenomenal when you think about it. It's not that long ago that everyone was raving about 1MP digital cameras costing more than £1000 ($1750.00). Now you can pick them up as free upgrades on your contract with a phone boasting 5MP or more.

Okay, the sensors in phone cameras are very small, so a 5MP digital compact or SLR will outshine a 5MP phone camera in every way. But as a visual diary for photo blogs (see page 122) or simply for taking snapshots when you're out and about, a decent phone camera is a very good choice.

In the field
To prove this, I decided to make the effort to take pictures using a mobile phone. I tried my own phone, but after a year of being

bashed and dropped its 2MP camera has been rendered pretty useless. Every picture I took suffered from ugly colour banding and image quality was poor. I then tried my son's phone. Not only was it a more recent model but also much less used and in better condition. The differences in the results were astonishing. They were clean, crisp, sharp and colourful, just like proper photographs taken with a proper camera.

Obviously, big enlargements from an image taken on a mobile phone are out of the question. Converting the 72dpi Jpegs captured by the camera into 300dpi Tiffs gave me images with an output size around 15 x 10 cm (6 x 4in). But actually, the kind of photographs you're going to take with a phone camera are more likely to be used, viewed and shared electronically by text, e-mail, uploading to websites and so on, rather than printed. So, output size isn't that important.

The key to making the most of your phone camera is accepting its limitations and working within them. Other than the ability to make an image lighter or darker by increasing or reducing the exposure, controls are minimal. It's a case of pointing and shooting.

But as I've proved with cameras such as the Holga (see page 142), this simplicity needn't get in the way of creativity. In fact, it can encourage rather than hamper it.

Taking photographs with the phone had an ever-present element of unpredictability and surprise, which added to the experience. If a shot worked, it worked. If it didn't, it didn't. It also felt rather weird using a phone to take 'serious' photographs, but it was also quite liberating at the same time.

The most frequent mistake that I made was trying to get too close to the subject. With no viewfinder to rely on, and no facility to prevent the camera's shutter firing even if the subject wasn't sharply focused, I got rather carried away, only to discover that lots of the images that I thought would work really well were actually out of focus.

Fortunately, enough of the images were successful, and they convinced me that there definitely is a place in my photographic life for a phone camera. All I have to do now is wait another nine months so I'm eligible for a free phone upgrade. But, who knows? By then the resolution may have reached 10MP.

◄▲ ALNMOUTH, NORTHUMBERLAND, ENGLAND
If I hadn't told you that these images were all made with a modest mobile phone (cellphone) camera, would you have guessed? Probably not.
A phone camera will never be a viable replacement for a digital compact or SLR if you're a serious photographer, but when used on the right subject the results are surprisingly good. If I ever found myself in a situation where the only means of taking a photograph was by reaching for my phone, I'd do it without hesitation.
CAMERA: SONY ERICSSON W880 2MP

POCKET POWER

Compact cameras are often seen as second rate compared to the more sophisticated single lens reflex (SLR) cameras. In a sense they are. SLRs have more features, usually offer greater control, can be fitted with a wide range of interchangeable lenses and, in most cases, offer superior image quality. But one thing compact cameras have going for them that SLRs don't is their small size.

Although there are exceptions, the vast majority of compact cameras are small enough to slip into a pocket and carry everywhere. That means wherever you go, you will always have a camera to hand to grab those fleeting photo opportunities that would otherwise be missed. Compact cameras also make great visual notebooks. You can use one to take shots for future reference, such as reminders of good locations, for example, or an idea for an image or project that suddenly comes to mind.

I admit that I always used to turn my nose up at the idea of a compact camera. Why bother with one when an SLR will produce superior results? Then 18 months ago I invested in a Sony Cybershot and my perceptions changed forever.

Small but perfectly formed

It was purchased primarily so that everyone in my family could take snapshots on holidays, special occasions and Sunday strolls. However, I soon realized that my new toy had much more to offer, and the more I used it, the more impressed I became with the results it was capable of producing.

With only six mega-pixels crammed into a tiny sensor, it will never be good for poster-sized prints. But how often do you print anything that big? Even when my images are published in books and magazines the majority are much smaller than full page.

To put this to the test, I started using the camera as a serious tool, taking it away on shoots and using it alongside my other equipment to see how it compared. Or I just took the compact out to see what I could produce with it. I even organized a workshop for a magazine to which I contribute where the readers involved were only allowed to use a digital compact camera. We were all operating well outside our comfort zones, without tripods, filters or any of the other paraphernalia we're used to. However, we spent an enjoyable afternoon snapping away, and the results surprised everyone.

What I found is that freed from the constraints imposed by bigger, heavier and slower equipment I was much more open-minded about what I shot. If I tried something and it didn't work out, the image could be erased forever and I would move on to the next idea. I also felt less self-conscious when I was taking pictures around other people because the general perception is that compacts are for snaps and serious photographers use fancy SLRs with big lenses.

One one occasion I photographed a sign outside a large furniture store. There's no way I would have done that with a tripod and SLR in the full glare of the public and passing traffic, but with a compact I could be much more discreet and no one seemed to take any notice whatsoever.

ℹ DIGITAL COMPACTS

There are dozens of digital compact cameras available, with prices to suit all budgets and specifications to suit all needs. What they all have in common, though, is the ability to produce top-class results. Digital technology is now so good that there is no such thing as a poor-quality camera. Even budget-priced models offer 4MP or more, which is enough to make 25.5 x20cm (10 x 8in) prints, while the latest launches boast up to 14MP and quality to match some digital SLRs.

Alternatively, if you want to ring the changes, why not go analogue and experiment with a film compact? My favourite is the legendary Lomo LC-A – turn to pages 66–69 to see what it's capable of.

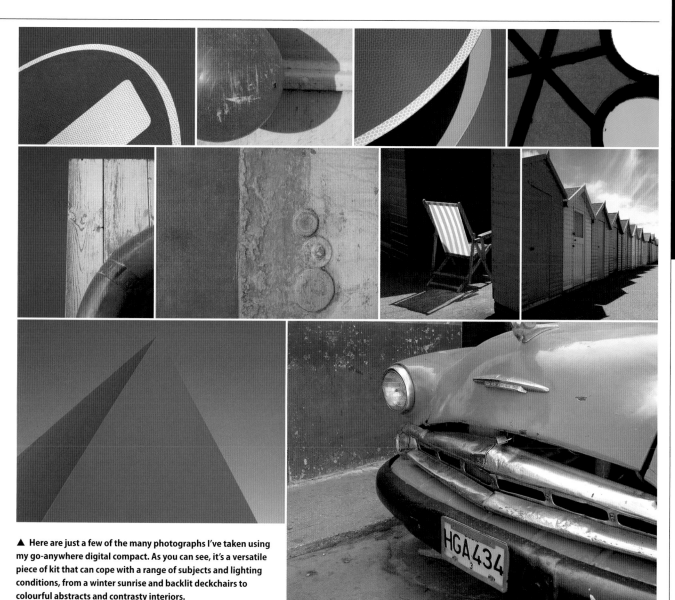

▲ Here are just a few of the many photographs I've taken using my go-anywhere digital compact. As you can see, it's a versatile piece of kit that can cope with a range of subjects and lighting conditions, from a winter sunrise and backlit deckchairs to colourful abstracts and contrasty interiors.
CAMERA: SONY CYBERSHOT 6MP/LENS: FIXED 6.3-18.9MM ZOOM

Go with the flow

The key when shooting with a compact is to work with the limitations imposed by the camera rather than fighting against them. You don't get ultra-wide or super-telephoto lenses on compact cameras, so steer clear of subjects that require them. You have no control over depth-of-field, so don't bother trying to get everything sharp from a few centimetres to infinity. If the exposure and metering are fully automatic, don't shoot in really tricky light, or if you do, accept that the camera may struggle.

Digital compacts are actually surprisingly good when it comes to getting the exposure right and coping with high contrast. A growing number of models also give you the option to shoot in RAW capture mode, which means you can adjust exposure, contrast, colour and more when the files are downloaded to a computer and processed.

Using filters is possible but fiddly. A polarizer can be rotated into prime position then held in front of the lens while a picture is taken, and securing grad filters with small blobs of putty adhesive isn't out of the question. But to be honest, I never bother. Instead, I concentrate on subjects and scenes where filters are unnecessary, such as abstracts, patterns, textures and details. I'm not interested in producing images with a compact that I would normally shoot with a digital SLR or medium-format film camera. I want to look at the world through different eyes and, hopefully, come up with images that are fresh, spontaneous and exciting.

If you need to put any of those things back into your own photography, you could do a lot worse than downsize and get creative with a compact.

PIN SHARP

Like the vast majority of photographers, I tend to take modern technology for granted. I've grown accustomed to cameras that boast sophisticated integral metering, numerous exposure modes, lightning-fast focusing and, more recently, a digital sensor with phenomenal resolving power.

But what was it like for the early pioneers of photography? They had none of these things yet still managed to create beautiful images. Eventually, my curiosity got the better of me and I decided to find out by taking a step back in time and working with a pinhole camera, the simplest picture-taking tool there is.

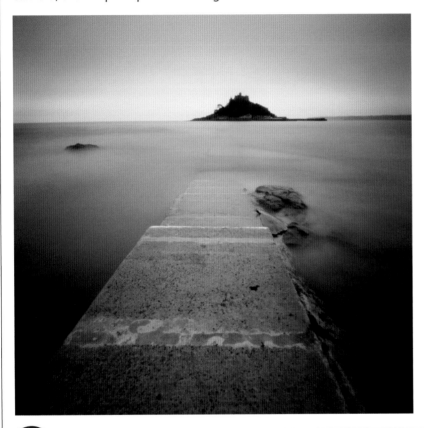

◀ **ST MICHAEL'S MOUNT, CORNWALL, ENGLAND**
This photograph was taken at dawn on a very dull, cloudy day. Light levels were low, which meant using a long exposure. Consequently, motion in both the drifting cloud and incoming tide has been recorded and adds atmosphere, while the concrete jetty leads the eye through the scene to St Michael's Mount in the distance. The deep blue cast is a result of the dull weather and reciprocity failure brought on by the long exposure.
CAMERA: ZERO 2000/FOCAL LENGTH: 25MM/FILM: KODAK PORTRA 160 VC

ⓘ DO IT YOURSELF

My pinhole adventure began in the summer of 2006 when I joined forces with my two young children and spent an enjoyable afternoon painting the inside of two old plywood boxes with matt black paint, fashioning pinholes from pieces of aluminium drinks cans and exposing sheets of outdated Ilford Multigrade photographic paper.

The cameras worked surprisingly well, and after we developed the exposed sheets of photographic paper in the darkroom to produce paper negatives, I scanned them (new technology does have its benefits!) to create positive black and white images.

Not surprisingly, the kids' interest faded after a couple of days. But mine didn't; I was hooked, and had soon become the proud owner of not one but two purpose-made pinhole cameras from the Zero Image range (see panel, page 90).

▶ Here's one of the first paper negatives produced by our DIY pinhole camera – and the print that resulted when I scanned the image and inverted it.

▲ BLYTH PIER, NORTHUMBERLAND, ENGLAND
I also use a 5 x 4in pinhole camera, mainly so I can work with Polaroid Type 55 pos/neg film (see page 53). As it is an instant peel-apart film I get to see the results immediately, though my main reason for using this film is its wonderful image quality and the distinctive border around the edge of the negative.
CAMERA: ZERO 2000/FOCAL LENGTH: 25MM/FILM: ILFORD XP2 SUPER

Pinhole cameras represent picture-taking in its most primitive form. You can't find a more basic way of taking a photograph than using a light-tight box with a tiny hole in the front that projects an upside-down image onto a sheet of silver-coated material placed inside it. It's where this magical art form of photography began, in the 19th century, and taking a look back at its origins is fascinating, inspiring and humbling.

Technology has come a long way since then, but you can still create wonderful images that have character, soul and individuality without relying on any of it. More importantly, the lessons learned from working with absolutely basic tools are bound to benefit your photography in general.

Point and shoot

The mechanics of using a pinhole camera are fundamentally the same as using any film camera, though its simplicity does impose certain limitations on how an image is made, and will stamp certain characteristics on that image.

For a start, there is no viewfinder to assist you in composing a photograph. You could make a compositional aid by using some black card or plastic that's held in front of your eye to give you an idea of the camera's field of view. However, I prefer to simply point and shoot.

It's surprising how accurately you can compose an image without the aid of a viewfinder, once you've had a little practice. And it's refreshing to work in such a simple way. As for wonky horizons, well, a small level placed on top of the camera easily solves that problem.

The pinhole acts as both lens and aperture and, because it must also be as small as possible to ensure the final image is relatively sharp, long exposure times of anything from 1/2sec in bright sunlight to several minutes at dawn and dusk on medium-speed film are unavoidable. This makes a tripod essential to keep the camera steady (a good thing because it aids accurate composition) and also means that any motion during exposure will record as a blur.

This is one of the main features of a pinhole image, and the one I like most. It's best revealed in seascapes, where long exposures allow the ebbing and flowing of the waves and the drifting of the

clouds to record as gentle mist. Urban scenes also work well with people and traffic crossing through the scene during exposure.

Calculating exposure is easier than you'd imagine. If you know the f/number of your pinhole (it's f/138 on my Zero 2000 camera) you can take an exposure reading with a camera or hand-held meter then double the exposure time for each f/stop reduction. For example, if the metered exposure is 1/2sec at f/22 it will be 1sec at f/32, 2sec at f/45, 4 sec at f/64, 8 sec at f/90 and 16sec at f/128, which is close enough to f/138 in my case.

Once exposures get beyond a few seconds, reciprocity failure kicks in and can cause underexposure. I don't worry about it if the calculated exposure is fewer than 30 seconds because the exposure latitude of colour negative film, which I choose over colour slide film for pinhole work, takes care of it.

Once the calculated exposure is beyond 30 seconds I do increase it by 50 per cent for exposures of 30–60 seconds and 100 per cent for exposures of over 60 seconds. You don't have to be accurate to the second here, so I either count elephants in my head or, for really long exposures, I use my wristwatch to keep track.

Where pinhole photography gets tricky is in bright sunlight when the calculated exposure is only 1/4 or 1/2sec. This is because if you have to open then close the shutter quickly there's a risk of jerking the camera and producing a shaky image. To avoid that, I use either a polarizing filter or a neutral density filter to increase the exposure, so 1/2sec becomes 2sec with a polarizer or 0.6ND filter, which is easier to execute. The filter itself is simply secured with blobs of adhesive putty in front of the camera. Crude but effective.

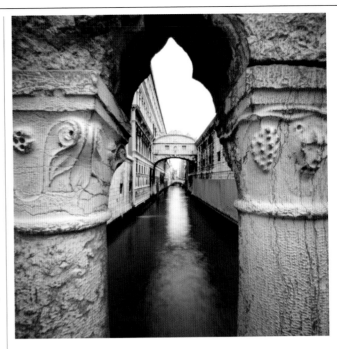

▲ **BRIDGE OF SIGHS, VENICE, ITALY**
For this view of the much-photographed Bridge of Sighs, I placed the camera just 7.5–10cm (3–4in) from the carved stone pillars so the bridge would be visible through the narrow gap. Endless depth-of-field and an ultra wide-angle view made this possible. Such an image could not be achieved with a normal camera.
CAMERA: ZERO 2000/FOCAL LENGTH: 25MM/FILM: ILFORD XP2 SUPER

ⓘ PINHOLE CAMERA OPTIONS

I use pinhole cameras made by Zero Image in Hong Kong. They're the Leica of the pinhole world, offering a range of cameras in formats from 35mm to 5 x 4in. All are beautifully crafted from teak and brass. Each camera has its own serial number etched on a brass plate and comes with a signed certificate of authenticity.

The Zero 135 is the smallest and produces both 23 x 35mm and 23 x 45mm panoramic images on 35mm film. My Zero 2000 takes 120 rollfilm and produces 12 6 x 6cm images per roll. The Zero 6x9 Multi-Format model also takes 120 film but gives you the choice of four image formats – 6 x 4.5cm, 6 x 6cm, 6 x 7cm and 6 x 9cm. For those of you who fancy shooting pinhole panoramas there's even the Zero 612 that creates 6 x 12cm images on 120 film.

I also use a Zero 45, which is a modular 5 x 4in model that accepts cut film holders, Fuji Quickload and Kodak Readyload backs and Polaroid 545i backs, all of which are attached by means of rubber bands. You can also attach a 6 x 12cm rollfilm back to shoot panoramas on 120 film.

For more information visit www.zeroimage.com, and to see examples of pinhole photography check these websites:
- http://www.pinholeday.org
- http://www.pinhole.com/
- http://www.pinholeresource.com
- http://www.f295.org

▶ This is the Zero Image 2000 camera that was used to make most of the photographs in this chapter.

Here to infinity

As well as long exposures, pinhole cameras also give you an ultra-wide angle of view and endless depth-of-field, two factors that can be put to great use.

The focal length of my Zero 2000 camera is 25mm, which on 6 x 6cm format roughly equates to around 16mm. Such an extreme angle of view can easily result in empty compositions. Fortunately, because the effective aperture is so small, depth-of-field extends from just a few centimetres to infinity. This means that empty compositions can be avoided by getting in really close to nearby features so they dominate the foreground and create a dramatic sense of perspective and scale. Converging lines in a scene created by paths, railing, jetties and piers can be especially effective and can also be exploited.

Using a pinhole camera for the first time is a weird experience simply because it's so unlike any other type of camera you'll ever encounter. The lack of a viewfinder is particularly disconcerting because with no way of setting up the shot accurately you've got no idea how it's going to turn out. But just following your instincts and hoping for the best is all part of the fun.

One thing's for sure; the results are rarely a disappointment. Although I've finally taken the plunge and invested in a digital SLR system, my Zero Image pinhole camera still has a permanent space in my backpack because, despite all the benefits modern technology has to offer, it's refreshing to turn your back on it once in a while and go back to basics.

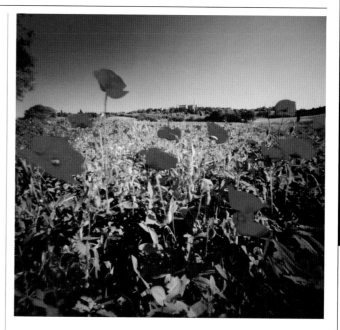

▲ **PIENZA, TUSCANY, ITALY**
The lack of a viewfinder needn't be an obstacle when using a pinhole camera. Just follow your instincts and see what happens. The results are never quite what you expect.
CAMERA: ZERO 2000/FOCAL LENGTH: 25MM/FILM: KODAK PORTRA 160 VC

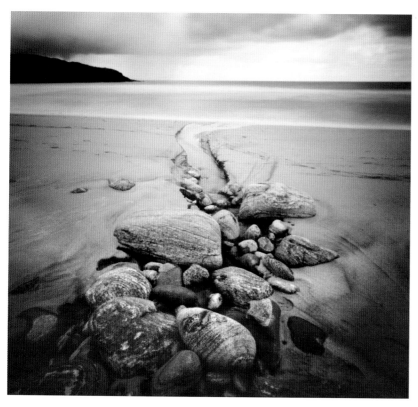

▲ **ISLE OF LEWIS, OUTER HEBRIDES, SCOTLAND**
Because the angle of view of most pinhole cameras is very wide, you must include foreground interest otherwise the composition will appear empty and boring.
CAMERA: ZERO 2000/FOCAL LENGTH: 25MM/FILM: KODAK PORTRA 160 VC

▲ **GLENCOE, HIGHLANDS, SCOTLAND**
The lake in the foreground of this scene was nothing more than a small puddle, but I set up the camera so it was only centimetres above the water. The extreme angle of view of the pinhole stretched perspective to make it seem huge.
CAMERA: ZERO 2000/FOCAL LENGTH: 25MM/FILM: ILFORD XP2 SUPER

PUBLISH OR BE DAMNED

There can be few things more exciting to a photographer than seeing their work in print.
It's the ultimate confirmation of success. I'll never forget the first time I had my own images
published in a photographic magazine in the mid-1980s. It was such an exciting, pivotal
moment in my life. Since then I've had thousands of photographs published and written
hundreds of magazine articles and 16 books on photography, but I still get the same buzz
when I open a publication and see my work on the printed page.

When I first became interested in photography, publishing books
was the preserve of a tiny minority who either had the financial
backing of a publisher or were wealthy enough to fund their own
expensive self-publishing projects. I was lucky and got the former,
though still can't afford the latter!

Today, however, thanks to advances in digital technology and
the rise of Print on Demand (POD) services, you don't need either.
Anyone can publish a book of their work for minimal, in some
cases zero, outlay.

The way printing used to work, it was only financially viable to
publish a book if you printed a large volume, meaning thousands,
of copies. Printing plates had to be created for each page of the
book and the printing press set up for each job, which is a time-
consuming and costly exercise. But with digital printing machines
no setting up is required. Pages are printed from digital files,
making small-run printing possible.

Print on Demand, as the name implies, involves printing
something only when an order is received – even just one copy

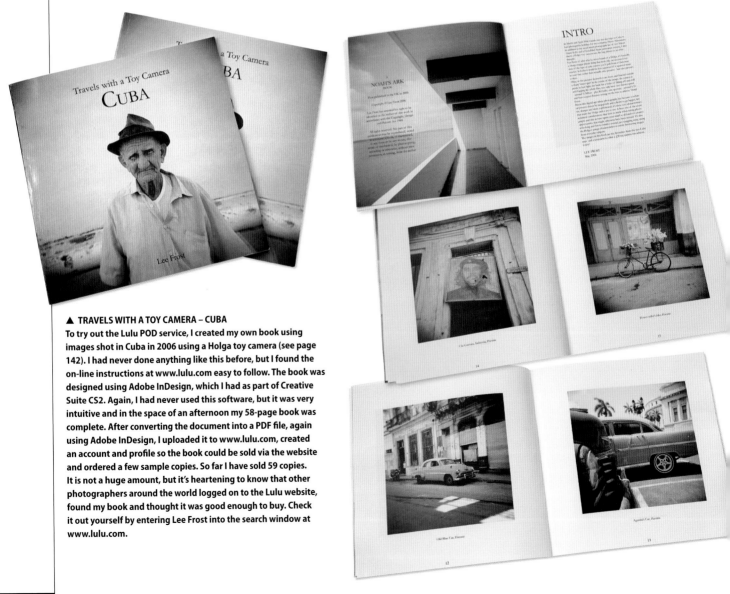

▲ TRAVELS WITH A TOY CAMERA – CUBA
**To try out the Lulu POD service, I created my own book using
images shot in Cuba in 2006 using a Holga toy camera (see page
142). I had never done anything like this before, but I found the
on-line instructions at www.lulu.com easy to follow. The book was
designed using Adobe InDesign, which I had as part of Creative
Suite CS2. Again, I had never used this software, but it was very
intuitive and in the space of an afternoon my 58-page book was
complete. After converting the document into a PDF file, again
using Adobe InDesign, I uploaded it to www.lulu.com, created
an account and profile so the book could be sold via the website
and ordered a few sample copies. So far I have sold 59 copies.
It is not a huge amount, but it's heartening to know that other
photographers around the world logged on to the Lulu website,
found my book and thought it was good enough to buy. Check
it out yourself by entering Lee Frost into the search window at
www.lulu.com.**

at a time if necessary. So, you could design a book of your work (or pay someone to do that job for you), have a few sample copies printed for promotional purposes, and then only reprint when copies have been ordered and paid for. To make life even easier, there are now a growing number of POD publishers around that not only print the books as and when required, but will also market and sell it on your behalf, paying you a royalty on each copy sold.

The best-known POD publisher is Lulu (www.lulu.com). To produce a book with Lulu, the first step is to create an online account, choose a book format from one of the options available and decide how many pages you want. Then you can use a cost calculator on the website to establish how much it will cost to produce each copy.

Lulu doesn't offer a design service or design software, but you can use any proprietary design software, such as QuarkXpress or Adobe InDesign. You just need to be able to convert the finished layouts into a print-ready PDF file, which can then be uploaded to the lulu.com website ready for printing. All this is completely free of charge. You only pay when you place an order for copies of the book, though you're under no obligation to do so.

The smart thing about Lulu is that as well as printing your books it will also sell them via the lulu.com website. You can specify the retail price of the book so that you make a profit on each sale. Orders are placed directly with Lulu, copies are printed and shipped by them (you don't have to do anything) then every few months royalties are paid to you on any sales achieved.

You're not going to get rich by publishing books via lulu.com, but it's a fantastic concept and well worth trying out if you want to see your work in print.

▲ This is the profile page for my Cuba book on the Lulu website. When you enter information about a book, keywords can be used to increase the chance of it coming up in a search and thereby maximizing sales.

▲ A preview of the book can also be created, allowing potential buyers to sample a few pages before they decide to place an order.

PHOTOBOOKS

A more straightforward way to turn your favourite images into a high-quality book is by using one of the many photobook services available. This usually involves downloading simple design software from the printer's website, dragging and dropping images of your choice into pre-designed page templates, and then uploading the completed layouts so they can be printed and bound.

Quality and flexibility do vary. At the cheaper end of the scale you won't have many design options and print quality may not be great. At the more expensive end the finished product will look like a proper commercially produced hardback book.

The only downside to photobooks is that the cost per copy is high, so they're not a viable option if you plan to sell copies and make a profit. As a way of presenting your work, however, they're perfect. Imagine being able to hand family and friends a copy of your very own coffee-table book. They also make wonderful gifts, for example, to document the first year of a baby's life, a wedding or any landmark occasion.

Here are some of the most popular photobook publishers:
Bob Books – www.bobbooks.co.uk
Yophoto – www.yophoto.co.uk
Photobox – www.photobox.co.uk
Snapfish – www.snapfish.co.uk
Album Factory – www.albumfactory.co.uk
Blurb – www.blurb.com

RED ALERT

Light is the raw ingredient of photography. Without it, the art of image-making wouldn't exist, and we'd keep bumping into things.

But the light we actually work with covers a very limited range because so-called normal photographic films – and most digital camera sensors – are only designed to record light in the visible spectrum. Beyond it, there's a vast, invisible world that we will never be able to see with the naked eye.

Look at a diagram representing the electromagnetic scale. It starts off purple (ultraviolet) at one end, gradually warms to form the visible spectrum, the bit we can see (think rainbow) before turning red and then infrared.

Photographically, it's possible to record the effects of infrared light using infrared-sensitive films such as Kodak HIE and Ilford SFX. Over the years I have exposed dozens, if not hundreds, of rolls of these films and, when handled properly, they can produce utterly amazing images.

That said, infrared film is tricky to work with. It's prone to fogging by visible light. The effective ISO varies depending on the light and weather conditions you use it in, so exposure bracketing is essential. You must shoot through a deep red or opaque infrared-transmitting filter, and the negatives require very careful printing to get the best from them. I should know – I've spent many a night locked away in my darkroom trying to tease successful images

from dense infrared negatives. I also know that the complications of using and printing infrared film have been enough to put many photographers off ever bothering to try.

Fortunately, it's now possible to record infrared light digitally using a modified digital SLR or compact camera and to produce stunning images in a matter of minutes. So if you've ever been discouraged from exploring the fascinating world of infrared photography in the past because it seemed too much like hard work, now's your chance to change all that.

▼ VITALETA, TUSCANY, ITALY
This image is a good example of what you can expect from an infrared-modified camera. The IR sensitivity has really brought out the drama in the evening sky, while the field of dry grass in the foreground has recorded in its characteristically light tone. Stunning.
CAMERA: NIKON D70 IR CONVERSION/LENS: 10-20MM/ISO:200

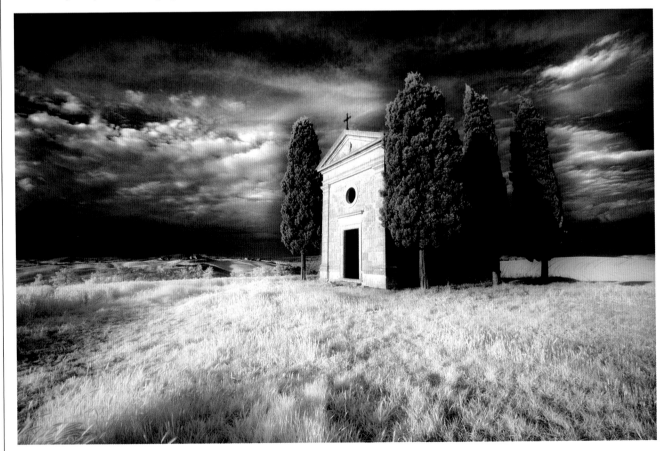

◄ ALNMOUTH, NORTHUMBERLAND, ENGLAND
Adding Diffuse Glow to a duplicate layer really heightens the infrared effect by enhancing the highlights. It's a technique I now use on all my infrared images in varying degrees.
CAMERA: NIKON D70
IR CONVERSION/LENS: 20MM/ISO:200

ℹ HOW IT ALL WORKS

Digital cameras normally have an infrared (IR) cut-off filter placed over the sensor. This blocks infrared light but admits visible light so that normal colour images can be recorded.

To make the camera sensitive mainly to red and infrared light, remove the IR cut-off filter and replace it with a new filter that does the opposite (i.e. blocks out visible light and admits mainly infrared light). This is a specialist job. It can be done at home if you're technically minded, but is best left to the experts if you're not.

In the UK there is currently one company offering an infrared conversion service – Advanced Camera Services (www.advancedcameraservices.co.uk). In the USA, Life Pixel is a popular choice (www.lifepixel.com) and as well as converting cameras, also sells the parts so you can convert your own. Excellent online instructions are provided to guide you through the process. Also check out Max Max (www.maxmax.com).

If you use your infrared modified camera straight out of the box, chances are the images will appear bright red. This is because the camera doesn't know it has been converted, and just thinks it's taking a normal colour picture. However, because the red pixels in the sensor are the most receptive to infrared light, the picture ends up red.

To get rid of this you need to create a custom white balance. (Refer to your camera's instruction book to find out how.) I created a custom white balance by photographing a patch of green lawn in my garden, though some photographers prefer to use a white card or even a blue card. You could try them all and see which works best. Each model of digital camera tends to produce different infrared results, so what works for a Nikon D70 may not be quite so effective with a Canon EOS 10D.

By creating a custom white balance setting, the images you record will go from being bright red to mainly monochromatic, though the sensor will still record some colour, known as false colour. It's up to you whether you retain it or not (see page 97).

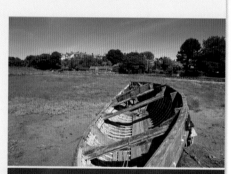

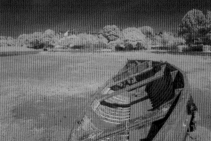

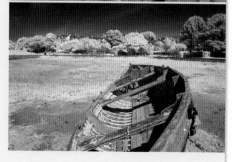

▶ This set of images shows, from the top: the scene as it appeared to the naked eye; the same scene shot with an infrared-modified camera set to auto white balance (AWB) and again with the same infrared camera but using a custom white balance taken from green grass.
CAMERA: CANON EOS 1DS MKIII AND INFRARED-MODIFIED CANON 20D/LENS: 24-70MM ON 1DS, 16-35MM ON 20D

Seeing red

I had my first digital SLR modified to record infrared light back in April 2008, and from the very first outing with it I was hooked.

Compared to shooting infrared film, digital infrared photography is simplicity itself. The results are as good as film images – in fact, better in many respects – but much easier and quicker to achieve. It would have taken me hours on end to print just a handful of infrared negatives, whereas now I can download and process dozens of digital infrared images in the same amount of time.

Modern modifications (see panel opposite) are done in such a way that you don't need to bother putting a deep red or infrared-transmitting filters on the lens, as was necessary when working with infrared film. Nor do you need to worry about the fact that infrared light focuses on a different point to visible light and adjust focus accordingly because the camera's focusing system is adjusted internally to compensate.

In practice, what this means is that you can use an infrared-modified digital camera like any digital camera. Even the exposures are hardly different. The difference is in the images that result: they're worlds apart.

In the infrared spectrum, the way things appear depends on the amount of infrared radiation they reflect. Water and blue sky record as very dark tones (often black) because little IR radiation is reflected, whereas foliage and grass reflects a lot of infrared light so it records as a very pale, almost white tone. Similarly, if you shoot portraits with an infrared camera, skin tones record as a pale, ghost-like tone while the eyes appear dark – a spooky combination that can work well.

Use an infrared-modified camera for interior shots, as I have done, and often it's hard to see any trace of an infrared effect. Similarly, if you shoot outdoors in bad weather and exclude anything from the composition that would normally show the infrared effect, such as foliage, the images will appear just like dramatic black and white photographs.

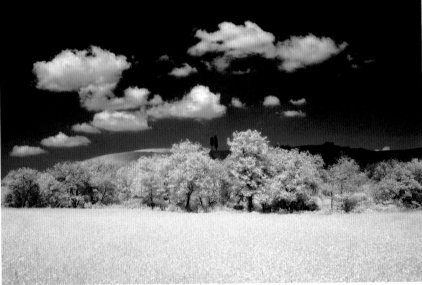

▼ **NEAR SAN QUIRICO D'ORCIA, TUSCANY, ITALY**
Bright sunlight, blue sky and fluffy white clouds are the ideal ingredients for infrared photography. In this scene I particularly like the way the two cypress trees on the hill have recorded as silhouettes because a cloud momentarily blocked the sun from view, throwing them into shadow.
CAMERA: NIKON D70 IR CONVERSION/LENS: 10-20MM ZOOM/ISO:200

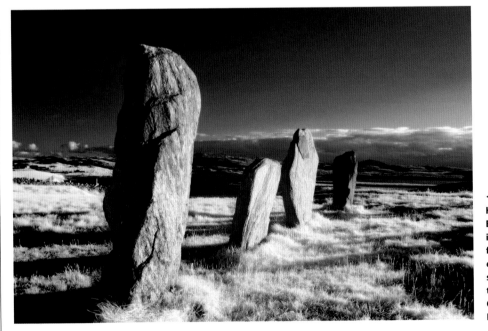

◄ **CALLANISH, ISLE OF LEWIS, OUTER HEBRIDES, SCOTLAND**
Even though you can produce great infrared images at any time of day, my favourite periods are early morning and evening when the sun is low in the sky, shadows are long and light sweeps across the landscape.
CAMERA: CANON 20D IR CONVERSION/ LENS: 16-35MM ZOOM/ISO:100

STEP BY STEP

Here's a step-by-step guide to show you how I get from the original RAW file captured by the camera to the final image. RAW files are processed in Adobe Camera Raw (ACR), which is part of Photoshop CS3.

Even though I've achieved excellent results by shooting with the camera set to Jpeg mode rather than raw, I recommend the latter because it gives you much more control once you start to work on the image. There's also less chance of digital noise if you shoot in RAW, and image quality will be optimized.

Step 1 Open the RAW file in Adobe Camera Raw. As you can see, it's a little on the light side because I exposed to the right to minimize noise in the shadows.

Step 2 First move the exposure slide to the left to darken the image and achieve the density that is needed.

Step 3 Next turn to Contrast, making the highlights and lighter tones lighter and the mid-tones darker to boost contrast and create more of an infrared effect.

Step 4 Remove the false colour by desaturating the image. You can do this just by pulling the Saturation slider all the way to the left.

Step 5 Open the image and save it as a 16-bit Tiff file to retain maximum detail and tonality.

Step 6 In Photoshop, make selective adjustments to Levels. First, select areas of the foreground and lighten then.

Step 7 Next, select the sky using the Polygonal Lasso tool and a feathering of 100 pixels and darken it by adjusting Levels for the shadows. You could do the same thing using Curves.

Step 8 I'm happy with the general look of the image so I make a duplicate layer and name it Diffuse Glow.

Step 9 I use Filter>Distort>Diffuse Glow to apply Diffuse Glow to the duplicate layer. This adds a delicate glow mainly to the highlights of the image.

Step 10 The Diffuse Glow overpowers the image so I reduce the opacity of the adjustment layer until the desired effect is achieved.

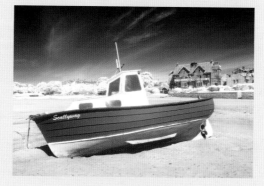

◀ **SCALLYWAG, ALNMOUTH, NORTHUMBERLAND, ENGLAND**
And here's the final image. The sky is nice and dark, the foliage is almost white and the addition of a little Diffuse Glow rounds off the infrared effect nicely. I'm happy with that, and it took no more than ten minutes to complete.

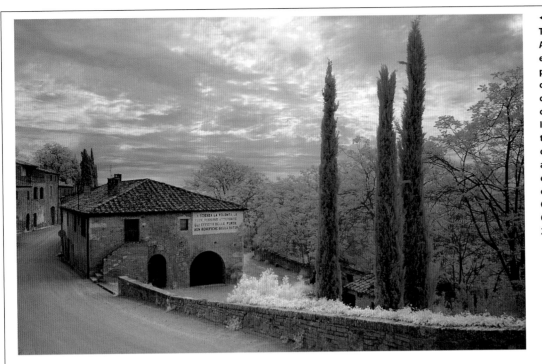

◄ LUCIGANO D'ASSO, TUSCANY, ITALY
An interesting side-effect of digital infrared photography is the way cameras record false colour. In 99 per cent of cases it looks odd and I desaturate the image to get rid of it, but occasionally I take a picture and the false colour really enhances it, as in this shot of an old Tuscan village.
CAMERA: NIKON D70 IR CONVERSION/LENS: 10-20MM ZOOM/ISO:200

Suitable subject

In terms of subject matter, anything goes, really. Whenever I'm out shooting I carry my infrared-modified Canon 20D with me and if I see anything that might make an interesting infrared image then I'll photograph it. Because the camera can be used hand-held, it's quick and easy to fire off a few frames. And if they don't work, I have lost nothing.

Landscapes are an obvious choice because any scene containing foliage and plant life will exhibit strong infrared characteristics.

Woodland is another contender, especially in spring when lush, green foliage records like delicate white snowflakes. I also enjoy shooting old deserted cottages or crumbling castles and monuments because the haunting look of infrared suits them perfectly, especially when ivy or other creepers grow around the doors and windows. In towns and cities anything graphic – modern architecture, bridges and sculpture – works really well.

Bright sunlight provides the best conditions for infrared

▼ WHITLEY BAY, TYNE AND WEAR, ENGLAND
In bad weather, with no foliage in the scene to show the effect, photographs taken with an infrared-modified camera tend to just look like stark black and white images, though I actually like the effect and find it easier to shoot digital black and white this way than by using an unmodified digital SLR to produce colour images that are subsequently converted to black and white.
CAMERA: NIKON D70 IR CONVERSION/LENS: 10-20MM ZOOM/ISO:200

▲ NOAH, NORTHUMBERLAND, ENGLAND
This is the very first digital infrared picture I ever took. My son and his friend were having a water pistol battle so I wandered over and grabbed a few quick snapshots, just to see how they would look. Notice the way skin tones record as a pale tone while eyes look dark and menacing.
CAMERA: NIKON D70 IR CONVERSION/LENS: 20MM/ISO:200

photography because the light is crisper and contrast is high. There's a greater concentration of infrared radiation for your camera to record, so the effect is stronger. Actually, one of the great things about infrared photography is that you tend to get the best results around the middle of the day when the light is harsh, which happens to be the worst time of the day for colour landscape photography. Consequently, you can pack your normal camera away and shoot infrared images instead, thus minimizing any down time due to a deterioration in light quality.

The same applies in bad weather. If the light is flat and the landscape appears grey and lifeless, don't pack up and head home, just reach for your infrared camera. The images may not be obviously infrared, but as dramatic black and white photographs they will work wonderfully and, once again, you've made the most of an unpromising situation.

The images in this chapter will give you an idea of what's possible. I've only been shooting digital infrared for a few months, but already I have hundreds of successful images. Wherever you go, and whatever the weather, you will always find that there's a great infrared shot to be taken.

So if you've recently upgraded your digital SLR and were wondering what to do with its predecessor, now you know. Instead of selling it on eBay for peanuts, send it off for infrared modification and breathe new life into your photography.

USING AN UNMODIFIED CAMERA

If you don't want to go to the expense of having a camera modified for infrared photography, the alternative is to test an unmodified camera to see if it's already sensitive to the infrared spectrum. Some digital SLRs and compacts are; some aren't.

To find out, all you do is point a TV or audio remote control towards it and press any button on the remote. If you can see the infrared beam being emitted by the remote, or any trace of it records on the picture you take, then the camera is capable of recording infrared light and needn't be modified.

To record infrared light with this camera you must place an infrared-transmitting filter over the lens so that it blocks out most of the visible light trying to pass through and only admits light at the red and infrared end of the spectrum, just the same as when working with infrared film. Suitable filters include the Hoya R72 and the B+W 092 or 093.

The downside of using an infrared transmitting filter is that because it blocks out visible light you can't actually see through it. This means that when taking photographs you must always use a tripod, compose the scene without the filter on the lens, focus manually rather than using autofocus and then, once you're ready to take the shot, attach the filter, at which point you won't see anything through the viewfinder.

The final stage is determining correct exposure. This will depend on the camera model in use, the lighting/weather conditions and the ISO setting of the camera, which should be kept low for optimum image quality. But don't be surprised if it's several seconds, even in bright sunlight.

Your best bet is to take one shot and see how it looks, then either increase or reduce the exposure accordingly. And always check the histogram to make sure that you don't clip the highlights or shadows.

Using an unmodified camera with an infrared filter can produce fantastic images, but it's much slower than if you use an infrared-modified camera, and because exposure times are always long, shooting moving subjects is out of the question.

▼ GATESHEAD, TYNE AND WEAR, ENGLAND
Creating stitched panoramas with an infrared-modified camera is just the same as with a normal camera. For this view of Newcastle Quayside from Gateshead, I shot a sequence of eight overlapping frames, stitched the RAW files using Photomerge in Photoshop CS3, then made any adjustments necessary to achieve the final effect.
CAMERA: NIKON D70 IR CONVERSION/LENS: 20MM /ISO:200

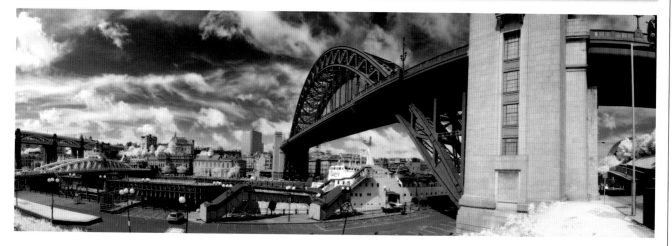

REPEAT AFTER ME

Everything we do follows a pattern of some kind, from the way we mow the lawn or brush
our teeth to the daily routine of our lives – get up, shower, dress, eat breakfast, go to work . . .
 We can't survive without repetition. It creates order from chaos, which in turn brings us
strength, stability and reassurance.

The same holds true for photography. Patterns are powerful because they attract attention and hold it. They engage the brain and stimulate the senses. Put one car in a parking lot and you have one car in a parking lot, but put another 20 cars next to it and a strong pattern emerges because cars, regardless of make or model, all look very similar. It's the same with telephone poles lining the street, chimney pots on rows of Victorian terraced houses, balconies on a Mediterranean hotel, faces in a crowd, stones in a wall, soldiers on parade, shoes on a market stall, sun loungers on a beach . . . Get the idea?

A telezoom lens is perhaps the best tool for shooting patterns because you can isolate details that are in the distance and exclude all unwanted information from the frame to reveal the pattern in its most powerful form. Telephoto lenses also compress perspective

and it is this characteristic that will emphasize pattern by making the repeated features in a scene seem closer together than they are in reality.

Often patterns will be so obvious that you can't avoid noticing them. However, the patterns that make the best pictures tend to be those that are more hidden and need a bit of effort from you.

The best way to spot them is by distancing yourself visually from whatever you're looking at. So, instead of seeing something purely for what it is, you need to look at the lines, shapes, colours and objects within it. In other words, you need to learn to view the world in an abstract way, because patterns are essentially abstracts – small parts of a much bigger picture.

ⓘ WHERE TO FIND PATTERNS

Here are a few tips on places where you're likely to find lots of interesting patterns:

• Any town or city will be packed with patterns. Look closely at office buildings, windows, doors, street furniture, road markings, the designs painted on cars, vans, buses and trucks, fancy brickwork and paving, and displays in shop windows and on market stands.

• Construction sites are great places to look. Piles of bricks, concrete blocks, timber, drainpipes, roofing slates, gravel, paving slabs, buckets, reinforcement bars, scaffold tubes and ladders are just some of the objects that create patterns.

• In the countryside natural patterns abound, such as furrows in a field, stone walls, lichens on rocks, fungi, rows of flowers and crops, trees in woodland and so on.

• Exploring obvious subjects can reveal patterns where you thought none existed. If you stand under a climbing frame, scaffolding or electricity pylon, for example, you can take some great pictures of the intricate lines, curves and shapes above you simply by focusing your attention upwards. Shooting from a high viewpoint can also reveal patterns, such as tables and chairs outside cafés, the shadows of people cast by a low sun and so on.

◀ CAMERA: NIKON F5 AND NIKON F90X/LENS: 105MM MACRO AND 80-200MM/FILM: FUJICHROME VELVIA 50

ROCK STARS

Living just a few minutes away from the Northumberland coast, and leading photo workshops around the UK, I spend an increasing amount of time by the sea. There I take photographs – and help others take photographs – of some of the most beautiful coastal scenery you'll find anywhere.

Unfortunately, as all keen landscape photographers in the UK know only too well, our fickle weather often gets in the way of art. Long spells of inactivity while waiting for the light to improve are commonplace.

Now, I'm not the most patient soul and after ten minutes of twiddling my thumbs I start to get restless. I'm also aware that when photographers have paid a lot of money to join a workshop and have spent months looking forward to it, the last thing they want to do is sit around because the weather's dull and grey and the classic views we've set out to shoot have lost their sparkle.

To counter this, I always try to have alternative subjects and locations up my sleeve that suit dull weather. This is not only so that we can remain active, but also because I feel it's important that photographers work outside their comfort zone and explore different subjects, techniques and styles. It's the only way to develop creatively and improve your eye for a picture. There are numerous grey day options, such as woodland, any form of moving water or old buildings, depending where you happen to be. However, whenever I am shooting on the coastline, the top of my list has to be rock abstracts.

Beaches and intertidal zones are full of fascinating geology, and include everything from jagged cliffs and amazing rock strata to sea-worn boulders and eye-catching erratics. Once you start to explore the wonderful variety of shapes, textures, colours and patterns they offer, it's amazing how many photographs can be taken in a relatively small area.

Erratic actions

When I set out to photograph rock details, there's no rhyme or reason to what I do. It's simply a case of wandering around and looking, looking a little closer, putting the camera and tripod down and trying to create something interesting in the viewfinder.

The composition could be based on colours, shapes, textures or a combination of all three. I don't intentionally set out to exclude all traces of scale but often find that I do so instinctively. This gives the resulting images an extra level of interest because it's not always obvious what you're looking at.

I have a particular penchant for sea-worn boulders. I find their smooth shape incredibly photogenic, especially when contrasted with rougher shapes and textures. I can also while away hours

▼ PORTH NENVEN, CORNWALL, ENGLAND
SANDYMOUTH, CORNWALL, ENGLAND
TARANSAY, OUTER HEBRIDES, SCOTLAND
These images were made in three different coastal
locations and show how the simplest subject matter can
make a highly effective image if you treat it as a series of
colours, shapes, textures and patterns rather than just a
few old rocks. As well as working individually, the images
are even more striking as a set because they're united by a
common theme.
CAMERAS: MAMIYA C220 TLR AND BRONICA SQA/LENSES:
80MM AND 150MM/FILM: FUJICHROME VELVIA 50

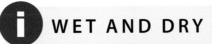

ⓘ WET AND DRY

It's purely personal, but I prefer to photograph rocks when they're dry.
This is because, as well as revealing greater depth of colour, tone and detail compared
to wet rocks, I also find their matt quality more attractive. To me it suits the soft, low-
contrast light of dull days that I prefer to work in. If I'm shooting in the rain I tend to
use a polarizing filter to eliminate glare and reflections on the surface of the wet rocks
so that colour richness is maintained.

looking for stones that have been thrown up by the tide and jammed into rock cracks, or single pebbles and boulders left stranded on rocky shelves by heavy seas. And though I hate to say it, if I don't find what I'm looking for, I'm quite happy to create it by moving rocks around to form interesting arrangements. Just think of them as outdoor still-lifes.

The most interesting area to work in tends to be the zone that's underwater at high tide but revealed when the tide is low, simply because it's in a constant state of flux. After a particularly strong tide, rock arrangements that have existed for days, weeks, even years can be washed away forever, only to be replaced by new ones. Every visit presents new opportunities, simply because little stays the same from one day to the next.

◄ SANDYMOUTH, CORNWALL, ENGLAND
The beach at Sandymouth is an amazing location for rock abstracts, and you could easily spend days there. I used a panoramic camera in upright format for this shot to emphasize the dramatic diagonal strata in the cliff face. Including pebbles at the base of the cliffs adds scale and shows that the strata literally rise from the beach in gigantic slabs.
CAMERA: FUJI GX617/LENS: 90mm/FILTERS: 0.3 CENTRE ND/FILM: FUJICHROME VELVIA 50

▼ ISLE OF EIGG, SMALL ISLES, SCOTLAND
Rocks and boulders don't have to simply be a source of abstract and close-up images – they can also be used as foreground interest in wider views. This limpet-encrusted rock caught my eye while exploring Laig Bay on the island of Eigg. It was sitting in its own sandy hollow and created strong interest in what was otherwise a flat and empty beach.
CAMERA: CANON EOS 1DS MKIII/LENS: 16-35MM/FILTERS: 0.9 ND HARD GRAD

Softly softly

My preferred light for shooting rock details is created by bright overcast weather that is characteristically low in contrast so colour and tone are fully revealed but neutral in colour temperature so the delicate colours in the rocks record as seen without the need for filtration. That said, I will shoot no matter how drab, grey and damp the weather gets because it will still produce great pictures, in black and white as well as colour.

When I first started shooting rock details and abstracts, it was almost as a consolation prize. It was just something to do when the light wasn't good enough for 'proper' landscapes. What I've come to realize along the way, however, is that far from being a poor relation to the grand view, these intimate images are every bit as interesting because ultimately, landscape photography is about one thing – rock. Even our very own planet Earth is known as the Third Rock from the Sun.

▲ PORTH NANVEN, CORNWALL, ENGLAND
Rock details also work well in black and white because the removal of colour strips them down to the bare essentials of pattern, texture and form.
CAMERA: COSMIC SYMBOL 35MM RANGEFINDER/LENS: FIXED 40MM/FILM: ILFORD XP2 SUPER

◄ PORTH NENVEN, CORNWALL, ENGLAND
SANDYMOUTH, CORNWALL, ENGLAND
TARANSAY, OUTER HEBRIDES, SCOTLAND
Rocks and boulders don't have to be simply a source of abstract and close-up images. They can also be used as foreground interest in wider views.
CAMERAS: MAMIYA C220 TLR AND BRONICA SQA/ LENSES: 80MM AND 150MM/FILM: FUJICHROME VELVIA 50

SANDS OF TIME

Beaches are great locations to find not only rock abstracts, as discussed in the previous chapter, but also intricate sand de tails that change minute by minute, hour by hour, in a never-ending kaleidoscope of patterns and textures. Outflow streams trickling gently towards the sea carve delicate filigree patterns as tiny rivulets of water fan out, shifting the sand grain by grain. Ripples left by the retreating tide form amazing desertscapes of miniature rolling sand dunes that are shifted and sculptured by the action of the wind.

I live just metres away from a beautiful sandy beach on the coast of Northumberland, and my view never stays the same for more than one day. With each cycle of the tide the canvas is wiped clean and a new, natural work of art is created.

This constant state of flux is both fascinating and inspiring. I know that at any given moment I can pick up a camera, head out and find something new and unique to photograph that will be gone forever in a matter of hours.

A retreating tide tends to be the most productive, mainly because the cleansing nature of the sea leaves everything looking new and pristine. Ripples are unmarked and perfect in their simplicity, and because the sand is wet they have a more obvious texture to them. If you head for the waterline you can also watch new patterns and details emerge for the first time and capture them in their virgin state.

Weather conditions play an important role in defining sand patterns. When the sun is low during the morning and afternoon it casts long, raking shadows that highlight the finest ripples and textures. Even individual grains of sand can be clearly seen, sparkling like tiny diamonds as the sunlight catches them. The colour temperature of the light is also lower, so the light is warmer and this enhances the natural warm colour of the sand to give it a healthy golden glow.

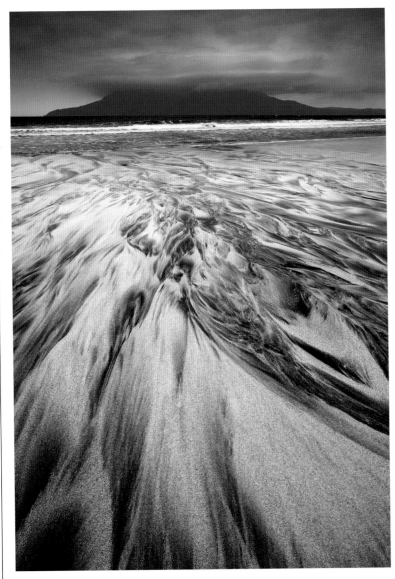

During the middle of the day when the sun is overhead, texture is subdued and sand ripples appear flat. However, in sunny weather the middle of the day is an ideal time to photograph outflow streams. The water appears clear and the patterns in the sand are more obvious. Using a polarizing filter will enhance them even more by removing unwanted reflections from the water's surface.

I also find cloudy, overcast days to be productive, especially for black and white images that have a more abstract quality. Texture won't be well defined, but the shapes created by sand ripples will be, so focus on them instead.

A standard or telezoom lens will be ideal for shooting sand details. Both tend to be capable of close focusing so you can fill the frame with small details, while a telezoom will compress perspective so ripples appear closer together and allow you to be more selective with your compositions.

◀ **LAIG BAY, ISLE OF EIGG, SMALL ISLES, SCOTLAND**
If you want to shoot amazing outflow streams, Scotland is the place to go. Burns flowing across beaches create amazing patterns as the water shifts and sifts the sand so that the grains from different types of rock are separated and scattered. I shot dozens of frames while exploring this stream. I used not only wide-angle views but close-up details as well. Weather conditions couldn't have been more perfect.
CAMERA: CANON EOS 1DS MKIII/LENS: 16-35MM/FILTER: POLARIZER

Ripples come in a huge variety of shapes and forms, from gentle, sinuous shapes to bold repeated lines and long, meandering furrows. There is no right or wrong way to photograph sand details, so just go with your instincts.

Water adds another useful compositional element. Channels between large dunes are transformed into shallow streams to create a wonderful contrast between the glassiness of the water and the coarse texture of the sand, while in deeper pools the ridges of dunes break the surface like the backs of imaginary sea serpents.

These things may not be obvious when you first set foot on a beach. But give yourself a few moments to wander around and explore. Let the sea breeze de-clutter your head and, as familiarity drifts away on the retreating tide, your imagination and creativity will spring to life.

ALNMOUTH, NORTHUMBERLAND, ENGLAND
These photographs, and many others, were all shot within a one-hour period while I was testing a new digital camera for a photography magazine. I hadn't planned on shooting sand details. I had set out to capture wider views of the coastline and see what the camera was capable of. However, when I started looking more closely at the beach I realized that the real interest was quite literally at my feet in the wonderful patterns and sculptured ripples. With one shot in the bag others quickly followed and before I knew it I had a whole collection.
CAMERA: CANON EOS 1000D/LENS: 18-55MM

SCALING DOWN

Although photography is a two-dimensional medium (images are flat, so they can only have height and width) it is possible to suggest depth (the missing dimension) by including something in the composition that gives a sense of scale.

Our brains are very good at remembering the relative size of things. Therefore if an object or element in a photograph appears small, but in real life it's big, our brain tells us it must be far away, which in turn suggests depth.

This effect, known as size recognition, works even more effectively when several objects of known size appear in the same composition and thus seem to contradict reality. For example, if you photograph a person standing in the foreground of a scene, they will appear to tower over the mountains behind them, but we know mountains are much bigger than humans so those mountains must be in the distance. Similarly, if something in the scene appears to dwarf a person, you know it must be big or very close to the camera.

Including something in a composition to suggest scale is useful if you want to make the photograph realistic and reassuring. But taking the opposite approach and removing all scale markers can be even more effective because then the viewer has no idea what they're looking at, or if they think they do, they can't be completely sure and this creates a strong sense of intrigue as their brains try to figure it out. The same effect can also be achieved by exaggerating

scale so that again what you see isn't necessarily the way it is in reality. We like to think that the camera never lies, but of course it can and does – all the time.

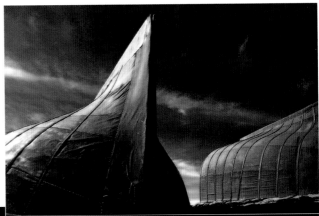

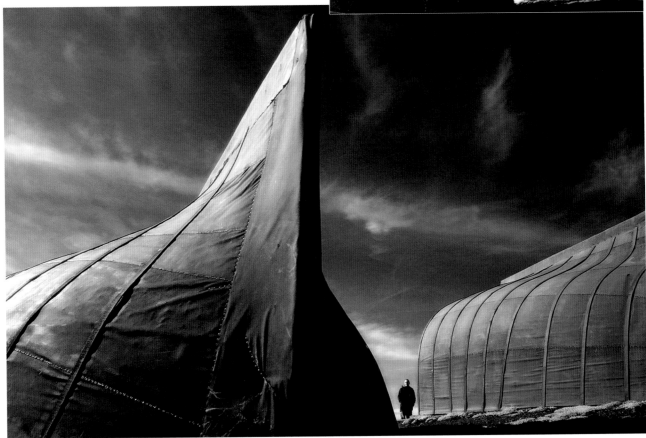

▲ RUMBLING KERN, NORTHUMBERLAND, ENGLAND

What are you looking at here? Is it an aerial shot of towering petrified sand dunes rolling down to a rocky plain, or a close-up detail of weathered rock? With nothing in the composition to suggest scale it's hard to tell, so a sense of mystery and intrigue is created. Actually, in this case the title gives the game away. We don't have towering petrified sand dunes in Northumberland, but we do have lots of interesting details along the rocky coastline. In reality this photograph covers an area of no more than 1sq m (10sq ft). Who said the camera never lies?

CAMERA: MAMIYA C220 TLR/LENS: 80MM/FILM: FUJICHROME VELVIA 50

◄ LINDISFARNE, NORTHUMBERLAND, ENGLAND

Here's a good example of scale being exaggerated by the use of a wide-angle lens. The lone figure standing between the unusual structures (they're actually huts made from the hulls upturned boats) appears totally dwarfed by them. In reality, they stand only 1m (3¼ft) or so higher than he does, but because I was using a wide-angle lens and shooting from a low viewpoint close to the nearest hut, perspective and scale have been blown completely out of proportion. That said, the impression of scale, even if it's untrue, is very powerful because with the figure so small in the frame we automatically assume that the structure in the foreground must be enormous, when in reality it isn't. As a direct comparison I have also included a shot of the same scene minus the figure. Although still a dramatic image, the lack of scale dilutes its impact.

CAMERA: INFRARED MODIFIED NIKON D70/LENS: 10-20MM

The long and the short of it

Different lenses can be used to exploit and exaggerate scale because of the way they record perspective.

If you place a wide-angle lens on your camera it can stretch perspective, and the truth, beyond recognition, making objects close to the camera seem much bigger than they really are and distant objects much smaller. The distance between those objects is also exaggerated.

Telephoto lenses do the opposite. They seem to compress perspective so the elements in a scene appear closer together than they are in reality and in doing so they play down the size difference between those elements.

I personally favour a wide-angle lens when it comes to exaggerating scale because they have the ability to turn the ordinary into the extraordinary. If you move close to an element in the foreground it looms large in the frame and dominates the composition while everything else seems to race away into the distance. The wider the lens, the more pronounced the effect, though don't feel you need to take it to the extreme – a focal length of 24mm or 28mm will work well. Once you go any wider there's a greater chance of the composition looking empty, and of the impact of the final image being diluted.

SCANTASTIC

Many photography enthusiasts own a flatbed scanner. This is because they are more versatile and economical than a dedicated film scanner, and allow the user to scan not only negatives and transparencies in all film formats, but also photographic prints, documents and other forms of flat artwork.

What few people realize is that even the most basic flatbed scanner can also be used as a large-format copy camera to scan and digitize 3D objects so they can be turned into high-quality images. It's basically the same idea as creating a self-portrait by pressing your face against a Xerox machine – only better!

◄ GERBERA
I bought this fine gerbera specimen from a local florist specifically to scan on my flatbed scanner. The amount of detail recorded is staggering. You can see individual hairs on the main image and grains of pollen on the front view of the flower. To achieve that degree of resolving power with a digital SLR you would need to spend 50 times the cost of a basic flatbed scanner.

The technique is very simple to try. All you do is place your chosen object on the glass platen of the scanner, and then scan it in the same way you would a piece of positive reflective artwork such as a photographic print. I mainly work with natural objects, such as flowers, seed heads and leaves, but you could use it with anything, natural or man-made, provided it's no bigger than the scanner platen.

Obviously, you need to take care if the object is heavy or abrasive because it could damage the platen, and any scratches or marks inflicted on it will appear on every scan you make subsequently, which will then require you to retouch them in Photoshop. An easy way around this is to have a sheet of glass cut to the same size as the platen to use as a protective cover that can be periodically replaced if it becomes damaged.

The lid of the scanner can't be lowered when there's a 3D object on the platen, so you also need to create some kind of hood that will cover and enclose it. I use an old box file sprayed inside with matt black paint. By cutting off the hinged lid I was left with a black box about 10cm (4in) deep, which is placed

▶ Leaf from a caster oil plant

HOW IT'S DONE

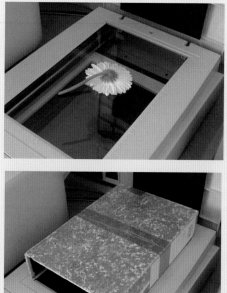

Step 1 Make sure the glass platen is clean. Place your chosen object directly onto the glass platen of the scanner.

Step 2 Place your hood (in this case an old box file sprayed black inside) over the subject and platen.

Step 3 Set the desired values in your scanner software. In this case the object is to be scanned at 300dpi to an output size of 24 x 24in (61x 61cm) and the file size will be 149.39Mb.

General | Frame | Densitometer

Scan Type: 42->24 Bit...
Filter: None
Setting: Save
Image Type: Standard

Name
<Untitled frame>

	Original	Scale %		Output	
⬌	5.6	428.3		24.0	inch
⬍	5.6	428.3		24.0	inch

Q-Factor | Screen | | Mbyte
1.5 | 200 | lpi | 149.39

300 | dpi

Prescan | Scan | Quit

◀ Helleborus are attractively spotted and mottled and the scanner brings out these details beautifully.

▼ Tulip stems have strap-like leaves and sturdy, upright stems, making them very distinctive.

over the object to be scanned. Not only does it contain the light from the scanner, but it also creates a plain black background that shows off the scanned object really well.

What's really impressive about this technique is the amazing image quality that can be achieved. Even a basic flatbed scanner costing under £50 ($85.00) will have a resolution of 1200 x 2400dpi and with that you can create enormous files and output images as huge prints. This means a 150Mb file with an output size of 61 x 61cm (24 x 24in) is easily achieved. If you want to, you can go way beyond that.

I tend to produce files around 100Mb and, at that size, the detail recorded by the scanner is phenomenal when you enlarge the image on screen. The downside of this high resolving power is that the scanner picks up every speck of dust, especially on the platen, so you need to keep everything as clean as you can. Despite my best efforts, I usually end up spending 20–30 minutes removing dust spots from the scan with the Healing Brush or Clone tool.

ⓘ LAYER UPON LAYER

Once you've got to grips with creating basic scanned images, try combining them with other scanned images using Layers in Photoshop. You could scan a wide variety of materials such as tracing paper, greaseproof paper, scuffed plexiglass, scratched film or fabrics to create textured images that you could then combine with the main image, for example. Use different Blending Modes to vary the way the layers are combined and adjust the Opacity to control how much of the texture layer shows through.

▼ Original scanned image

▲ Scan of greaseproof paper ▲ The two images combined

Manipulation in Adobe Photoshop

The initial scan is made in colour, so once you've cleaned it up you need to decide how you want the final image to look. I start with simple desaturation, using Image>Adjustment>Desaturation in Photoshop. From there I make adjustments in Levels, Curves, Channel Mixer and Brightness/Contrast to flatten and soften the image tones and create a delicate art feel. Finally, I tone the images. There are various ways to tone black and white images digitally,

using Curves, Channel Mixer and so on, but I use Hue/Saturation. Select Image>Adjustments>Hue/Saturation, click on the Colorize box, and then move the Hue/Saturation sliders around until you're happy with the effect. For the images here, I used a Hue value of around 25 and a Saturation value of 10, though this is purely down to my personal taste.

SHADOWPLAY

Shadows are formed whenever an object comes between a light source and a surface. The most common one we encounter is our own shadow. It follows us everywhere when the sun is shining, and then hibernates when it isn't. But shadows are formed by pretty much everything, natural or man-made, big or small. Shadows possess a great power in photography, not only to reveal texture and form and to create a sense of depth but also to evoke moods. Shadows can even become the subject in themselves, rather than just a shady image of it.

Outdoors, shadows are created by the power of the sun. When it's out in full force, shadows are crisp and dark. When the sun is obscured by clouds the light is softer and so are any shadows that are formed. Thus, when the sun is totally hidden behind cloud and the sky becomes one big, diffuse light source, shadows cease to exist because there's no direction or power to the light. So, if you want strong shadows you also need strong light.

The angle at which light strikes an object is also significant because this dictates the size, shape and density of the shadow. When the sun is low in the sky during early morning and late afternoon, shadows are very long and thin because the angle between the sun and the surface on which the shadows are cast is acute. The shadows are also relatively weak because they are partially filled in by light reflecting from the sky overhead.

As the sun climbs higher in the sky, so the angle between it and the earth increases and the light becomes more intense. Consequently, shadows become shorter and darker until with the sun overhead – at its zenith – both the light intensity and shadow density are at a maximum but the shadows themselves are short. If you want to capture shadows at their most interesting, the key is therefore to be shooting during the morning and afternoon rather than the middle of the day. Texture and form are also enhanced when the sun is low in the sky and shadows are long, whereas with the sun high in the sky and shadows short, modelling is dramatically reduced and everything looks rather flat and featureless.

◀ MESARIA, SANTORINI, GREECE
The shadow in this photograph creates a mirror image of the spiral staircase as a result of the angle at which the early evening sun was striking the building. Shadow density is high because the sun was still very strong, despite the late hour. The fact that the shadow was being cast on a whitewashed wall was a lucky bonus because it shows it off to full effect.
CAMERA: NIKON F5/LENS: 80-200MM/FILTER: Polarizer/
FILM: FUJICHRIOME VELVIA 50

Keep the sun on one side of the camera if you want shadows to sweep across the scene and reveal texture, or shoot towards the sun so they race towards the camera. Flare can be a problem when shooting into the light, but you can avoid it by hiding the sun behind a building or a tree.

I find urban locations are a better hunting ground for shadows than the countryside. I do use shadows to bring my landscapes to life, but when it comes to shooting shadows for their graphic appeal, towns and cities offer more suitable subject matter. Buildings, doorways, windows, fences, lamp posts, stairways and steps can all be a source of great shots. Old buildings, such as churches, cathedrals and mosques, are also worth exploring because they have intricate detailing both inside and out that casts equally intricate shadows.

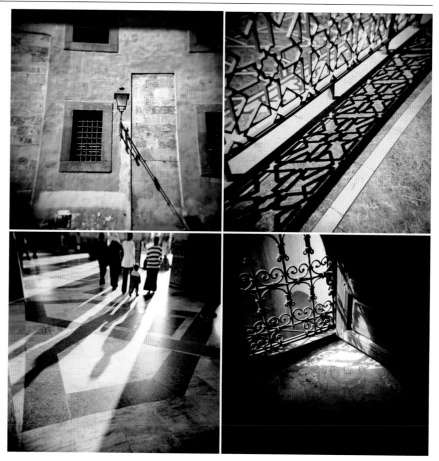

▲ PISA, ITALY
RABAT, MOROCCO
CASABLANCA, MOROCCO
MARRAKECH, MOROCCO
These four images show the difference shadows can make, not only in terms of creating a feeling of depth but also by adding visual impact. They were all taken hand-held using simple plastic toy cameras and have a unifying theme running through them due to the striking use of light and shade.
CAMERA: HOLGA 120GN AND DIANA F/LENS: FIXED 60MM AND 75MM/FILM: ILFORD XP2 SUPER

ℹ INSIDE JOB

Shadows can be created indoors by shining a light source onto interesting objects. I use an old 35mm slide projector because the light is intense and can be controlled by adjusting focus on the lens. Slides can also be placed inside the projector to colour the light and cast patterns. Placed on a tabletop next to the props in the still-life, it produces bold side-lighting and casts long, sweeping shadows that bring the composition to life. Try it yourself. Any powerful light source could be used instead of a projector.

▶ CLOCK COMPONENTS
I dismantled an old, broken alarm clock to source the objects in this still-life, arranged them on a sheet of white card, and then placed a slide projector behind and to the side to cast long shadows in front of every cog.
CAMERA: NIKON F5/LENS: 105MM MACRO/ FILM: FUJICHROME VELVIA 50

SHAPING UP

Everything, whether natural or man-made, has a shape, and photography is all about capturing those shapes to create images that are pleasing to the eye. Saying that, shape isn't always something we actively think about when we take pictures. The quality of light is considered, as is the subject matter itself and the way a scene or subject is composed. We're also aware of colour, texture and pattern. But when was the last time you thought, 'Hmm. That's a really nice circle. I think I'll photograph it'?

While looking through some of my images recently, I came across several where it was the shapes formed by the subject, rather than the subject itself, that provided the visual appeal. They were almost abstract in their composition, so it was clearly the shapes that had captured my imagination because I had given them centre stage – subconsciously if not consciously.

I was rather surprised by this. I had seen something in my photographs, months, perhaps years after they were taken that I'd missed when they were originally composed. It got me thinking about shapes and their importance, and now they're up there on the mental checklist that I work through when composing an image.

Emphasizing shape

The two main factors that determine how well shape is defined are light and colour.

Light creates contrast by casting shadows, which highlight texture and modelling in an object so it looks three-dimensional. This in turn reveals its shape.

If you take a round object and light it from the front it will look like a flat disc because shadows fall away from the camera and no sense of depth is implied. But move that light 90° so the object is sidelit and it will be transformed. One side will appear lighter in tone than the other due to the fall in intensity away from the light source itself, while shadows will sculpt and model the object so its shape is clearly revealed.

Colour works in a similar way by creating contrast. If you place a yellow vase against as blue wall, the shape of the vase will be emphasized because its colour is brighter than the wall behind it. In reverse (blue against yellow), the effect wouldn't be as strong because the object colour really needs to be brighter than the background.

▼ **OIA, SANTORINI, GREECE**
I spotted this arched window while wandering around the village of Oia early one morning. The window itself is of little interest, but the column framed through it against the blue sky makes all the difference. Careful positioning was crucial to get the composition just right.
CAMERA: NIKON F5/LENS: 80-200MM/FILTER: POLARIZER/FILM: FUJICHROME VELVIA 50

▼ **SAHARA DESERT NEAR MERZOUGA, MOROCCO**
Deserts are full of wonderful shapes, created by the soft, sweeping curves of the dunes and the way sunlight casts shadows to highlight them. Early morning or late evening is the time to shoot them, when the sun is low and shadows are long. Find a high viewpoint so you can look down on the sea of dunes and use a telezoom lens to home in on the shapes.
CAMERA: NIKON F5/LENS: 80-200MM/FILTER: POLARIZER/FILM: FUJICHROME VELVIA 50

▲ FIRA, SANTORINI, GREECE
The light was perhaps too frontal here to reveal the repeated church domes at their best, but colour came to the rescue. The dark blue of the smaller dome breaks up the relationship between the foreground dome and the sky. The cross also contrasts nicely with the smoothness of the domes and provides a useful focal point.
CAMERA: NIKON F5/LENS: 80-200MM/FILTER: POLARIZER/FILM: FUJICHROME VELVIA 50

Cool colours (blues and greens) also make better backgrounds because they recede, whereas warm colours like red, yellows and oranges advance; they leap out.

A final consideration is how the photograph is composed. You need to keep things simple because, if there's too much going on in the frame, the shapes will be lost. A telezoom lens is the best tool for the job because it allows you to adjust focal length until all unwanted elements are excluded from the frame. Additionally, the way telephoto lenses compress perspective can help to emphasize shapes, especially when they're repeated. Using your feet to physically get closer can also make a big difference, as can slight changes in viewpoint, which alter the juxtaposition of the elements still left in the composition.

ⓘ MONOCHROME SHAPES

Shapes can be revealed as effectively in black and white as they can in colour, as the photograph here demonstrates. The same rules apply in terms of using light and shade to your advantage, but instead of having colour contrast at your disposal you have tonal contrast to offset a shape from its background.

I find that high contrast works best when shooting in black and white, to a point where the shape may appear as a silhouette. This means there will be no sense of depth (silhouettes are as two-dimensional as you can get) but the play of dark tones against light more than makes up for that, and the results can be truly striking.

▼ FIROSTEPHANI, SANTORINI, GREECE
This photograph was taken during a family holiday. During the day in the full glare of the sun, the palm wasn't worth a second look. But in the evening it was thrown into silhouette against the wall, kissed by the last of the rays, and its shape really stood out.
CAMERA:DIANA F/LENS: FIXED 75MM/FILM: ILFORD XP2 SUPER

◀ YELLOW BEANS
This simple still-life was created by scattering a selection of bright yellow cod liver oil capsules on a slide-viewing lightbox so they were underlit. I then moved in close with a macro lens and filled the frame with the repeated shapes.
CAMERA: NIKON F5/LENS: 105MM MACRO/FILM: FUJICHROME VELVIA 50

SHOOT A THEME

One of the trickiest aspects of having photography as a hobby is that opportunities to get out and about with a camera are often few and far between. Then frustratingly, when they do finally come along, or you unexpectedly find yourself with a few hours to spare, and you can't think of anything to shoot.

For this reason, I would always recommend that you have some kind of project either in the pipeline or in progress. That way, when the chance to pick up a camera comes along, you have a purpose and can maximize your time.

Several possibilities are explored throughout this book, such as photographing household objects (page 46) and developing long-term projects (page 72).

Another useful project is to shoot to a specific theme. This could be anything you like, and the time limit you decide to set yourself could be as brief as your lunch break or as long as the rest of your life. The point is that setting yourself a brief gives you a focus and helps you to get started, even if you deviate from it after a while and concentrate on something completely different that has captured your interest.

Many years ago I remember seeing a portfolio published in a photography magazine with the title '10 Minutes'. The photographer behind it had a busy career and little spare time, so instead of fretting about not being able to visit new and exciting locations, he decided to only take pictures within a ten-minute walk of his home. The results were fantastic because he managed to overcome familiarity and see everything through a stranger's eyes. No doubt when he did manage to travel further afield his photographs were even more stunning because his eye had become so finely tuned.

Another photographer kept his creative inspiration alive by continually visiting new locations. Every weekend he would jump on a train, turn up in a town or city he'd never set foot in before, spend the day taking pictures, and then return home. As you might expect, the photographs he took were extremely good.

Safety in numbers

Setting a theme or brief is something I often do when leading photography workshops, because it helps to focus everyone's thoughts and give them direction. It's especially useful in bad weather when the shots we planned to take at a location don't materialize and we need to move on to Plan B. Even something as open as, 'Okay, you've got one hour to produce half a dozen photographs' can work because it forces you to really look and dig deep into your creative reserves.

The images that result may not win awards and you may not want to hang them on your wall, but taking them will have taught you something and made your eye for a picture just that little bit sharper.

Being out and about with a camera must always be preferable to propping your feet up on the dog and watching TV, after all.

◀ DOORS, CUBA AND MOROCCO
I've always found architectural features such as doors and windows interesting simply because they all perform exactly the same function and yet differ so much in terms of size, colour and design. It's natural, therefore, that when I'm travelling I always manage to return with a few more images to add to my collection.
CAMERA: NIKON F5 AND NIKON F90X/LENS: 28MM, 50MM AND 70-200MM/FILM: FUJICHROME VELVIA 50

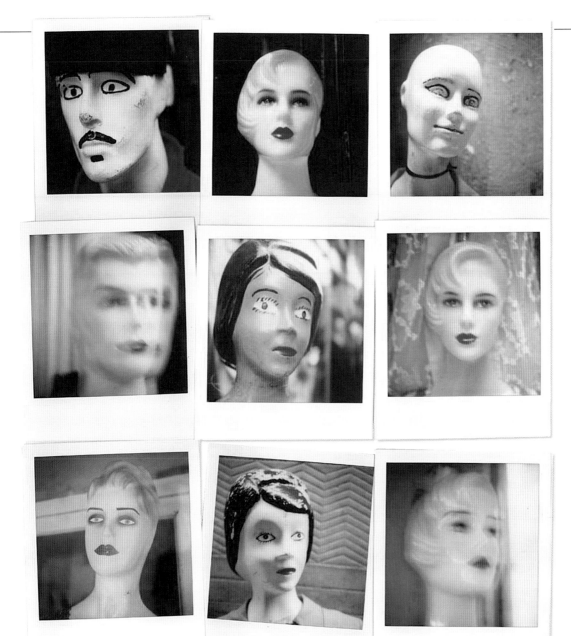

PHOTO ADVENTURES

Not sure what to shoot? Then try one of the ideas listed below. Photo-sharing websites such as Flickr, Photoposts and Fotolog (see page 122) can also be a good source of ideas and inspiration.

- Numbers
- Windows
- Doors
- A specific colour
- Amusing signs
- Graffiti
- A specific word

- Arrows
- Stripes
- Circles
- Reflections
- Faces
- Shadows
- Squares

- Door knockers
- Torn posters
- Mailboxes
- Clouds

▲ MANNEQUINS, MOROCCO
During a trip through Northern Morocco in April 2007, I was struck by the bizarre and rather scary mannequins used to display clothing, so I decided to photograph them with a Polaroid camera. I managed to find a few in every town and city I passed through and it added a fun element to my photography.
CAMERA: POLAROID SX70 SONAR AF/LENS: FIXED 116MM/FILM: POLAROID TYPE 779

STANDARD BEARER

I'm standing in the shady interior of a mud building in southern Morocco when suddenly a young man breezes by. Instantly I'm struck by his proud features and before I know it, I've asked him if he would mind me taking his photograph. He hesitantly agrees, so I direct him to a nearby doorway where reflected daylight is flooding in. Despite the fact that it's dazzling outside, light levels inside are still low and I'm shocked when the metering system of my Nikon F90x tells me the exposure is 1/4sec at f/4.

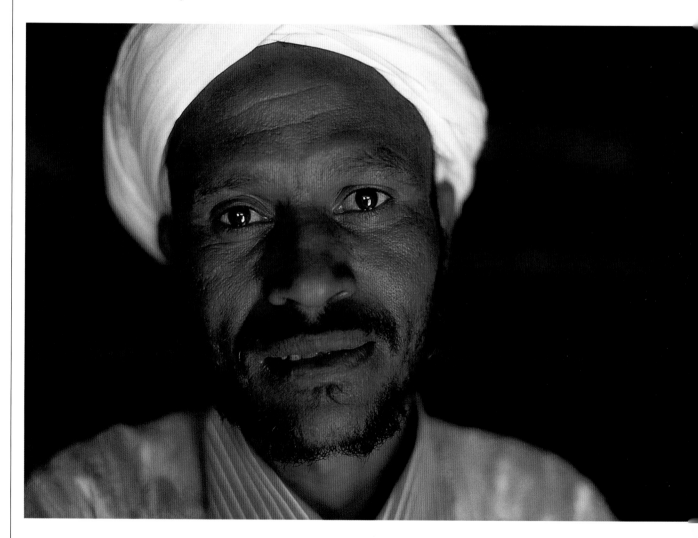

Had I been using a zoom lens I'd be struggling to get a shot at all because even if it opened up to f/2.8, which is as wide as any zoom lens will go, I'd still be looking at a shutter speed of 1/8sec. Holding the camera at that level would test the steadiest hand, even if the lens had vibration reduction.

But I'm not using a standard zoom. I'm using a 50mm prime lens, boasting a maximum aperture of f/1.4, a whopping two stops faster than an f/2.8 lens. Instead of feeling under pressure, I'm relaxed and in control. If I want to, I can open up to f/1.4 and work at a much safer shutter speed of 1/30sec. However, because the 50mm lens is so small and light it's easy to hand-hold at slow shutter speeds without fear of camera shake. So I settle on a compromise exposure

▲ **AIT BENHADDOU, MOROCCO**
The 50mm prime lens is a versatile lens I find invaluable for travel photography. It suits all subjects from portraits to details and the stunning optical quality is better than any zoom you're likely to find.
CAMERA: NIKON F5 AND F90X/LENS: 50MM F/1.4/FILM: FUJICHROME VELVIA 50

of 1/15sec at f/2, fire off half a dozen frames and the shot's in the bag.

Since that day a 50mm lens has saved my hide many times. The best travel pictures are often taken in extreme conditions where you have to work quickly and confidently without the aid of a tripod, and for me the most versatile lens for that job is the 50mm prime.

▲ HAVANA, CUBA
The perspective of the 50mm standard lens is similar to that of the human eye, so the picture it produces have a very natural look to them, rather than appearing stretched or compressed.
CAMERA: NIKON F5/LENS: 50MM F/1.4

◄ HAVANA, CUBA
The 50mm prime standard lens is an ideal general purpose focal length and being small and light can be used handheld used in all types of lighting. This man made an irresistible subject as I explored the streets of Havana, and my 50mm lens came into its own yet again.
CAMERA: NIKON F5/LENS: 50MM F/1.4

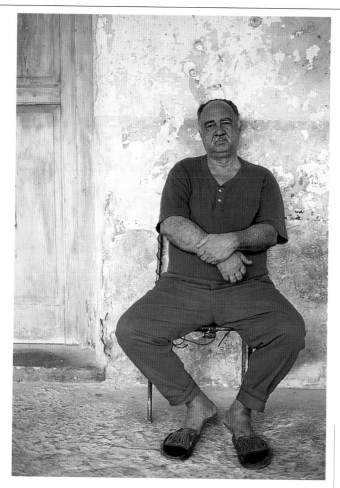

The good old days

When I acquired my first 35mm SLR more than 20 years ago it was normal to buy it with a 50mm standard lens. Then, some time later, you bought either a 28mm wide-angle if you were into landscapes, a 135mm tele if you preferred portraits or, if you could afford it, both. These days, SLRs are sold with zoom lenses, so the 50mm prime has slowly faded into obscurity. However, despite using zooms myself, I still carry a 50mm standard lens as well, and when advising photographers on the gear they need for my photographic holidays and workshops, I always sing the praises of the 50mm standard as a versatile lens for all-round use.

It's not just the fact that the 50mm prime lens is small, light and fast that makes it such an attractive proposition. I use it for hand-held shots in low light more than any other lens.

There's also the angle of view. Wide-angle and telephoto lenses get much less into a picture than our eyes see and they stretch and compress perspective along the way. However, the 50mm lens shows the world as it really is and as our eyes see it. Some might suggest this makes the 50mm lens boring, but for me the opposite holds true.

Subject matters

The angle of view also makes the 50mm prime lens ideal for photographing a wide range of different subjects. It can be used successfully for portraiture provided you don't get too close to your subject, which results in slight distortion of the facial features because 50mm is a little short for headshots. Saying that, on a digital SLR with a DX-sensor, the focal length will increase to around 75mm, making it perfect for frame-filling portraits.

Standard lenses work well for landscapes too. They offer enough depth-of-field at small apertures, such as f/16 and f/22, to produce strong compositions with foreground interest and front-to-back sharpness.

They are also suitable for architectural photography and close-range action. Their close-focus ability, usually 45cm (18in) or less, makes them ideal for capturing details, patterns, textures, abstracts and still-lifes, just the kind of thing that travel photographers love to shoot to capture the flavour of a place.

Finally, there's the image quality. I've yet to see a picture taken with a 50mm prime lens that wasn't pin sharp and able to knock the socks off anything produced by a cheap, slow standard zoom, which is what most SLRs come bundled with these days. You can forget about distortion because there won't be any, and expect your shots to be as sharp at the corners as they are at the edges, across the aperture range.

I'm not suggesting that you ditch your standard zoom in favour of a 50mm lens, but what I am saying is that you shouldn't dismiss acquiring one just because you already have a zoom lens that covers 50mm. The 50mm prime lens is a different animal altogether. It can open up creative doors that a zoom lens will simply slam in your face. It can make successful photographs possible in situations where, armed with only a zoom lens, you have to give up and walk away.

For all of the above reasons, the 50mm standard lens is worth every penny of the asking price.

START A PHOTO BLOG

So you've got this passion for photography that's taken over your life. Every spare minute is spent behind a camera and your collection of images is growing – fast. The thing is, what are you going to do with them all? You can inflict your art on family and friends occasionally, but to anyone who isn't interested in photography looking at someone else's photographs can grow very boring very quickly, especially when you start pontificating about hyperfocal focusing and reciprocity law failure.

One solution that's becoming increasingly popular is to create your own blog, a kind of photographic online diary where you upload images for all the world to see and invite people to comment. Not only will the feedback you receive be helpful and encouraging, but having a forum for your work will perhaps give you more of a purpose when you have the chance to pick up a camera and take pictures. You will also become part of a creative community of people around the world who exchange thoughts and ideas so, all in all, your photography is bound to benefit.

Join the club or DIY?

There are two main options you can take up when it comes to creating a photo blog. It can either be an extension of your own photography website if you happen to have one. Or, if not, there are numerous photo-sharing websites of which you can become a member.

The latter option is in many ways the easiest because membership is usually free, you can use the host's web interface to create galleries so you don't actually need any web or design knowledge, and you'll be joining an instant community where hundreds, perhaps thousands, of other photographers will immediately have access to your blog. If you create a blog that's linked to a personal website, building up a list of regular visitors will take longer because, initially, no one will know it exists.

The advantage of a personal website, however, is that you have carte blanche over design so you can really go to town with how it looks, which contributes significantly to the visual impact. Also, what tends to happen is that fellow bloggers search the internet for other blogs and when they find one they like, it's added to a list of web links on their own blog. Other photographers check out those links, and before long your own blog will be receiving visits from photographers throughout the world – that is, if it's any good.

ⓘ WEBLINKS WORTH CHECKING

As well as individual photographers publishing their photo blogs on the internet, there's also a growing number of photo-sharing websites where you can become a member and upload your own work for all to see. Here are the most popular.

http://photoposts.net
http://photoposts.org
http://fotolog.com
http://www.fotothing.com
http://www.flickr.com
http://gruppof.blogspot.com
http://www.photoblogs.org
http://www.londonphotobloggers.org

PRIMARY
A photo blog by Lee Frost

Archive
September (2008)
August (2008)
July (2008)
June (2008)
May (2008)
April (2008)
March (2008)
February (2008)
January (2008)

ℹ️ PHOTO BLOGS WORTH A LOOK

There are tens of thousands of photoblogs out there on the net covering all interests, subjects and levels of photographic skill. Many bloggers aren't experienced photographers and use a camera simply as a visual diary so they can share their lives anyone interested logging on. However, more and more enthusiast and professional photographers are discovering the joys of blogging, and their sites will provide an endless source of inspiration. Here are a random few worth checking out that I discovered while surfing the net.

www.ianfarrell.org/blog
http://friskypics.com
http://apparentlynothing.my-expressions.com
http://www.pic-a-day.co.uk
http://www.jimbus.org
http://www.29twelve.com/blog
http://www.mysteryme.com
http://thatwasmyfoot.my-expressions.com
http://this-charming-cam.my-expressions.com
http://wvs.topleftpixel.com

Pick a subject

The theme of the blog is up to you. Some photographers try to upload one photograph every day to create an online diary of their lives, but the majority upload images when they can. It really depends what your aim is. Blogging is a great way to show your work to a global audience so you might choose to upload only your best shots, the images that you're really proud of. Equally, you could set yourself a blog project, such as documenting your neighbourhood, taking pictures in your lunch break, or photographing a specific subject. If you're not sure where to begin, take a look at blogs by other photographers. What you'll quickly realize is that anything goes.

▼ PRIMARY – A PHOTO BLOG BY LEE FROST
The images here aren't from a real blog but one I created for the purposes of this book. However, they do show a fairly standard photoblog format. There is a home page displaying the title of the blog. I chose 'Primary' because the underlying theme is colour. It is a random selection of images and offers access to a month-by-month archive of images that have been uploaded to the blog since it was started. Double-clicking a thumbnail image on the homepage or one within one of the archive folders displays an enlarged version of that image with the title, the date it was taken and, where relevant, some background information. Visitors are also given the chance to leave comments, and other images in the blog can be accessed using forward and backward arrows.

archive • home • links • about < • now • >

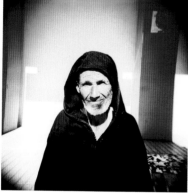

Smile 18th March 2008

Taken through the window of a bus in Ourazazate, Morocco. We were waiting at traffic lights and this charming guy was just standing by the roadside, looking at me. I had a Holga on my lap so I raised it, fired it once then gave him a big smile back.

Comments please

archive • home • links • about < • now • >

Candy stripe 7th August 2008

Comments please

123

STORM CHASER

By the fourth evening I was ready to accept defeat. Once again I'd spent two hours or more waiting patiently on the bank of Warkworth's River Coquet. I had been dodging downpours and praying for light that refused to come just so I could get the shot I wanted of the town's magnificent castle bathed in golden sunlight.

I knew the shot was there for the taking. It was just a case of gambling with the elements and sitting out the weather until a break occurred. I hoped that when the break did come the light would hit the right spot. But I was seriously beginning to wonder if a break would occur at all and my enthusiasm was fading fast.

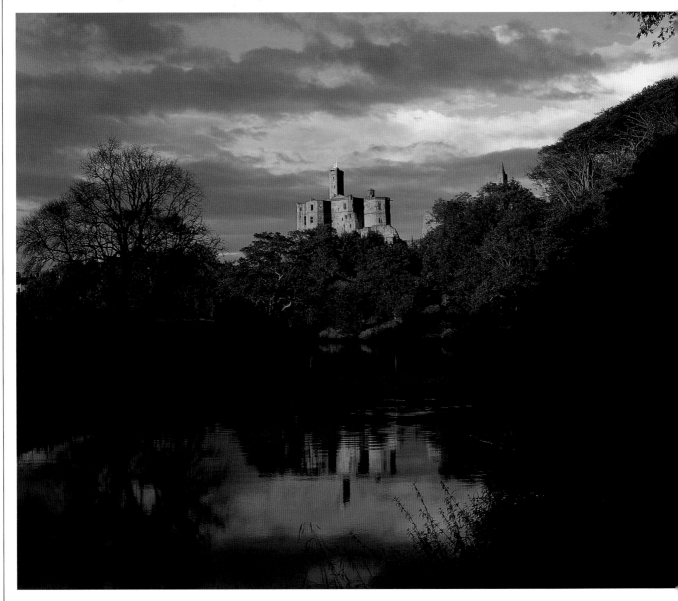

▲ WARKWORTH CASTLE
Here's the shot that took me four days to get. Was it worth the effort? Absolutely. I've been back to the same location 15 or 20 times since, but I've never seen light quite as dramatic. It was one of those magical moments when everything came together just at the right time, and I was lucky enough to be there and capture it. Though I am a firm believer in the old saying 'The harder you work, the luckier you get'.
CAMERA: PENTAX 67/LENS: 165MM/FILM: FUJICHROME VELVIA 50

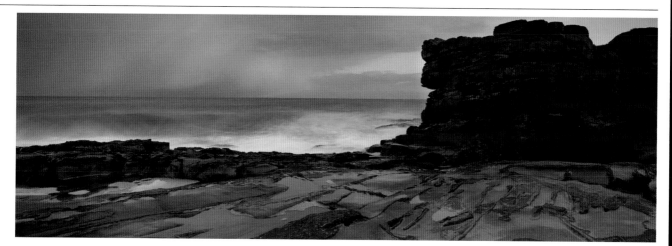

I'd done all the usual stuff like asking the clouds very politely if they'd move for a few minutes, and doing a quick good-weather dance around my tripod. But that didn't work. Neither did muttered expletives or threats of violence, and with sunset just a few minutes away there seemed little point in waiting any longer.

Then suddenly, without warning, the clouds parted, a shaft of golden sunlight broke through and the castle shone like a beacon. Hastily I took a spot meter reading from the sunlit walls of the keep and starting shooting. Frame after frame, I frantically bracketed exposures just to be sure, and tried to grab as many shots as I could of the amazing light. Then as quickly as it appeared it was gone again as the sun slipped behind another cloud. The panic was over, but after four days of waiting and watching I'd got the shot.

That's bad weather for you. It's just so unforgiving, so unpredictable – and at times so boring. If you head outdoors when the sun's shining you can more or less guarantee what kind of shots you'll end up with. They'll be bright, colourful, easy to expose. But when the sky is a sea of inky black cloud, a gale is blowing and rain is falling, you really are in the lap of the gods. And that's where the fun begins. The question is, are you willing to join in?

Tricks of the light
Bad-weather photography is all about harnessing light. It's about waiting for the elements to collide and create something magical. You never know when or if that's actually going to happen, but unless you make the effort to get out there, you'll never be in a position to make the most of it when it does. Being in the right place at the right time is definitely the name of the game.

The most dramatic conditions tend to occur when the sun suddenly breaks through a storm, and sunlight illuminates the landscape. Sometimes it bathes the foreground of a scene; at others it acts like a spotlight and isolates just a small area in the distance. Until it happens, however, you just never can tell so you need to get yourself ready and stay alert.

Whenever I can, I prefer to be on location with a shot lined up then wait for a break to come, which doesn't always happen. I mount my camera on a tripod, compose the scene, select the aperture I need to obtain sufficient depth-of-field (rarely anything wider than f/11 if I'm including foreground interest) and fit any filters I feel will be necessary.

▲ RUMBLING KERN, NORTHUMBERLAND, ENGLAND
This dramatic panorama shows a hailstorm blowing in off the North Sea. I didn't realize it was a hailstorm at the time. I was too focused on capturing the scene on film before the clouds blew over. Minutes later I was racing for cover as the storm finally reached the coast and I was blasted with a million tiny balls of ice. Who says you don't have to suffer for your art?
CAMERA: FUJI GX617/LENS: 90MM/FILTERS: 0.3 CENTRE ND AND 0.6ND HARD GRAD/ FILM: FUJICHROME VELVIA 50

An ND grad is a must to tone down the sky and emphasize the stormy effect. A 0.6 hard grad is usually strong enough, but sometimes I'll use an 0.9 to make the sky darker in the shot than it was in reality.

Then I wait, peering up at the sky every few minutes to see how the clouds are drifting in relation to the sun and trying to predict when a break might come. If you do this wearing good sunglasses you can often see the sun lurking behind the clouds without actually dazzling yourself.

Early morning and late afternoon are prime times for this kind of photography, mainly because the light is warm. So, if the sun manages to break through you get a wonderful contrast of warm light against a dark sky, often with purple, pink and blue tones in it. This combination can look stunning.

ⓘ WILL IT? WON'T IT?

Accurately predicting changes in the weather takes knowledge and experience. However, there is a little trick, known as the Crossed Winds Rule, that you can try. Here's how it works. Turn your back to the surface of the wind then turn 30° clockwise. If, from this position, the clouds appear to be moving left to right, weather conditions are likely to deteriorate. If they're moving right to left, the cold front is receding so conditions are likely to improve in the next few hours.

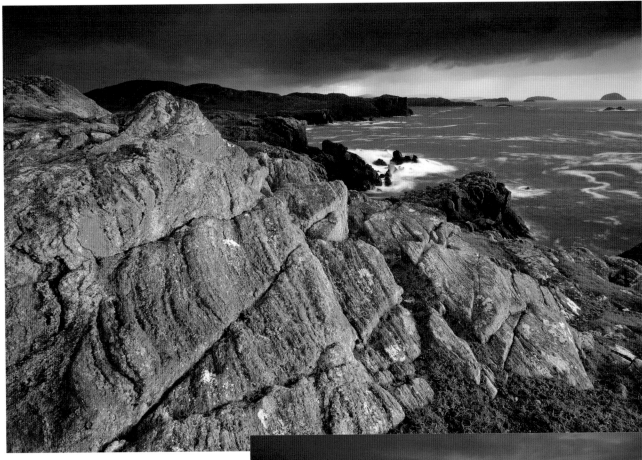

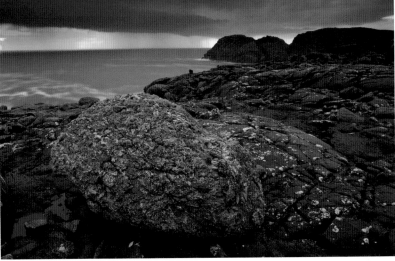

▲ ▶ ISLE OF LEWIS, OUTER HEBRIDES, SCOTLAND
When I set out to walk to this location there was a
greater chance of me getting a soaking than great
pictures. In the end I got both, in reverse order. Just as
I reached the clifftop the evening sun broke through
and lit the foreground rocks with golden light. It looked
amazing, though I could see that it wouldn't last for
long. I changed viewpoint when the sun dipped behind
cloud and took the second shot as the sun began to
set. Minutes later the heavens opened and by the time
I reached the cover of my cosy cottage I looked like a
drowned rat.
CAMERA: CANON EOS 1DS MKIII/LENS; 16-35MM/FILTER:
0.9ND HARD GRAD

In situations where the light keeps threatening to break but
never quite manages it, another option is to shoot into the sun.
Doing this can produce dramatic sunburst effects with light from
the sun radiating from behind the clouds. That light may not be
powerful enough to illuminate the landscape, but it will make the
sky look amazing.

Wet and wild

Rainy weather makes life more difficult because you have the
added problem of keeping your gear dry. But don't let this put you
off. The landscape may not look particularly inviting, but there are
plenty of other subjects out there.

How about photographing people hiding beneath their coats
or rushing home after work in a downpour, clutching colourful
umbrellas? To add interest to your pictures, combine a slow shutter
speed of, for example, 1/30 or 1/15sec, with a burst of electronic
flash, so any movement is blurred by the ambient exposure but
frozen by the flash.

Actually showing rain in your pictures is a little trickier, but it is
not a complete impossibility. One option is to include a puddle in

ⓘ PROTECTING YOUR GEAR

- Carry your gear in a waterproof backpack. Many models now have a waterproof cover that can be pulled over the pack.
- Place a skylight or UV filter on your lenses so the filter bears the brunt of the elements rather than the delicate – and expensive – front element.
- If you're shooting in rain, place your camera and lens inside a polythene bag. With a hole cut and held around the front of the lens with an elastic band you'll have a waterproof cover.
- Carry a special lens cleaning cloth in your pocket so you can wipe away any moisture that gathers on the front of the lens. Water droplets or spray reduce optical quality and cause flare. A piece of

chamois leather can be used to soak up water on the camera body or lens barrel.
- If you get caught in a downpour or you're waiting around for a shot during light rain, place a stuff sack over your camera and lens to keep them dry. These sacks are intended for sleeping bags but they're lightweight and waterproof.
- Once you return home, allow the camera to warm up naturally to room temperature before removing lenses, film or lens caps. This prevents condensation building up on and inside the body.
- Never allow your camera or lenses to remain wet for longer than necessary. Once you are under cover dry them off.

the foreground so you can see the patterns created by raindrops as they hit the ground. Or, in a really heavy downpour, use a telephoto lens to home in on rain bouncing off a car, a windowsill or the surface of a street.

An even better technique is to wait for the sun to come out so that the rain is backlit. By using a shutter speed of 1/30sec or slower, each drop will record as a glistening streak falling from the sky. Try to shoot against a dark background if you can, so the rain streaks stand out. This works well on close-ups of flowers.

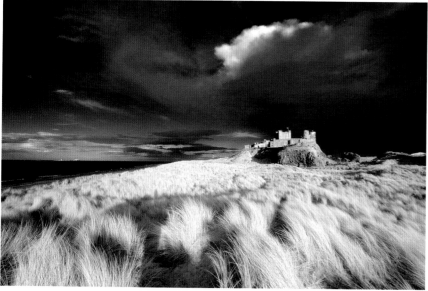

▲ ISLE OF LEWIS, OUTER HEBRIDES, SCOTLAND
You don't need direct sunlight to produce successful shots in stormy weather. Here the soft reflected light really brings out the rich colours in the rusting iron of the deserted shack while the brooding sky makes no secret of what the weather was like.
CAMERA: CANON EOS 1DS MKIII/LENS; 24-70MM/FILTER: 0.9ND HARD GRAD

◀ BAMBURGH CASTLE, NORTHUMBERLAND, ENGLAND
Storm light also looks great in black and white, so don't always feel compelled to shoot in colour. I took this shot while strolling along Bamburgh Beach. I could see that the sun would eventually break through so I positioned myself on the dunes and waited. When the break did come it was amazing, and lasted for 20 minutes or more.
CAMERA: INFRARED MODIFIED NIKON D70/LENS: 10-20MM

STRETCH YOUR IMAGINATION

Panoramic photography has played a central role in my photographic life for more than a decade now. From the moment I first used a 6 x 17cm camera I knew it was the format for me, and wherever I travel in the world I often return home with more panoramic images than anything else. There's just something about the panoramic format that appeals to my visual senses, and I find it much easier to capture the drama and beauty of a scene.

▼ DUNSTANBURGH CASTLE, NORTHUMBERLAND, ENGLAND
When you're shooting in low light using long exposures, shooting a sequence of images for stitching is less practical. In the time it takes to shoot the sequence the light can change, leading to inconsistencies in image colour and density. Movement in the sky and water is also difficult to merge accurately so joins may be visible in the final image. For these reasons, I still prefer to shoot film when working in low light.
CAMERA: FUJI GX617/LENS: 90MM/FILTERS: 0.6ND HARD GRAD AND 0.3 CENTRE ND/
FILM: FUJICHROME VELVIA 50

In 2005 I wrote a whole book on panoramic photography, which gave me the opportunity to experiment with different cameras and explore the genre in much more detail.

Back then, panoramas were still being shot predominantly with film using cameras such as the fantastic Hasselblad Xpan, or my favourite, the Fuji GX617. Digital technology still had a way to go and though a few photographers were starting to stitch images together digitally to create panoramas, it was a complicated and

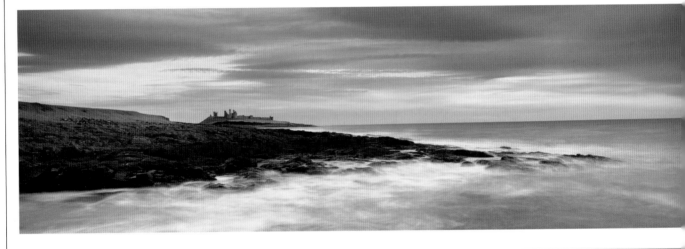

time-consuming technique that demanded a degree of fairly in-depth knowledge.

Thankfully, all that has now changed, and with my own recent switch over to digital capture I've now embraced digital stitching myself while continuing to use a panoramic camera.

Given the choice, I'd rather shoot panoramic images with a single press of the shutter release, so if I can get the shot I want with my Fuji GX617 film camera I will always reach for it in favour of my Canon digital SLR. Familiarity has a lot to do with this. I've been working with the Fuji for a decade now and I know it like an old friend. The Canon has been in my possession for just a few months, so I'm still getting to grips with it.

Don't move

In some situations, a single shot is also more effective than a stitched sequence. I shoot a lot of coastal landscapes in low light using long exposures, which means that motion is recorded in the sea and sky. If you try to shoot that kind of scene as a sequence, the images may be difficult to stitch seamlessly because the software can't find a convincing join. With my Fuji GX617 film camera, however, I don't have that concern and it doesn't matter if the exposure is five seconds or five minutes.

The same applies when shooting urban scenes where people and traffic are moving through the scene. With a film camera like the Fuji or Hasselblad Xpan you capture panoramas in a single exposure. However, if you attempted to shoot a stitched sequence of the same scene your computer would blow a fuse trying to merge the images.

ⓘ PARALLAX ERROR AND THE NODAL POINT

If you mount your camera on a tripod using the tripod bush on the camera's baseplate, as you rotate the camera between frames to shoot a stitching sequence a phenomenon known as parallax error occurs when the relationship between features that are close to the camera and others further away changes. Parallax error can make it tricky to stitch images accurately, though modern stitching software is very good at correcting any error.

If you want to eliminate parallax error, you need to position the camera on your tripod so that it rotates on its optical centre or nodal point. There are numerous brackets available for this purpose, and they also help you locate the nodal point for each lens as their positions do differ.

Some photographers swear by these brackets, others don't. I'm in the latter camp and my images stitch together perfectly well. I also tend to shoot a lot of sequences hand-held and they work fine too. So, in my opinion you might as well save your money and spend it on something more useful.

▼ **THE MITTENS, MONUMENT VALLEY, UTAH, USA**
My favourite camera for panoramic work is the Fuji GX617. I've been working with it extensively for the last decade and never cease to be impressed by the quality it achieves. That said, having recently invested in a Canon EOS 1DS MKIII I can see that it's going to be a tough call, and for scenes where the Canon offers no practical disadvantage compared to the Fuji, the versatility of digital capture is likely to win favour.
CAMERA: FUJI GX617/LENS:90MM/FILTERS: POLARIZER, 0.6ND HARD GRAD AND 0.3 CENTRE ND/FILM: FUJICHROME VELVIA 50

More for your money

Where digital stitching does win hands down over film is in its versatility. If I want to shoot two frames and stitch them I can, but if I want to capture a full 360° panorama I can do that too. I also have a much greater lens choice for my Canon digital SLR than I do on my Fuji GX617 and this of course gives me endless compositional freedom.

This is aided by the development of amazing stitching software. Gone are the days when you needed to make sure everything was perfect in order for the software to cope with it, or have in-depth knowledge of Photoshop so you could assemble the images manually, using layer masks and brush tools to blend images and paint away the joins. Today, the software is not only quick and easy to use, but it's very clever. Distortion is automatically corrected and seamless panoramas are created by placing the source images in a folder and leaving the software to do the rest.

You're not limited to stitching basic sequences of images on a single plane, either. It can handle random selections of images, so if you want to create massive files for mammoth prints you can photograph a scene bit-by-bit like a joiner, and then let the software do the work of blending all the images together.

Not convinced? Then give it a try. You can download free trials of most software packages, including Photoshop CS3. If you do, be prepared to spend some money though, because I guarantee that when the trial period expires you'll be desperate to buy it.

▲ SEILEBOST, ISLE OF HARRIS, OUTER HEBRIDES, SCOTLAND
Here's the final stitched panorama in all its glory (see panel opposite). No matter how hard you look, there are no telltale joins to give the game away. Image quality is also exceptionally high due to six individual frames being combined and I would be happy to make prints more than 1m (3¼ft) long from this file. The sky looks polarized, but it isn't – polarizing filters must be avoided when shooting stitch sequences because they can cause uneven banding across the sky.
CAMERA: CANON EOS 1DS MKIII/LENS: 24-70MM

▼ BUTT OF LEWIS, ISLE OF LEWIS, OUTER HEBRIDES, SCOTLAND
I couldn't capture a wide enough view of this scene in a single shot so instead I shot a sequence of five frames and stitched them together using Photomerge in Photoshop CS3. I didn't even bother to mount the camera on a tripod, preferring to shoot hand-held to save time, but the images blended together perfectly.
CAMERA: NIKON D70 INFRARED CONVERSION/LENS: 10-20MM ZOOM

HOW TO CREATE A STITCHED PANORAMA

There are various software packages available that have been designed to stitch images together and create panoramas. Examples include PTGui (www.ptgui.com), PanaVue ImageAssembler (www.panavue.com) and Realviz Stitcher (www.realviz.com). I use the Photomerge option in Adobe Photoshop CS3, which is quick, simple to use and produces seamless panoramas with ease. Photomerge in earlier versions of Photoshop tended to get a bad press, but Adobe have ironed out any flaws and it's now as good as proprietary stitching software. Here's how to create a panorama using Photoshop Photomerge.

Step 1 Mount your camera on a tripod and make sure the tripod head is level so that when you rotate the camera between shots it doesn't go out of square. I use a Gitzo levelling base, which allows me to level the tripod head even if the tripod itself isn't level. Do a quick practice scan across the scene to work out how many frames you need to shoot. Each frame should overlap by 30–40% to help the software achieve a seamless stitch.

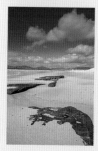

Step 2 Take a test shot from an average part of the scene (not the lightest or the darkest) and check the image and histogram. If it all looks fine set that exposure with your camera in manual mode so you use exactly the same exposure for each frame. If you don't do this the exposure may vary and image density will differ, making a seamless stitch difficult. Note that the camera is on its side. This isn't essential, but the pixel depth of the final pan will be greater if you turn the camera on its side so image quality will be higher and you can make bigger prints.

Step 3 Take a shot with a hand in front of the lens. This will help you identify where the sequence begins when you download the images onto a computer. If you don't mark the start and end of the sequence you can easily get confused.

Step 4 Swing the camera to the far left or right of the view you want to capture, focus manually and take the first shot. Move the camera slightly to the left or right and make your second exposure. Keep doing this, overlapping each image by 30–40%, until you reach the other end of the scene.

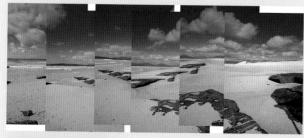

Step 5 Take a shot of your hand again to denote the end of the sequence. All the frames between the two hand shots are the ones you need to stitch later. Some photographers shoot their left hand at the start with fingers pointing to the right and their right hand at the end, fingers pointing to the left.

Step 6 Download the images onto a computer. If you shoot in RAW, batch process the RAW files so they all receive the same adjustments and corrections, otherwise inconsistencies will creep in. Place those images in a folder on the computer desktop.

Step 7 Open Photoshop CS3 and go to File>Automate>Photomerge. Select the layout style you want to use. Auto is the default setting and usually works fine. I also use Cylindrical and Perspective. Next, click on the Use tab, select Folders then click on Browse.

Step 8 Click on the folder containing the images you want to stitch and they will appear in the Photomerge dialog box. Click OK and let Photomerge perform its magic. This can take several minutes if the source files are big.

Step 9 After several minutes the stitch should be complete and you'll see something like this. In this case the image is upside-down simply because I didn't rotate the source files through 90° before stitching them. You can also see that I need to crop the edges of the stitch to tidy it up. This is common, especially if you don't use a nodal point bracket to eliminate parallax error (see panel, page 129).

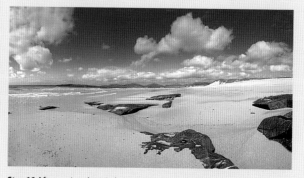

Step 10 After saving the stitch, I rotate it through 180° and flatten the layers (Layer>Flatten Image). I adjust the Levels and Curves until I'm happy with the overall look of the image. I remove any distracting elements using the Clone Stamp tool. The stitch is complete and has an output size of over 85cm (33in) at 300dpi.

TAKE A BREAK

In the last decade, overseas travel has gone from being an occasional indulgence to a regular treat. Thanks to the enormous growth in budget flights from regional airports and affordable hotels, many of us think nothing of jumping on a plane and heading off to a foreign city for the weekend, and not just to tried and tested destinations such as Paris, Venice or Barcelona. Warsaw, Tallinn, Prague, Istanbul, Riga, Bucharest, Marrakech, Krakow and Tangier are among the cities now being frequented by adventurous travellers who want to explore different countries and experience different cultures.

Photographically, city breaks are also a great idea. They are just long enough for you to get to know a place and tap into its photographic potential but not so long that everything starts to feel familiar. Trying to fit photography into a busy life is difficult because there are always other tasks that end up taking priority. But if you get some dates in your diary and book your flights well in advance, when they're nice and cheap, you can get away from it all and focus completely on one thing – taking photographs.

Do your homework
In the meantime, start doing some research so you have an idea what to expect when you arrive. This will enable you to plan the trip in such a way that makes the most of your time.

Where you stay is important. You might be able to save a bit of money by choosing a hotel that's away from the main hub, but if that's where all the interesting subject matter is you'll waste a lot of time travelling to and fro. It's worth spending the extra so that you're in the heart of the place.

Get hold of a guidebook and check websites for information about tourist attractions, such as buildings, monuments, parks and gardens, or anything that could be a good source of pictures. Find out if there are any special events such as carnivals and festivals taking place while you're there. These can be a blessing if you're into that kind of thing, but a nightmare if you're not because it could mean the city is overrun.

Make use of the internet. It's an invaluable source of information and ideas. If you enter your chosen destination in the Google search window it will come up with dozens, if not hundreds, of web links. Even better, if you click on Images when Google has done its initial search you'll be able to access hundreds of photographs of the place you're planning to visit. Most of the images are likely to be fairly ordinary, but they will give you a fantastic visual guide to what you can expect. From there you can compile a hit list of things to photograph. Then, armed with a map of the city, put them into a logical order so you can go from one to the next.

Pay particular attention to classic viewpoints. Every city has one, and usually they're best visited at sunrise or sunset so you need to know exactly where they are in relation to your hotel. As well as photographing the classic views and monuments, also make an effort to shoot smaller, less obvious details that capture the character of the place. Markets and souks are ideal for this. Photograph food, textiles, herbs and spices and local delicacies. And remember, it's the people who make a place what it is, so be sure to shoot a few local portraits while you're there to round off your city break photo essay.

Bon voyage!

ⓘ GOT THE GEAR?

Deciding what equipment to pack for your city break is important. Take too much and it will be a burden, too little and you'll miss opportunities.

For many years my staple travel kit was a Nikon 35mm film SLR with 20mm, 28mm, 50mm and 80-200mm lenses. These days it's a Canon digital SLR with 16-35mm, 24-70mm and 70-200mm zooms. Additional items include a polarizing filter plus 0.3, 0.6 and 0.9ND grads, a remote release, a lightweight tripod, half a dozen 4Gb memory cards, lens cloths and an antistatic brush.

Because I enjoy experimenting with alternative techniques I will also pack one or two other cameras, taking my pick from various Holgas and Dianas, Polaroid SX70s, a pinhole camera, a Lomo LC-A compact, a Lubitel twin-lens-reflex camera or, more recently, an infrared-modified digital SLR, all of which are covered in this book.

▶ **MARRAKECH, MOROCCO**
Although only four hours' flying time from London, Marrakech is a different world. It's exotic, mysterious, slightly menacing and totally mesmerizing. I've been visiting the city for almost 15 years, and though it has changed dramatically in that time, it's still an amazing place to explore and photograph. The colours, sounds, smells and textures will leave you spellbound. It's well worth visiting over a long weekend.
CAMERA: NIKON F5/LENS: 50MM AND 80-200MM/FILM: FUJICHROME VELVIA 50

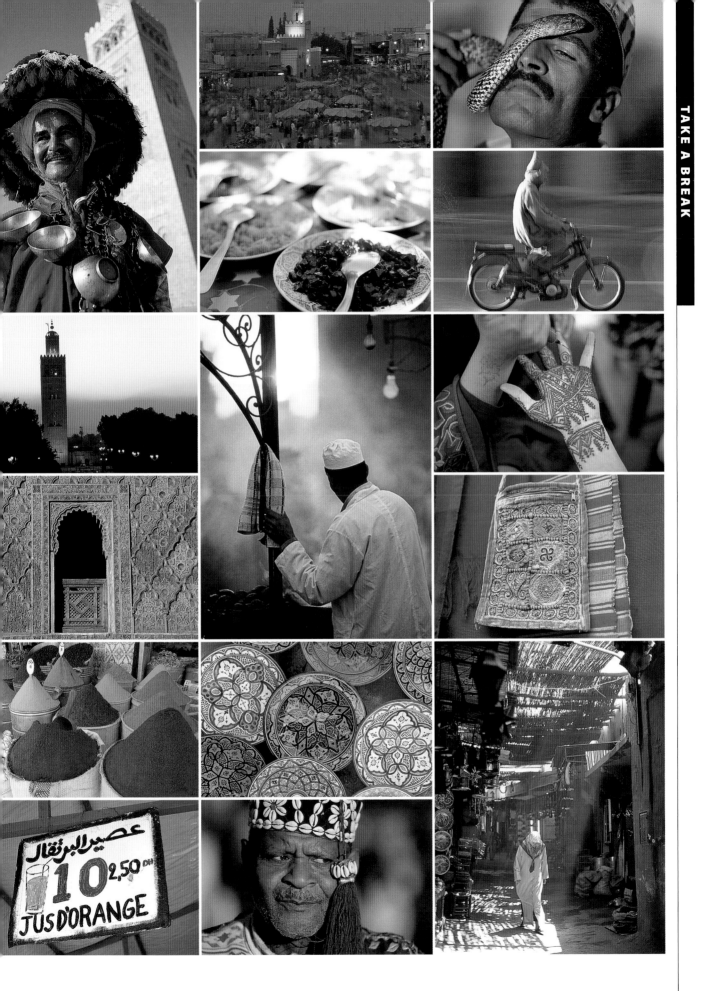

THREE OF A KIND

When we take a photograph it's usually considered in isolation, as a stand-alone piece of work that lives or dies on its own merits. However, when it comes to presenting images, perhaps in an exhibition or a portfolio, for example, partnering them with other images is commonplace, and the visual impact they offer is usually much stronger.

▲ ONE, TWO, THREE
The idea for this triptych came to me while I was experimenting with Polaroid still-life shots. I initially set up and photographed the three pebbles. Then as I was dismantling the pile of stones I realized that I could shoot a progression of three images, the first featuring just one stone, the second featuring two and the third featuring all three, and then present them together. Recently this image was requested for possible publication as a large stretched canvas so my fingers are crossed.
CAMERA: POLAROID SX70 SONAR AF/LENS: FIXED 116MM/FILM: POLAROID TYPE 779

One way of doing this is by creating a triptych, where three images are displayed as a united group or one image has been divided up into three sections. The term triptych (pronounced trip tick) has its roots in the Ancient Greek word *triptychos*, which means three-fold. Artists have used the concept since early Christian times, when the triptych was a common format for altar paintings, where a large central panel was flanked by two smaller, related works. More recently, however, photographers have embraced the idea, as have publishers of art posters, canvases and prints, and they are becoming quite common. There are three basic ways to create a photographic triptych.

• One is to take a single photograph and divide it into separate images. Panoramics work well because you end up with three square images and the finished triptych looks balanced and

pleasing on the eye. One of my own panoramic landscapes was turned into a triptych by a poster publisher and went on sale in a renowned Swedish retailer as a pack of three square prints ready to frame. I wasn't sure about it myself initially, but it went on to sell thousands of copies around the world. (My opinion changed.)

As well as horizontal panoramas, verticals also work well, the main difference being that the three image panels are placed one above the other rather than side by side. Some portrait photographers have adopted this idea, shooting a full-length studio portrait of their subject then turning it into a life-sized block-canvas triptych. Mounted on a wall, the effect can be stunning.

Of course, you don't have to start out with a panoramic image. Any format can be used as the basis of a triptych, even an upright photograph, which would end up as three long, thin images when divided into three. It's really up to you. Whichever format you work from, the final result will be impressive and certainly turn heads.

• The second approach is to take three separate photographs of a scene, moving the camera as required between frames so there's no overlap. This is obviously more involved because the three images must be identical in terms of exposure and colour balance, so camera controls have to be locked to ensure consistency.

That said, you may feel it's a more artistic and honourable way of creating a triptych and therefore worth the extra effort. After all, anyone can slice up one photograph into three.

• The third option is to produce three separate images that are closely related, but not in such a way that if you joined them together they would look like one continuous image. This is where your imagination can run riot. How about taking three disjointed images of the same scene, or uniting photographs of three subjects shot in different places at different times but with a common theme running through them? It could even be three different shots of the same subject, three portraits of the same person but with different facial expressions, or three shots that show the evolution of a composition, like my pebbles triptych opposite. There are no rules here. Just experiment and see what happens.

The great thing about creating a triptych is that it works with landscapes, architecture, still-life, portraits, close-ups, animals, sport, nature or just about any subject you can imagine.

That said, when choosing images for this treatment you need to ask yourself if they will work, especially if you intend to divide a single image into three panels. Simple compositions tend to work better than those that are detailed and cluttered, and you need to make sure that the dividing lines don't cut through important areas or the composition will be compromised.

▼ POPPIES, TUSCANY, ITALY
The easiest way to create a triptych is by taking a single image and dividing it into three separate panels. I prefer to do this with panoramic images because the 3:1 format means I end up with three square panels and the final triptych has a balanced, harmonious feel about it. I might even print this one and hang it on my wall.
CAMERA: FUJI GX617/LENS: 300MM/FILM: FUJICHROME VELVIA 50

TIME AND TIDE

Despite shooting a diverse range of subjects and continually experimenting with new ideas and techniques, one specific area of photography I find myself being drawn back to time and time again is low-light coastal landscapes.

I can't imagine a combination of elements more conducive to successful image-making than waves washing over a deserted beach or crashing against a rocky shore in the soft light of dawn or dusk. Slowly drifting sky is transformed into delicate sweeps of colour, almost as if it were painted by hand, while the sea itself, ebbing and flowing, continuously repositions itself on the image as a series of layers that represent the passing of time, each one subtly different from the last. By contrast, stationary elements stand out in stark 3D against the soft swirl of light and colour.

YOU WILL NEED
- TRIPOD AND CABLE RELEASE
- ND GRADUATED FILTERS
- SOLID ND FILTERS
- TIDE TABLES
- AN ALARM CLOCK

▼ **SANDYMOUTH, CORNWALL, ENGLAND**
At dawn and dusk the light is soft and atmospheric. Light levels are low so you have no choice but to shoot at long exposures.
CAMERA: FUJI GX617 PANORAMIC/LENS: 90MM/
FILTERS: 0.9 ND HARD GRAD AND 0.3 CENTRE
ND/FILM: FUJICHROME VELVIA 50

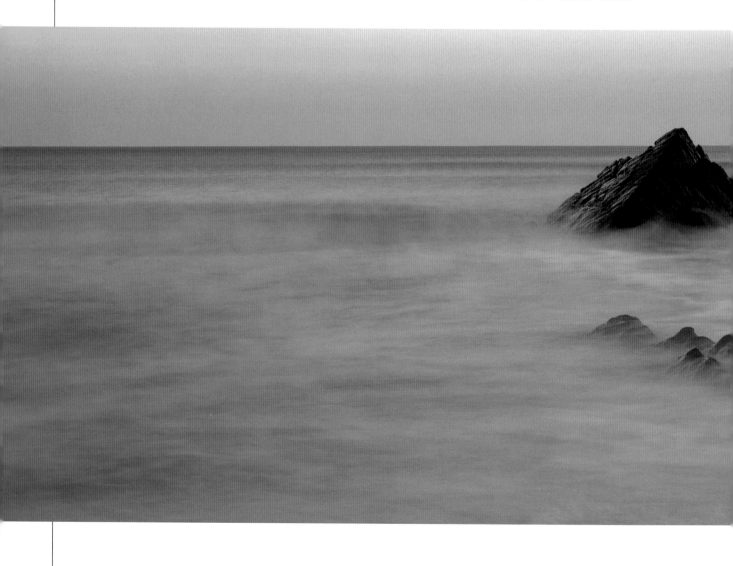

The technique required to capture this effect involves nothing more than opening your camera's shutter and then standing back to let nature take its course. That said, there are various steps you can take to put the odds of success in your favour.

First, you need to find the right location. There are no hard and fast rules here, other than making sure there is something stationary in the scene for the tide to wash around or against. All manner of natural or man-made structures – rocks, jetties, walkways, piers, steps, mooring posts, wind turbines – can be used. I find it pays to explore potential locations during the daytime when visibility is good and there's no time pressure, and then return later to take the shots.

Whether a location works better at dawn or dusk will depend on the direction it faces. You can use a compass to establish that. However, don't assume that if you're on the east coast you need to be there at dawn, or similarly that dusk is the only time to shoot on the west coast. Even if you're on a west-facing beach it can still be possible to take successful dawn shots because colour from the eastern sky can creep westwards. The same applies to east-facing locations at dusk. I've taken long exposure seascapes at both dawn and dusk in the same locations and they were equally effective.

Watch the time

More important than the time of day is the state of the tide, because this can make or break a great image. You can buy tide tables for any region in the UK, but when I know I'm going to visit a certain area I check tide times online using a website such as http://www.bbc.co.uk/weather/coast/tides.

Whether high tide, low tide or somewhere in between is the most suitable will depend on the location. Features such as groynes and jetties tend to be most photogenic at or near high tide as you want the sea to wash around them to optimize the blurred/sharp contrast, whereas rock formations on a beach may be totally submerged at high tide and only visible when the tide is lower.

There's a lot to be said for returning to the same location time after time so you learn where the tide needs to be in order to work with certain features. Local knowledge, combined with tide tables and the high and low water marks on Ordnance Survey maps, will

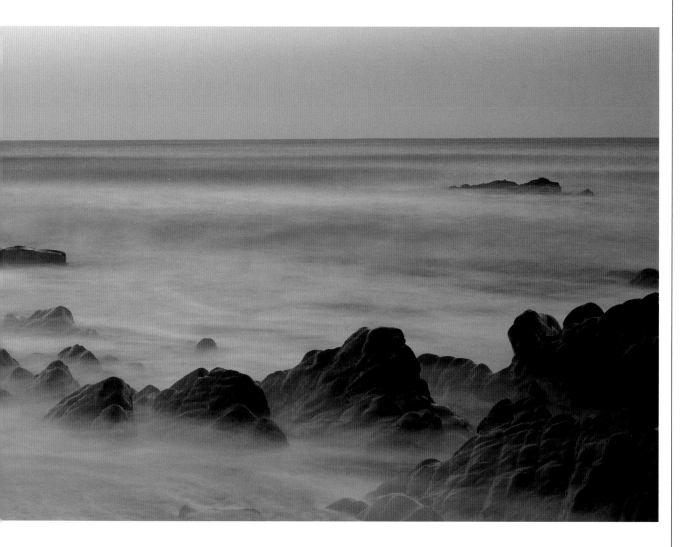

then help you decide where you need to be and when. You may have to wait before the tide is at just the right level at the right time.

Weather or not

Prevailing weather will have a big impact on the mood of the final image, but don't be misled into thinking that you need perfect conditions. Yes, it's great if the dawn or dusk sky lights up with vibrant colour because that colour will also reflect in the sea and the effect can be truly wonderful. But it's surprising how much colour both film and digital sensors can detect and record using long exposures, even when, to the naked eye, everything seems rather muted.

Dull, grey weather can also be hugely successful because long exposure images taken in such conditions tend to come out with a deep blue cast. This is partly due to the colour temperature being

▼ VIEW FROM SCARISTA, HARRIS, OUTER HEBRIDES, SCOTLAND
To emphasize the effect of the sea recorded with a long exposure, include solid objects such as rocks in the composition, so they contrast with the softness of the blurred water. Here the bold shape of the rock outcrop also adds impact to the composition and helps to lead the eye into the scene.
CAMERA: CANON EOS 1DS MKIII/LENS: 16-35MM AT 16MM/FILTER:0.9 ND HARD GRAD/EXPOSURE:20 SECONDS AT F/16

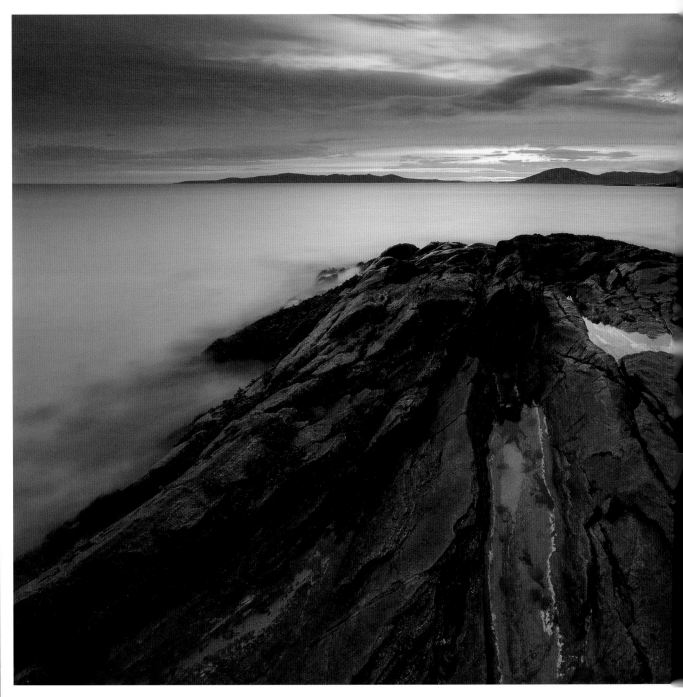

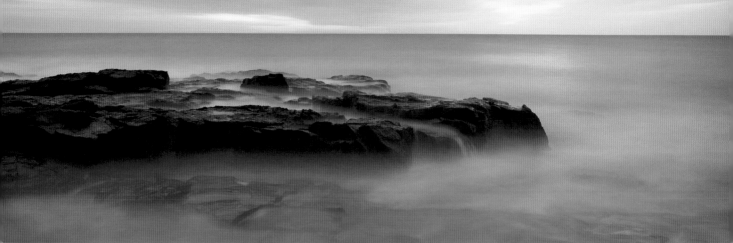

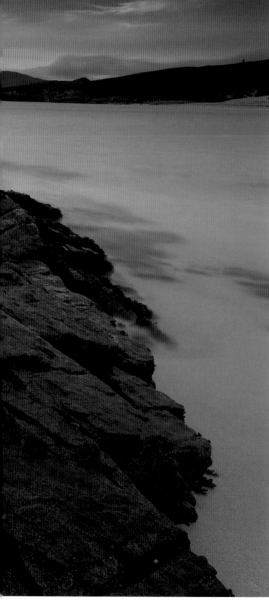

▲ NEAR CRASTER, NORTHUMBERLAND, ENGLAND
On cloudy days the light has a distinct blueness that long exposures record far more vividly than the naked eye can ever detect. This photograph was taken at dawn and is unfiltered. The rich blue hue is courtesy of the film's vibrant colour rendition, the high colour temperature of the light and reciprocity failure brought on by an extreme exposure.
CAMERA: FUJI GX617/LENS:180MM/FILM: FUJICHROME VELVIA 50/EXPOSURE: 3 MINUTES AT F/45

▼ PORTH NANVEN, CORNWALL, ENGLAND
As well as wide views, look also for interesting details on the shoreline. On the evening this photograph was taken the tide was coming in fast and quickly submerging granite boulders on the beach. I used a short telephoto lens to fill the frame with an interesting arrangement of boulders, then waited for waves to wash over them before tripping the camera's shutter.
CAMERA: BRONICA SQA/LENS: 150MM/FILM: FUJICHROME VELVIA 50/EXPOSURE: 8 SECONDS AT F/22

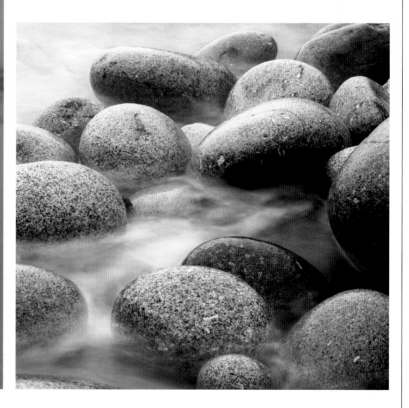

quite high in bad weather, which means the light has a greater content of blue, but also because reciprocity law failure brought on by the use of long exposures causes colour shifts.

Digital cameras seem just as able to record this effect as film, though if you find that your digital images are a touch on the grey side, setting the camera's white balance to Cloudy or Tungsten will make them bluer. Or, you can simply adjust colour temperature when processing your RAW files. Blue 82A cool or 80 series blue filters can be used with film to achieve the same effect, though I find them unnecessary because Fuji Velvia is more than capable all by itself. One type of filter you will need for film or digital is the good old ND grad. Shooting at dawn or dusk, the contrast between sky and foreground is high so unless you 'grad' the sky down it will overexpose and wash out, ruining the final image. With film I find a 0.9ND grad the most suitable and I also use 'hard' grads as the neutral density

▼ TREBARWITH STRAND, CORNWALL, ENGLAND
When the tide is coming in and you're shooting from beach level, you need to act fast and be careful. If waves wash around your tripod legs there's a danger that they will sink into the wet sand mid-exposure, resulting in a blurred image. More importantly, you need to make sure you're not left stranded by the incoming tide, which can be highly dangerous. Always be aware of what's going on behind as well as in front of you.
CAMERA: FUJI GX617/LENS: 90MM/FILTERS: 0.9ND HARD GRAD AND 0.3 CENTRE ND/FILM: FUJICHROME VELVIA 50/ EXPOSURE: 16 SECONDS AT F/32

ⓘ HOW TO ENSURE PERFECT EXPOSURE

I use a hand-held spot meter as my Fuji GX617 and Mamiya 7II lack integral metering. Readings are taken from mid-tones in the foreground, such as wet sand or rocks, and then I bracket. If the metered exposure is 30 seconds at f/22, I'll make one exposure at that, a second at 45 seconds and a third at 60 seconds. Alternatively, if the metered exposure is longer, instead of bracketing by extending the exposure time I open up the aperture. For example, if the metered exposure is 60 seconds at f/22 I'll make one exposure at that, a second for 60 seconds at f/16.5 and a third for 60 seconds at f/16.

Bracketing is necessary to compensate for reciprocity law failure, which causes film to lose speed during long exposures and this results in underexposure. I find that at exposures of 10 seconds or less it's not so crucial, but at 30 seconds and beyond an exposure increase of ½–1 stop is necessary.

If you're shooting digitally, of course, you have instant feedback so what I'd suggest is that you compose the shot, put any ND and ND grad filters on the lens, set the camera to aperture priority AV mode and make your first exposure, leaving the camera's multi-zone metering to sort out the correct exposure time.

The only limitation to this method is that the longest programmed exposure time most SLRs can achieve is 30 seconds, and if light levels are really low or you want to record more motion, you may need to expose for a minute or longer, which means setting the camera to Bulb (B) and making the exposure manually. If this is the case, set the lens to a wider aperture, take a meter reading in AV mode, and then double it for every f/number you stop down by. For example, if the metered exposure is 20 seconds at f/11, it becomes 40 seconds at f/16 and 80 seconds at f/22. Make one exposure at 80 seconds, check the preview image and histogram and if necessary make a second exposure at 120 seconds (an extra half stop) and so on until you get it spot on.

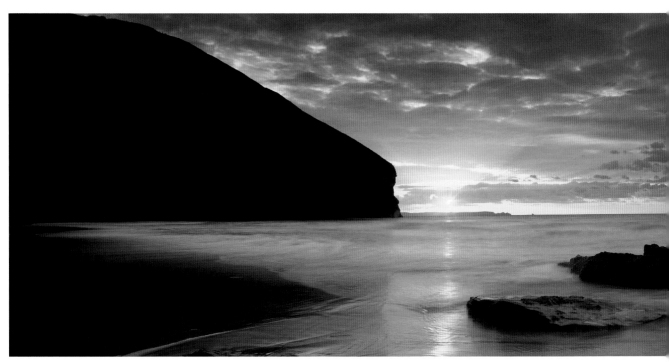

▲ OLD PIER SUPPORTS, BLYTH, NORTHUMBERLAND
This photograph was made using a pinhole camera which, by its very nature, makes long exposures unavoidable even during the middle of the day (see page 88). I set up the camera and tripod close to the old timbers, opened the shutter and let nature take its course.
CAMERA: ZERO IMAGE 45/FOCAL LENGTH: 75MM/FILM: FUJI ACROS 100/EXPOSURE: 30 SECONDS AT F/216

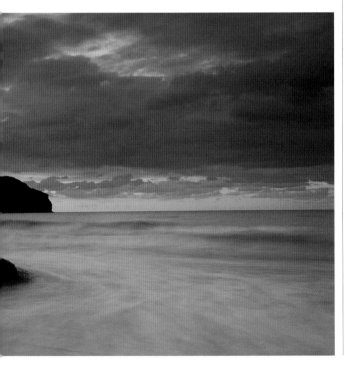

part of the filter is more consistent down to the central zone where it fades to clear. That said, I've worked alongside digital shooters before and found that they need to use a 0.9ND grad plus a 0.3 or 0.6 to get the same result.

The longer the better

Solid neutral density (ND) filters are also handy for increasing the exposure time. I generally find that with ISO50 film and a lens aperture of f/22 or smaller I don't need them because exposures are long enough. In clear conditions, 30–60 seconds is commonplace, and several minutes will work in cloudy weather. However, if your lens only stops down to f/16 and the lowest ISO your camera can manage is 200, you may find that the longest exposure you can use is only four seconds, say, which is too brief to record sufficient motion in the sea and sky because you need a minimum of 30 seconds to do that.

By using an ND filter you can force an exposure increase. If the metered exposure is four seconds, for example, with a 0.6ND filter on the lens it becomes 16 seconds, with a 0.9ND it will be 32 seconds and with a 1.2ND it becomes one minute.

What I find most satisfying about this technique is that until you see the final image you have no idea quite how it will look. But one thing's for sure: it's never a disappointment. Colours seem richer than you remembered them, familiar views are transformed and the wonderful atmosphere created by the blurring of the sea and sky is truly magical.

TOY STORY

Back in March 2006 I flew out to Cuba to lead a photographic holiday. As usual, I packed my preferred travel kit of two Nikons, a Hasselblad Xpan panoramic camera, various lenses and 50 rolls of Fujichrome Velvia. But just as I was about to close the equipment cupboard, I noticed something lurking in the shadows.

It was my Holga 120GN toy camera. I'd bought it a year or so earlier, shot a few rolls of HP5 then forgot all about it. So, feeling slightly guilty, I blew off the dust and chucked it into my backpack, along with a few rolls of outdated Fuji NPS Pro160 120 colour negative film.

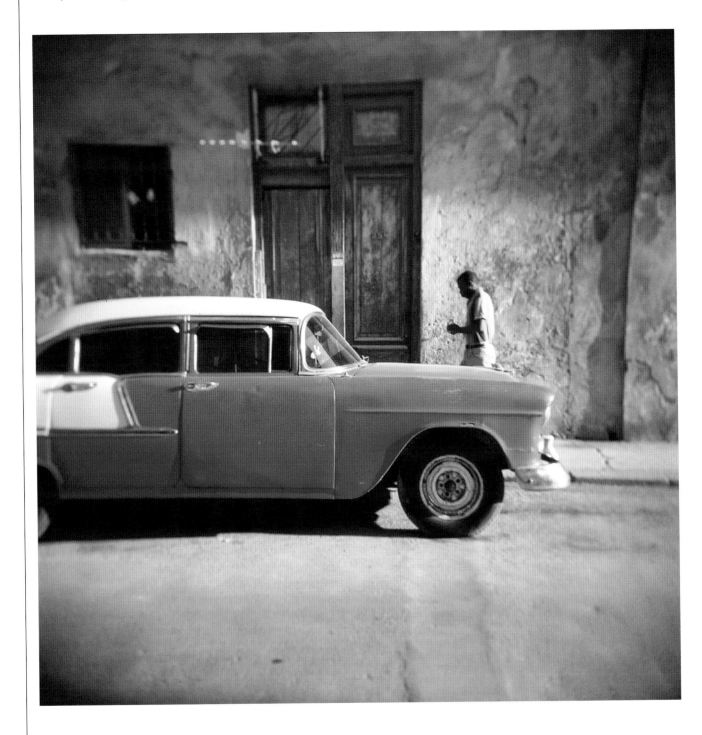

Two weeks later, the trip was over, the processed films arrived back from the lab and I excitedly rushed to my office for a first look. As always, the Velvia slides looked great. But the Holga images astounded me. I only used the camera as an afterthought as I didn't expect to get much from it, but the results stopped me in my tracks. For the first time in years I had an epiphany. I couldn't believe how amazing the Holga shots looked. They were quite unlike anything I'd seen before. They captured the crumbling character of Cuba perfectly, far better than super-saturated, super-sharp Velvia. Ever since then, the Holga has been a constant companion.

You might be thinking, 'So what?' But what I haven't mentioned is that the Holga 120GN is a cheap, plastic, mass-produced 6 x 6cm rollfilm camera that costs just £20 ($35.00). Brand new. Boxed. Guaranteed. (Well, I'm not sure about the guarantee.)

The Holga was developed in China in 1982 so that people with little money could still own a camera. But in the photographic world you tend to get what you pay for and something had to give. In the Holga's case, it was everything.

The result is plastic and flimsy and more likely to squirt water into your face than take pictures. But take pictures it does.

◀ HAVANA, CUBA
This image was made on my first trip with a Holga and is responsible for my obsession with toy cameras. I love everything about it – the sharpness at the centre and gradual softening towards the edges, the rich colours, the vignetting, the fact that the man walked into the scene just as I was about to fire . . . I couldn't have dreamt it up.
CAMERA: HOLGA 120GN/LENS: FIXED 60MM/FILM: FUJI NPS PRO 160

▼ CAPITOLIO, HAVANA, CUBA
This is what happens if the film doesn't wind tightly onto the take-up spool. Light creeps behind the backing paper and fogs the edges of the film. Do I care? Absolutely not. The fogging helps to frame the building and also makes it a unique image. Try achieving that in Photoshop.
CAMERA: HOLGA 120GN/LENS: FIXED 60MM/FILM: FUJI NPS PRO 160

ⓘ TOY SHOP

There are three different Holga models available, all producing 12 6 x 6cm images on 120 rollfilm. There is the basic 120GN, the 120GFN, which comes with a built-in flash, and the 120GCFN, which has dial-in coloured filters for the flash. The 'G' on the name denotes that the camera has a glass lens. Earlier Holgas bearing the 'S' or 'N' badge have a plastic rather than glass lens, though this doesn't seem to make much difference to image quality.

The most sought-after classic toy camera is the Diana. Made in China in the 1960s by the Great Wall Plastic Factory, it was originally intended as a cheap promotional camera and funfair prize. It takes 120 film but has a 4 x 4cm image format and records 16 frames per roll. You can often find original Dianas on eBay, or one of up to 50 Diana clones, such as the Hi-Flash, Banier, Arrow and Great Wall.

Dianas have just one shutter speed of around 1/100sec, plus three apertures (f/16, f/6.3 and f/4.5), which are formed by holes in small metal discs. Dianas also have three distance settings. Like the Holga, they're prone to light leaks and one of my Dianas is so bad that I have to cover every seam and joint with gaffer tape so that the camera itself is completely unrecognizable. But then, that's all part of the fun of toy camera photography.

The original Dianas ceased production in the 1970s, but a new version of the camera, the Diana+, is now being manufactured and sold by the Lomography Society (see pages 66–69).

Among the other vintage cameras that fall into the toy camera category are the Fujipet, Kodak Brownie Hawkeye, Falcon Junior, Mercury Satellite and Agfa Clack.

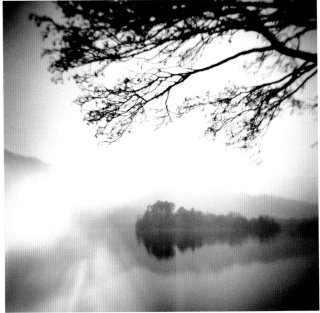

▼ GRASMERE, LAKE DISTRICT, ENGLAND
Light leaks are common in toy cameras, especially old Dianas. However, it isn't necessarily a bad thing because when the leaks work to your advantage, the results can be out of this world. I have a range of toy cameras that suffer from specific problems but rather than trying to solve them, I try to harness them creatively, as shown here.
CAMERA: DIANA F/LENS: FIXED 75MM/FILM: FUJI NPS PRO 160

▲ HONEY SELLER, TRINIDAD, CUBA
It's possible to take successful portraits with toy cameras like the Holga, but you need to make sure your subject's face is positioned in the centre of the frame where the lens is reasonably sharp. Getting the focusing distance correct can be hit and miss. I usually take three or four shots at slightly different focus settings to put the odds of success in my favour.
CAMERA: HOLGA 120GN/LENS: FIXED 60MM/FILM: FUJI NPS PRO 160

Okay, Holgas are not very sharp. Except for a sharpish sweet spot in the centre of the picture everything blurs away as if you've gone mad with a jar of Vaseline. The corners vignette and, if you're unlucky, your camera may leak light, or the back may fall off mid-roll.

Optics? They offer a fixed, slightly wide-angle 60mm lens. The latest Holgas boast a glass lens, but that doesn't seem to have made much difference to image quality.

Exposure and metering? Well, it's either 1/100sec at f/11 or bulb at f/11, which means that correct exposure is reliant on the wide exposure latitude of negative film. Load a Holga with slide film and you're going to be disappointed.

Focus? No predictive AF, I'm afraid. It's all manual with four dubious distance settings denoting 1m, 2m, 6m and 10m–infinity. Generally these aren't very accurate, so it's worth taking each shot at two or three different distance settings to ensure your subject is sharp in one of them.

To take a picture you depress a lever on the side of the camera, which activates the spring shutter. Film is wound onto the next

ℹ TOY CAMERA PANORAMAS

Because film inside the Holga – or any other toy camera – is manually advanced and the shutter can be fired regardless of whether you wind on or not, it's possible to create unusual panoramic images by only partially advancing the film after each shot so you make a series of exposures that slightly overlap. You can do this for an entire roll if you like, to create one long image.

With care it's possible to move the camera after each frame so the final panorama looks convincing, except for the obvious joins. However, I prefer to take a more random approach so parts of the scene are captured more than once. Sometimes, I'll actually wander around and shoot overlapping frames from different positions to give the image a sense of time. It's totally hit and miss, but great fun.

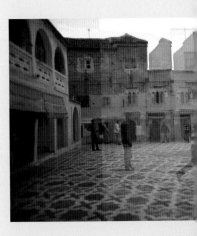

▶ CHEFCHAOUEN, MOROCCO
Here's a Holga panorama. I took a series of shots as I scanned across the courtyard but didn't worry about some parts of the scene, or some people in the scene, appearing more than once.
CAMERA: HOLGA 120GN/LENS: FIXED 60MM/FILM: FUJI NPS PRO 160

▼ SAHARA DESERT NEAR MERZOUGA, MOROCCO
If your toy camera images aren't unusual enough in their naked state, why not try cross-processing your film? The weird and wonderful colours combined with coarse grain and increased contrast will really make them stand out from the crowd.
CAMERA: HOLGA 120GN/LENS: FIXED 60MM/FILM: FUJI PROVIA 400F

▲ PAIGNTON, DEVON, ENGLAND
The Diana camera differs to the Holga in that its images have an overall softness rather than a sharp centre and soft edges. That said, Dianas are also like snowflakes in that no two are the same, so that characteristic could be unique to mine. What I like about the Diana is the 4x4cm image size, which not only means I get 16 frames per roll of 120 film but also that unexposed areas of film around the image can be used to create a border.
CAMERA: DIANA F/LENS: FIXED 75MM/FILM: FUJI NPS PRO 160

frame manually and a red window on the back of the camera tells you when you've got to the right frame number. Alternatively, you can create multiple exposures (even if you don't want to) by re-firing the shutter without advancing the film.

I admit that things aren't sounding very good so far, but ironically, all these unsophisticated characteristics are what make the Holga and other toy cameras such a joy to use. The lack of control frees you to just wander around, snapping away without a care in the world. I found using my Holga to be a real breath of fresh air and a complete creative release – the perfect antidote to this digital age.

Toy camera photography is so casual. You don't need light meters, tripods (though you can mount a Holga on a tripod for bulb exposures), filters, separate lenses or any of the paraphernalia normally associated with serious photography. You just sling a Holga over your shoulder – it's so light you won't even realize it's there – stuff a few rolls of 120 ISO400 black and white or colour negative film in your pocket, and away you go.

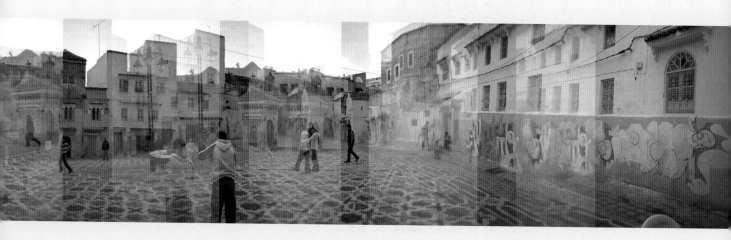

With the technical side of photography removed from the equation, you can concentrate solely on the art of seeing. In fact, I've found that the images I take with my toy cameras are totally different from those produced with more sophisticated equipment. They have an innocence and simplicity about them, and a wonderful dream-like quality that feeds the imagination and allows you to create your own narrative, instead of hitting you between the eyes with sharpness and detail.

Lack of perfection also encourages the user to break the so-called rules of composition. It no longer matters if the horizon is slightly wonky or the main subject is breaking out of the frame. Blur, whether mild or severe, can add to the magic and mystery of toy camera images.

Not convinced? Then why not try one for yourself? With such a low price tag you've got nothing to lose. However, like me, you will probably find that your perception of what makes a great photograph will be changed forever, and for the better.

TOY CAMERAS ON THE WEB

www.toycamera.com
www.holgamods.com
www.holga.net
www.flickr.com/groups/toycameras/
www.lomography.com

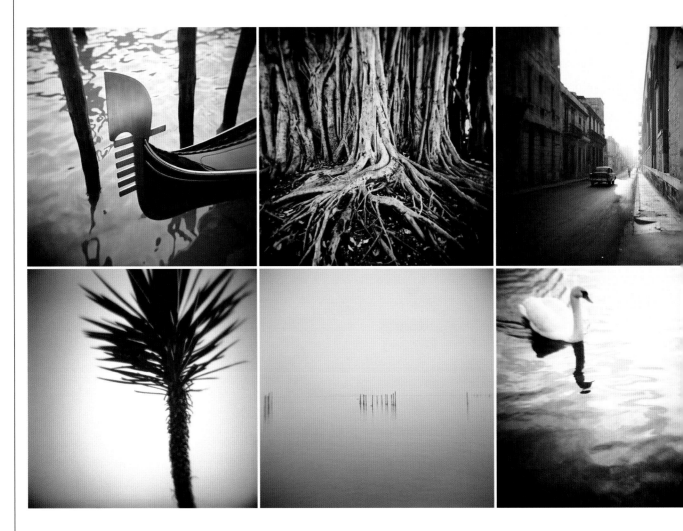

▲ CAMERA: HOLGA 120GN AND DIANA F/LENS: FIXED 60MM AND 75MM/ FILM: ILFORD XP2 SUPER

TOY CAMERA TIPS

• If the film doesn't wind onto the take-up spool tightly, fogging will result. I've actually had some nice effects from this, but to avoid it, fold up a bit of film carton and push it under the film spool so it's held more securely in place.

• If your camera leaks light use strips of black gaffer tape to cover the offending cracks (and prevent the back falling off at the same time, which it's prone to do). If you use a Diana camera, or a Diana clone, cover all joints and seals with gaffer tape because light leaks are almost guaranteed.

• Don't trust the distance settings on the lens. I always take two or three shots of the same subject with the lens set to a different distance. If I estimate the subject is 2m (6½ft) away, I'll do one frame with the lens set to 2m, a second with it set halfway between the 1m and 2m symbols and a third with it set halfway between the 2m and 6m symbols. Of the three, one frame is always sharp (a term I use loosely when referring to toy cameras).

• If you want to use filters on the Holga lens, secure them with putty adhesive. Or, with a bit of force, you can screw a 46–49mm stepping ring into the soft plastic of the lens mount, and then either screw 49mm filters into that or attach a filter holder.

• If you want to shoot close-ups with a Holga, attach supplementary close-up lenses. I did some tests and found that with the lens set to the 1m symbol, minimum focus is reduced to 63cm (25in) with a +1 dioptre lens, 35.5cm (14in) with a +2 and 24cm (9½in) with a +4.

• The viewfinder probably shows less than 80% of the image area, so expect to get a lot more in the shot than you anticipate.

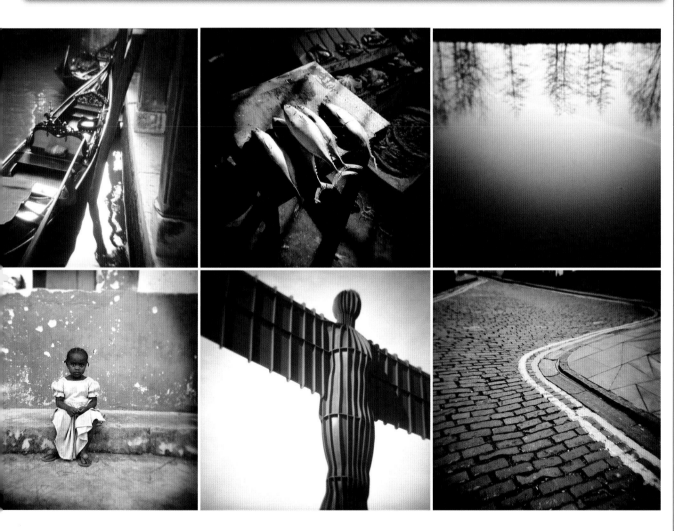

TWO FOR ONE

The first medium-format camera I owned was a Mamiya C220 twin lens reflex camera. It was the late 1980s, I was just getting seriously into photography, and though I hankered after a Hasselblad, a secondhand TLR was all my meagre budget would stretch to so, grudgingly, I bought one.

It wasn't a happy union. TLRs were cheap because they were no longer fashionable, and as soon as funds allowed I upgraded to a Pentax 67. This was a camera with street cred, a camera to be proud of. But age does strange things to the mind, and 20 years later I suddenly started to think a TLR might be a useful addition to my kit. I never really gave it a chance the first time round. I was more bothered about my image than those coming from my camera. It was time to set things straight.

Several weeks and much eBay-bidding later, my camera arrived to a much more enthusiastic welcome this time round.

Notwithstanding the bargain price I managed to acquire the camera for, around one-third of what I'd paid two decades earlier, the main attraction of the C220 was the format. After 20 years of shooting rectangular pictures and criticizing the square format, I suddenly realized that I really liked the square pictures. Rather than simply crop 6 x 7cm images to a square, however, I decided to do the job properly and buy a square-format camera.

What really appeals to me about the twin-lens reflex design is that you see with one lens and take the picture with another. The taking lens is directly beneath the seeing lens, which means that the viewfinder never blacks out as it does with an SLR, so you can see exactly what's going on in the frame even while the film is being exposed. This is why TLRs were so popular for weddings and portraits – you never lost sight of the subject. It's also invaluable when using long exposures in low light as you can see if anything strays into the picture area mid-exposure and also assess if things, such as breaking waves, are entering far enough into the picture area.

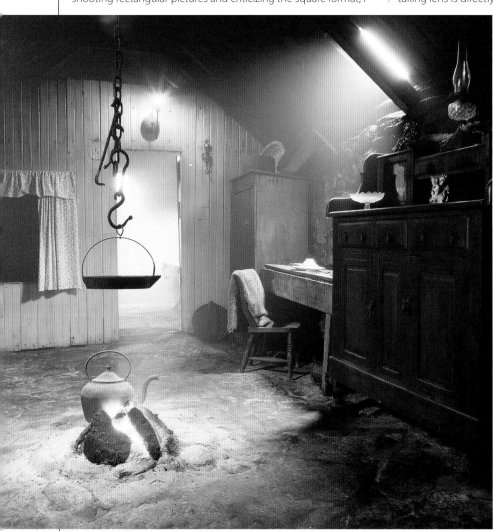

◄ ARNOL BLACKHOUSE, ISLE OF LEWIS, SCOTLAND
This was a tricky subject to shoot. Not only was the room filled with acrid smoke from a peat fire, but there were mixed light sources to contend with (firelight, tungsten light and daylight) and contrast was very high. Nevertheless, the Mamiya C220 coped with it admirably, producing a balanced, high-quality image that would hold its own against any digital SLR, despite the Mamiya costing next to nothing in comparison.
CAMERA: MAMIYA C220 TLR/LENS: 55MM/FILM: KODAK PORTRA 160 VC

▲ SHIEILING DETAIL, ISLE OF LEWIS, SCOTLAND
Despite its low cost, the image quality that can be achieved with the lenses for the Mamiya C220 (and its big brother the C330) is surprisingly high. Working with the waist-level viewfinder is also a pleasant change if you're used to having a camera pressed against your face.
CAMERA: MAMIYA C220 TLR/LENS: 80MM/FILM: KODAK PORTRA 160 VC

WHAT CAN I DO?

The Mamiya C220 offers the same level of specification you'd expect from any traditional medium-format camera. The basic camera is non-metering and comes with a waist-level finder, though I'm sure a prism finder is available if you look hard enough.

The 6 x 6cm film format produces 12 images on 120 rollfilm and 24 on 220 rollfilm, and the camera can be fitted with the following interchangeable lenses: 55mm, 65mm, 80mm, 105mm, 135mm, 180mm and 250mm. All these lenses have leaf shutters, which means that you can synchronize electronic flash at any shutter speed, and the range of shutter speeds offered by each lens is 1–1/1000sec plus bulb (B).

Focusing is manual and works by means of a bellows system, which enables you to focus very close (down to around 20cm/8in with the 80mm lens) without using attachments. There are also scales on the side of the camera for exposure compensation and depth-of-field with the different lenses.

Looking down
Working with a waist-level finder seemed rather strange at first, as did the fact that the image on the focusing screen is back-to-front. However, I now see both these factors as an advantage. The waist-level finder makes the image more remote, more detached, so being able to assess it objectively is easier. And I also work on the basis that if the composition looks good back-to-front, it's bound to work the right way round.

To me, one of the biggest attractions of TLR cameras, however, is the fact that they use bellows to focus so you can focus very close without the need for special attachments. My Mamiya 7II rangefinder camera has a minimum focus of 1m (3¼ft), which is fine for landscapes, but not so fine for close-ups and portraits. My Mamiya C220, on the other hand, which costs around 15 times less than the 7II, will focus down to about 20cm (8in) with the 80mm lens attached, making it much more versatile. I love using it to shoot such details as the patterns and textures in rock in a landscape. I also often keep it loaded with black and white film so I can alternate between colour and black and white.

What you see
The one thing that you have to watch out for with a TLR camera is parallax. Because you see the subject with one lens and photograph it with another, what records on film will differ slightly from what appears on the focusing screen. It's not an issue for distant subjects or wide views as parallax is minimal, but when you are shooting at close-focusing distances it's much more evident and can spoil your composition.

Markings on the focusing screen help to avoid problems and with practice you learn how to adjust the composition to overcome parallax. Alternatively, you can pick up a handy attachment on eBay called a Mamiya Paramender, which fits between the camera and tripod head and allows you to compensate for parallax.

Image quality on the whole is superb. In addition to the 80mm standard lens that came with the camera body, I also purchased a 55mm wide-angle lens and, despite the fact that both are more than 20 years old and lack the fancy multi-coating you expect on modern optics, they turn in a fantastic performance. The images are crisp and sharp from corner to corner and I can make hand-prints from the negatives or inkjet prints from scanned negatives as large as 61 x 61cm (20 x 20in).

Time for change

If you've already made the switch to digital, the idea of reverting to film may seem like an alien concept. However, if you've taken up photography in the last few years, chances are you never used a film camera seriously before and went straight for a digital SLR instead. If that's the case, I'd consider buying a camera like the Mamiya C220 because you'll be surprised at just how different and satisfying the process of taking pictures is when you load actual film into your camera instead of a memory card. I'm not suggesting one is better than the other. Frankly, we're all bored with that argument. What I

▲ TARANSAY, OUTER HEBRIDES, SCOTLAND
With a minimum focusing distance of just a few centimetres you can use the C220 to shoot small details in the landscape, though make sure you adjust the composition to account for parallax error, otherwise the final picture will look rather different to how you expected.
CAMERA: MAMIYA C220 TLR/LENS: 80MM/FILM: FUJICHROME VELVIA 50

am saying, though, is that they're different disciplines. As a dyed-in-the-wool film shooter I even find that switching from a rectangular format such as 6 x 7cm to the square of the C220 changes the way I see and think and that in itself results in different work.

Just because you have embraced new technology, there's nothing to stop you dabbling with the old as well. And at the kind of prices you can pick up old film cameras, like the Mamiya C220, it's not as if you're having to make a huge financial commitment. However, the benefits to your photography could be huge.

◄ GRASMERE, LAKE DISTRICT, ENGLAND
The square format of the C220 is ideal for landscapes. It produces quiet, balanced compositions that are perfectly suited to simple scenes like this. CAMERA: MAMIYA C220 TLR/LENS: 55MM/FILM: FUJICHROME VELVIA 50

FROM RUSSIA WITH LOVE

A much cheaper, simpler alternative to the Mamiya C220 is the Russian Lubitel TLR. The makers of this multi-million-selling camera ceased production in the late 1980s but it has achieved cult status around the world thanks to its crude, plastic design.

Lubitels can be picked up at secondhand stores or on auction websites for the price of a few rolls of film. However, in capable hands they can produce surprisingly good results. I've owned one for a while now and I'm more than happy with the images produced. Some compare the fixed 75mm lens to the early Carl Zeiss lenses used on vintage Hasselblads.

The Lubitel's features are fairly basic. It has apertures from f/4.5 to f/22, shutter speeds from 1/15–1/250sec plus bulb (B), flash sync at all shutter speeds, manual film advance and focusing, waist-level viewfinder and minimum focus of 1.3m (4¼ft). It's compact and lightweight, measuring just 125 x 95 x 90mm (5 x 3¾ x 3½in), and produces either 12 6 x 6cm images on 120 rollfilm or 15 6 x 4.5cm images if you insert an accessory mask.

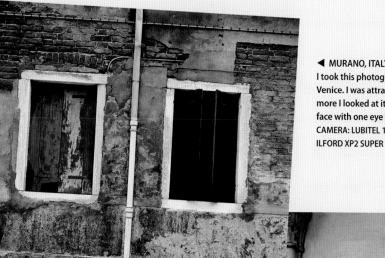

◀ MURANO, ITALY
I took this photograph while waiting for a waterbus back to Venice. I was attracted to the symmetry of the scene, but the more I looked at it, the more I was convinced I could see a face with one eye winking at me.
CAMERA: LUBITEL 166 UNIVERSAL/LENS: FIXED 75MM/FILM: ILFORD XP2 SUPER

▶ CARNEVALE, VENICE, ITALY
Despite the crude quality of its build and basic features, the Lubitel 166 is relatively quick and easy to use and capable of producing high-quality images with a beautiful tonality.
CAMERA: LUBITEL 166 UNIVERSAL/LENS: FIXED 75MM/FILM: ILFORD XP2 SUPER

VACANT POSSESSION

Whenever I find myself standing outside an abandoned old building, I'm suddenly gripped by a desperate urge to leapfrog fences, crawl through broken windows and tip-toe across rotting floorboards just to take a look inside.

It's the sense of mystery and intrigue that draws me in. Old buildings are the guardians of so many secrets. They have been witness to laughter and tears, good times and bad. History has taken place behind their walls. When a building that was once home finds itself empty, its atmosphere is also tinged with sadness. Who were the last people to live there? And why did they leave?

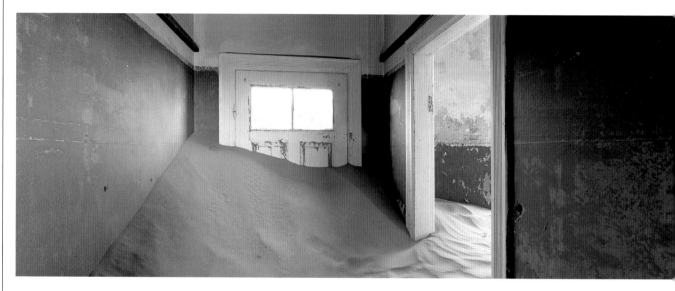

▲ **KOLMANSKOP, NAMIBIA**
The old diamond-mining town of Kolmanskop is slowly being consumed by the Namib Desert. I took this photograph five years ago. By now, the room, even the whole house, may have been buried forever.
CAMERA: HASSELBLAD XPAN/LENS:30MM/FILTERS: 0.45 CENTRE ND/FILM: FUJICHROME VELVIA 50

It's not uncommon to enter abandoned homes in remote areas and find such personal possessions as furniture, clothing, cutlery, pots and pans, books, toys or cans of food still inside. It's almost as though the former inhabitants simply walked out one day and never came back.

In the town of Kolmanskop in Namibia, southern Africa, that's pretty much what happened. The town sprang up in the early 20th century when diamonds were discovered in the area. However, 30 years later it was deserted and has been left to the ravages of nature ever since.

At the height of the diamond rush there were 300 Germans and 800 Namibian labourers living in Kolmanskop and life there was downright lavish for some of the inhabitants. Grand German houses were constructed for the managers and key workers. There was also a casino, a hospital, a furniture factory, a lemonade and

soda plant, four skittle alleys, a swimming pool and a grand hall complete with a theatre and an orchestra that played at tea dances.

Walking through the town today is a surreal experience. Kolmanskop was built on the edge of the Namib Desert, and for the last 50 years, the desert has slowly been claiming it back. Some buildings are gone forever, buried deep beneath the shifting sands, while several of the grander houses cling on hopelessly. Broken windows and shattered doors no longer hold back the wind-blown sand and, over the years, this has accumulated so that some rooms are already half full, the sand banked high in one corner where the wind has been brought to an abrupt halt. Exotic wallpaper, bleached and tattered, still adorns walls. Heavy roll-top baths sit in bathrooms, along with porcelain hand basins that haven't seen a drop of water for decades.

Closer to home

But you don't have to go all the way to southern Africa to witness this. During a trip to Tuscany in May 2008, I was amazed how many imposing farmhouses lay abandoned and crumbling. The odd one or two were clearly in the process of being renovated, but the majority stood empty and forlorn, windows and doors boarded and 'No Entry' signs warning off nosy photographers.

Eventually, curiosity got the better of me and I decided to enter one of the houses. This was not an easy proposition because it was

surrounded by a high fence, but when I get an idea in my head . . .

It soon became clear that the interior was in a bad state, but there were still some fascinating finds, such as an old chair propped against a pink wall in a room where the floor was scattered with books and children's toys. An old wine bottle sat on a windowsill, covered in cobwebs and dust. I must have spent at least two hours inside taking photographs, and could have stayed much longer.

Remote, sparsely populated areas tend to be where these abandoned homes are still found. In such areas, economic hardship or natural disaster have driven people away, never to return.

In the far reaches of the Scottish mainland and outlying islands, deserted houses are widespread. You can see them in almost every village. Many are ruined blackhouses, abandoned in favour of more modern dwellings in the 1920s and 30s. However, a large proportion of vacant dwellings appear to have been occupied until recent times and most likely were abandoned when the last owner or tenant passed away. With depopulation still widespread in the Highlands and Islands, often there are no family members left in the area willing to take the property on, so it's left to fall into disrepair.

All the same

Wherever the building happens to be, the ravages of time tend to have the same effect. I have photographed interiors in Scotland that looked no different from interiors in Namibia thousands of miles away. They have a unifying look and feel about them. The doors fall off their hinges, windowpanes are smashed, thick layers of dust cover every surface, paintwork blisters and cracks and wallpaper hangs off the walls.

Another factor that unites abandoned old buildings is the quality of light you find inside. With no electricity to provide artificial lighting, the only illumination available is daylight streaming in through doorways and windows or, in many cases, through the holes in the roof.

Direct sunlight acts like a spotlight, picking out specific areas while all around is plunged into deep shadow. This is ideal for shots of details such as an old chair propped against a wall or to highlight the texture in peeling paint.

I prefer non-direct light because it's much softer and full of atmosphere. In sunny weather, such illumination is created

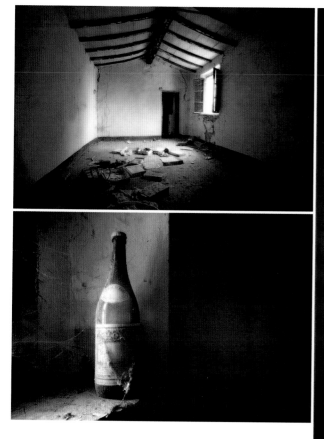

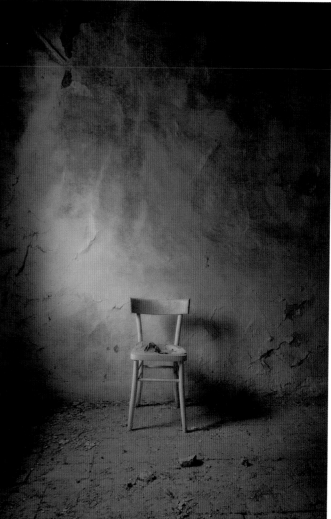

▲ ▶ COSONA, TUSCANY, ITALY
This old farmhouse was like a photographic Aladdin's cave. Not only could I take great wide-angle shots of whole rooms, but also close-ups of smaller details, such as the old chair propped against a wall and the cobweb-covered wine bottle. I must have spent two hours inside, but barely scratched the surface of its photographic potential.
CAMERA: NIKON D70 INFRARED CONVERSION/LENS: 10–20MM/ISO:200

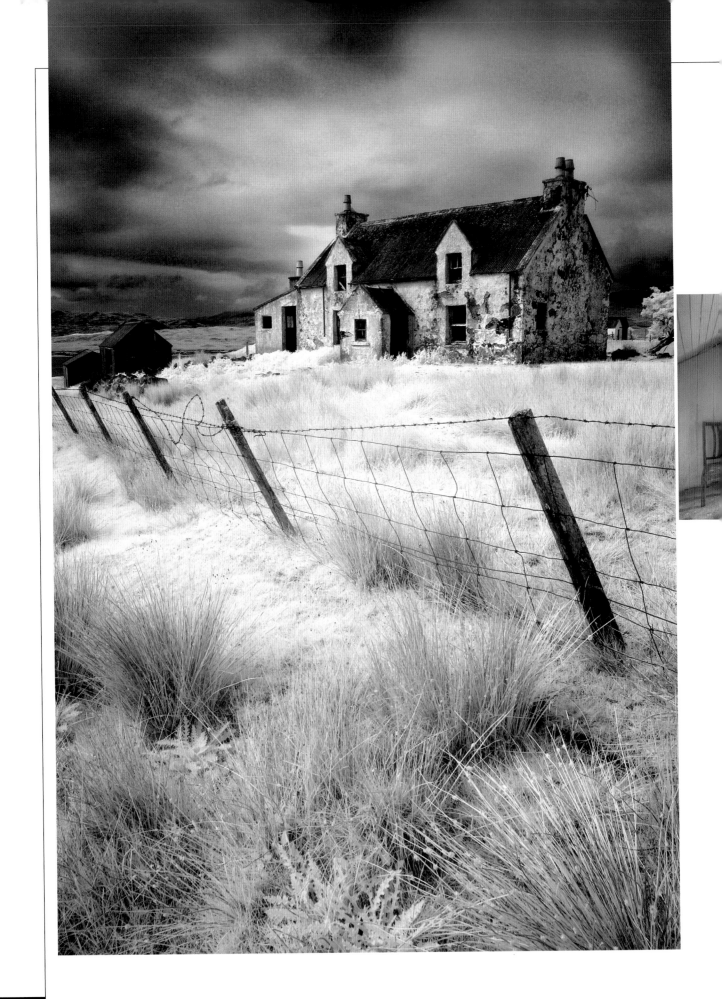

ⓘ ENTER AT YOUR OWN RISK

A building may be abandoned, but it's still private property. Don't assume you have a right to enter at will. Trespassing is against the law and in some countries can result in prosecution.

Where possible, I try to speak to someone living nearby and enquire if they think it would be okay to go inside and take photographs. If they advise against it, I respect their advice and move on.

Safety must also be taken seriously. Old buildings are often dilapidated and unstable. Staircases and floorboards could collapse under your weight, or the ceiling could fall in. If there are signs displayed warning 'Danger. Do not enter', think twice before you proceed. And if you decide to enter anyway, always exercise extreme caution. No picture is worth serious injury, or worse.

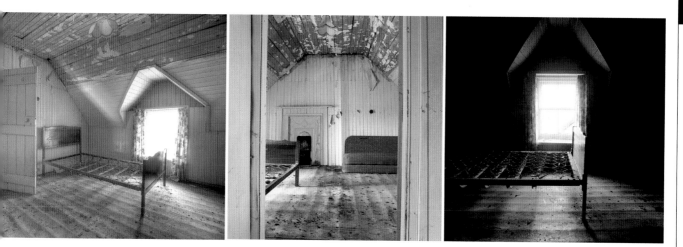

◀ ▲ ISLE OF LEWIS, OUTER HEBRIDES, SCOTLAND
I've photographed this deserted croft on two occasions now and noticed a definite deterioration in its condition in the two years between visits. The bleak, isolated location and somewhat drab exterior offer no hint of the surprises hidden inside, including walls painted bright yellow and lurid green. There's even a shocking pink fireplace. Old chairs and bed frames still in situ provide further interest, and the delicate light of a dull day really brings everything to life.
CAMERA: MAMIYA C220, CANON EOS 1DS MKIII AND CANON 20D INFRARED CONVERSION/LENS: 55MM ON MAMIYA, 16-35MM ON CANONS/
FILM: KODAK PORTRA 160 VC IN MAMIYA

by light reflected from the sky or exterior surface, while in dull, overcast weather, all light entering is reflected because the sky acts like a giant diffuser over the sun.

Usefully, you get this wonderful soft light on rainy days, which is an ideal time to head for an old building because you can get under cover to keep dry and continue shooting in light that's just right for the subject. Most of my own photographs of abandoned buildings are taken in dull or wet weather because if it's dry and sunny outside that's generally where I will be. It's only when the weather takes a turn for the worse that I start looking for alternative subject matter.

The type of pictures I take depend on the state of the interior and what's left inside. For example, if the rooms are empty shells then I tend to use a wide-angle lens and shoot the whole thing. I check out the view from one room to the next because doorways can be used as a compositional frame. In addition, if

the light outside is intense I usually exclude any windows as they will overexpose and blow-out. However, that said, old interiors make ideal subjects for HDR images where the extreme contrast is merged into a single image (see page 35). Where furniture and personal possessions have been left behind you can really go to town, shooting a series of 'found' still-lifes. The patterns and textures found inside old buildings also deserve attention.

Finally, let's not forget the exterior itself, which frequently offers as much photographic potential as the interior does. Shoot a general view to show the building in its environment, then move in closer and start looking at smaller details. This might include the colours and textures in old window and door frames, rusty roofing materials and weathered timber. Once you have got started, it's very difficult to stop, but when you eventually do you should have a set of images that paint a fascinating portrait of a building nearing the end of its natural life.

VERTICAL LIMIT

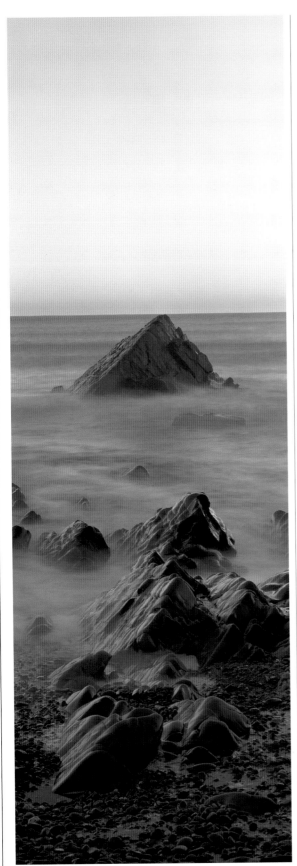

The panoramic format has become increasingly popular in recent years as more photographers use purpose-made cameras such as the Hasselblad Xpan or digital stitching software to create dynamic images. I'm a great fan of the 3:1 format myself, as many of the images in this book demonstrate. I find it easy to compose using the narrow rectangular shape, and the resulting images have great visual strength because they draw the viewer into the scene.

What few photographers ever do is turn a panoramic camera on its side to shoot vertical images. However, I have found this to be a really effective technique because it produces much simpler, almost abstract results. And, by excluding so much of the scene on a horizontal plane, it jars the senses and leaves the viewer wondering what was going on outside the frame.

The key is to choose the right kind of scene. Whereas horizontal panoramas minimize the amount of foreground and sky in a composition, vertical panoramas do the opposite as they rely on there being an interesting foreground to lead the eye into and through the scene, and an attractive sky to top it off. This is because the images are read differently by the viewer. Horizontal panoramas are scanned from left to right so they don't rely on foreground interest, while vertical ones are viewed from bottom to top, so they do.

Coastal scenes are ideal for vertical panoramas. Rock-strewn beaches offer many opportunities. You can use the rocks as visual stepping stones to carry the eye in leaps and bounds from the foreground and into the heart of the scene. Ripples on a sandy beach do the same thing.

In the urban landscape, use the lines created by things like road markings, railings and pavements to draw the eye into the scene. Look for strong vertical lines in buildings, monuments, sculptures and structures such as bridges, and optimize their impact by shooting vertical panoramas. It's best to move in close with a wide-angle lens on the camera so perspective is exaggerated and the lines are emphasized.

Front to back

When shooting from ground level you'll need to maximize depth-of-field to make sure everything in the scene records in sharp focus. This is especially the case when using a wide-angle lens that will capture everything from your toes to infinity. Stopping down to f/22 or beyond if you can will be necessary with a panoramic camera. Alternatively, if you shoot a series of images to stitch together you can adjust focus as you move the camera between frames.

High viewpoints are beneficial in this respect because everything in the scene is far off, there's no near foreground to worry about and you don't

◄ SANDYMOUTH, CORNWALL, ENGLAND
Having shot a number of horizontal panoramas of this scene, I suddenly realized that it would also work well as a vertical and promptly turned my camera on its side. The foreground rocks lead the eye nicely towards the pyramid-shaped rock offshore while the clear sky adds a sense of openness to the composition.
CAMERA: FUJI GX617/LENS: 90MM/FILTER: 0.3 CENTRE ND/FILM: FUJICHROME VELVIA 50

▶ MARRAKECH, MORCOCCO
Shooting from a terrace café above the main square in Marrakech, I had a clear view down and across to the Koutoubia Minaret in the distance. Heavy gradding of the sky was required to hold that intense colour but still record detail in the foreground.
CAMERA: HASSELBLAD XPAN/LENS: 90MM/FILTER: 0.9ND HARD GRAD/FILM: FUJICHROME VELVIA 50

▶▶ SALFORD QUAYS, MANCHESTER, ENGLAND
This suspension bridge was ideal for a vertical panorama as part of the extravagant structure was passing overhead. Turning my camera on its side enabled me to make the most of the dramatic lines it created.
CAMERA: HASSELBLAD XPAN/LENS: 45MM/FILTER: POLARIZER/FILM: FUJICHROME VELVIA 50

▶▶▶ KOLMANSKOP, NAMIBIA
Exploring one of the deserted houses in this former diamond-mining town, it suddenly struck me that standing in one room I could see through to several others. The repetition of the open doorways and the changing colours from one room to the next created an eye-catching scene that I decided was best captured as a vertical panorama.
CAMERA: HASSELBLAD XPAN/LENS: 90MM /FILM: FUJICHROME VELVIA 50

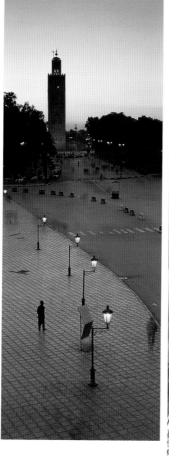
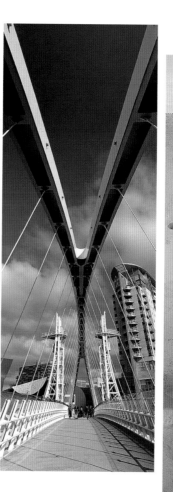
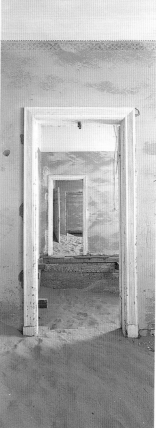

need extensive depth-of-field to contend with. You will also have a much clearer view of everything, especially in towns and cities. Try shooting from a tall building (in an area with a lot of high-rise architecture, you may be able to find a tower that stands taller than the surrounding buildings and enables you to look down on them). You'll be able to capture everything from ant-like people on the ground below, up to the buildings opposite you, and then beyond to the open sky.

ℹ EQUIPMENT CHOICE

If you like the idea of shooting vertical panoramas with a panoramic camera, there are numerous options. In 35mm format the Hasselblad Xpan is the main contender and though no longer manufactured, it's easy to pick up on the second-hand market. The 45mm standard lens is the best choice for general use, though the wider 30mm is a fantastic option; the 90mm allows you to shoot more selectively.

Rotational panoramic cameras such as the Noblex 135 series and Horizon 202 are other alternatives. They use a fixed lens with a rotating slit shutter to create wide-angle panoramic images with an angle of view of around 120–140°.

Rollfilm panoramic cameras are more numerous, but also bigger and more expensive. I use the Fuji GX617 system, which can only be purchased second-hand now. There are comparable 6 x 17cm models available from Horseman, Widepan and Fotoman.

Failing that, shoot a sequence of digital images and stitch them together. Turn to page 128–131 to find out how it's done.

INDEX